THE ART LOVER'S GUIDE TO
PARIS

CONTENTS

FOREWORD

I WAS THRILLED at the prospect of writing *The Art Lover's Guide to Paris*. Then, on further contemplation, daunted. While I know and love Paris, having been in and out of the French capital for years, writing cultural stories and participating in artistic projects, how on earth was I going to condense the immense art offerings of this city into a pocket book, and where to start?

While beginning with a splash of history, the rest of the chapters were shaped to offer a wealth of practical information on how to access art on various levels in Paris, with a focus on inspiring readers to go forth and have emerging experiences. I've seen so many tourists floating around Paris, lost and confused over the years, and always think it's such a shame when there are just so many incredible artistic experiences to have after a visit to the Louvre – they just needed a bit of help.

Before I began writing, I revisited the museums, the galleries, private collections and libraries and spent every Thursday night hopping between art openings, meeting with artists, and art enthusiasts (some of whom I already knew, and many I didn't). Armed with camera, microphone and notepad, I attended the open workshop festivals, sketch classes, bid at an art auction and interviewed gallery owners, auction house heads, artists, an art lawyer, collectors, artists' associations and museum directors.

With tulips on my desk, I hit the keys. Debussy and my family and friends kept me inspired. Before I knew it I had written far too much! To make the editing experience sweeter, I worked in the cafés of the exquisite arty hotels (that you'll read about here) over hibiscus infusions and devilishly rich hot chocolates. The aim was to create crisp text to inform and inspire.

Whether you're already in Paris or considering a trip, I hope this guide will lead you to intriguing artworks, places and people. While it was impossible to include everything, especially the thousands of great galleries across the city, I hope you'll find yourselves well directed with plenty of ideas to give your visit a dramatic head start.

And while the Parisian art types may seem a little scary at first glance, I encourage you to be brave, say *bonjour*, strike up conversations at the openings, galleries and events – you'll soon get into the swing of it. Also, don't be shy to bid at an auction, try sketching at an art class, head outside the central destinations and discover art in unexpected places. Pack a notepad, charge your batteries, be equipped with comfortable shoes, and a chic outfit, and most of all, have fun!

Acknowledgements

I'D LIKE TO THANK everyone who helped make this book possible and the writing of it enjoyable, including:

Jan & Hacene Boukabou, Julien Thonnard, Frédérique Bilbaut-Faillant, Annie Wright, Lila Graffin, Irina Dunn, Selwa Anthony, Yasmin Boland, Luke Davies, Thierry de Lachaise, Luc Saucier, Fatiha Selam, The Billarants, Pin Affleck, Jonathan Wright, Janet Brookes, Lori Jones, Karyn Burnham, Patricia Chriss, Juliette Dumartin, Juliette Dragon, Monica Loncola-Dergosits, Maria Cynthia, Helen Szaday, Harriet O'Malley, Tom Oliver, Esther Wohlgemuth the publicists and staff of the museums, galleries, fairs and hotels I visited in and around Paris, Fino & Annaba and Debussy.

1

WHY PARIS? A SPLASH OF ART HISTORY

AS IN ALL SOCIETIES, art in France has existed since people first drew in caves and threaded beads. It continued to develop over the centuries, then along came Charlemagne ('Charles the Great', 742–814) switching on a light that woke Europe from the Dark Ages[1]. He encouraged arts, culture[2] and education[3], unified the language[4] and commissioned artists to

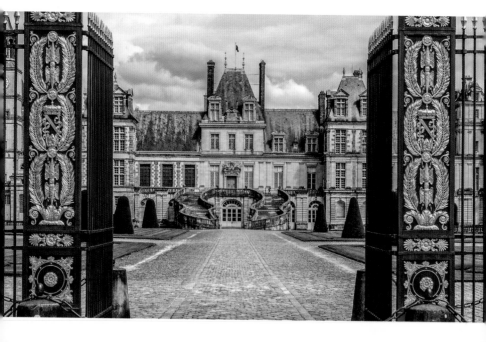

▼ The Fontainebleau Palace with its noble gardens is today a lovely day trip from Paris with its 'Napoleon Museum' (see 'Arty Day Trips').

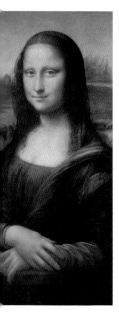

▲ *Leonardo da Vinci's Mona Lisa which is on display at the Louvre Museum, Paris.*

produce sculpture, manuscripts and frescoes for the courts. (Although Charlemagne is considered a great influence on western culture, his interest in the humanities did not transfer to humanity: he murdered thousands of Germanic pagan Saxons who refused to convert to Christianity).

Throughout Europe decorative and religious art continued in the service of the royal courts. The candle that was burning was about to flare.

Paris' romance with art was truly ignited by the well educated François I, whose reign started in 1515. Following wars in northern Italy, François procured many artworks and, in doing so, brought the Renaissance to France.[5][6](His mother's interest in the Italian Renaissance had a strong influence on him). He invited Italian architect Sebastio Serlio to decorate his château along with Italian designers and craftsmen thus creating the famous school of Fontainebleau.

One of the artists was none other than Leonardo da Vinci who arrived at Amboise in 1516, bringing three portraits: Saint Anne, Saint Jean Baptiste and, you guessed it, the Mona Lisa (known to the French as La Joconde). Da Vinci stayed in France and lived in Chateau de Cloux (now Chateau de Clos Luce) until his death in 1519 at the age of 67.

In 1543 the Louvre Palace was converted into the main residence of the French kings, and François started an art collection in the form of portraits of the French kings. In 1546 he converted the Louvre into French Renaissance style.

François became a patron of the arts. He built up the royal library and opened it up to international scholars. In 1530 he declared French the national language. Under the recommendation of humanist and scholar Guillaume Budé he set up the College Royal, then College des trios Langues (now the College de France) opposite the Sorbonne in what became known as the Latin Quarter. As well as mathematics, students could study Greek, Hebrew, Aramaic and Arabic.[7] These initiatives produced a cross fertilisation of ideas. After this breath-taking legacy however, François' humanity careered downhill with brutal murders of thousands of Protestant Huguenots after he suspected them of attempting

to overthrow not only the church, but him too.

Under François I Renaissance architecture was widely used in churches and public buildings, replacing the more sombre Gothic style. The high vaulted, airy, intricate style inspired thought and creativity. During the sixteenth century Paris became the largest centre for publishing after Venice – François encouraged writers and expanded the library.

The sixteenth century also saw the introduction of street lighting in Paris, the first theatre production and the first ballet performance. François' reign also marked a healthy continuation of Dutch artists moving to France. Paris of the sixteenth century was the largest city in Europe with a population of about 350,000, though smaller than London. Power was centralised. The population included French from the provinces, Italians, German, Flemish and Dutch craftsmen and printers. The monarchy continued François' tradition of adorning their palaces with art and sculptures.

In 1682 Louis XIV lost interest in the Louvre and moved his residence to the Palace of Versailles, leaving behind the royal collection of paintings and statues including classical Greek and Roman works. In 1648 Louis founded the royal Academy of Painting and Sculpture, later tightly controlled by the king's chief advisor, Jean-Baptiste Colbert, who also determined which art would decorate the Palace of Versailles. The Louvre became a residence for artists and a series of salons were held. In 1750 Louis XV sanctioned a display from the Royal collection, opening a hall for public viewing in the Luxembourg Palace on Wednesdays and Saturdays. The genie was out of the bottle, leading the public to approach art as pleasurable and social and so becoming an unstoppable force that was to influence the passion for, and display of, art that we see everywhere in Paris today.

The eighteenth century saw a burst of scientific and philosophic activity: The Enlightenment. Following the French Revolution, the National Assembly decreed that the Louvre should be used as a museum to display the nation's masterpieces; it opened on 10 August 1793, and in 1797

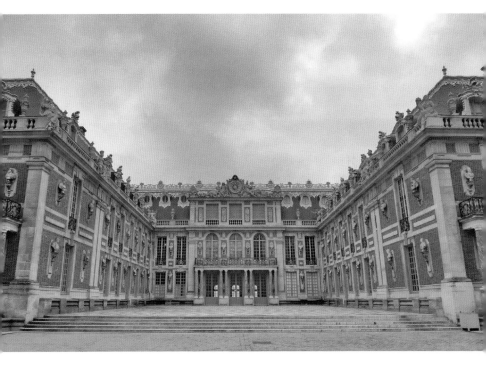

▲ *The Palace of Versailles which became Louis XIV's residence in 1682.*

Napoleon brought back art treasures following successful campaigns.

The Revolution saw an influx of artists, including women, from around the world, drawn by the sense of freedom and experimentation. More academies opened in Paris. Women were sought after artists, though had restrictions on them and were victims of vicious rumours. Despite this, they endured and benefited from the newly opened salons.

In the early 1860s a group of artists, who became known as the Impressionists, defied the tradition of restricting painting techniques and started using light brush strokes, painting outside the studio and depicting ordinary people doing ordinary things rather than revering historical figures. They outraged the juries of the *Academie des Beaux-Arts*, the preserver of French values, who refused to exhibit their works in the Salon de Paris. In stepped Napoleon after widely

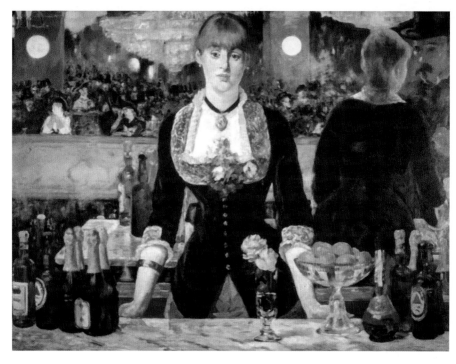

▲ *A Bar at the Folies-Bergère, 1882, by Manet.*

publicised protest and the *Salon des Refuses* was organised. The public first went to scoff at the works, but soon began to accept the paintings of the growing number of artists, with the artists themselves organising private exhibitions and private sales.[8] When Pissaro, Cezanne, Manet, Monet and Courbet were rejected for the 1867 World Fair, Manet and Courbet opened their private galleries next to the fair.

By 1880 British artists, dissatisfied within the British art world, turned to Paris and the New English Art club was formed in 1886 to promote British Impressionist works. More than 2,000 British artists and 14,000 works were presented at the Paris salons. Hundreds more international artists arrived to bring delight to Paris and to gather up its riches, especially the Paris views.[9]

Under Emperor Napoleon III, Paris hosted five World fairs between 1855 and 1900, showcasing technical and scientific

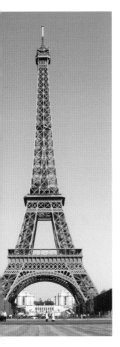

▲ The Eiffel Tower which was built in 1889.

developments, industry, economy and culture. Napoleon modernised Paris, commissioning Baron Haussmann to redesign Paris, bringing light and space into the streets, creating parks and farmlands and a host of other artistic, social and economic projects.

In 1889 the Eiffel Tower was built when Paris hosted the World Fair to celebrate French achievements on the anniversary of the French Revolution. A petition called: 'Artists against the Eiffel Tower' was published in Le Temps. It was considered an eyesore by many; actually it is still by certain Parisians, but most have embraced the city's iconic landmark.

The Grand and Petit Palais that hold many of the prestigious art fairs today were both built for the 'Exposition Universelle 1900'. While the Exhibitions drew spectators and artists from around the world, few Parisians could afford the entrance fees charged, but at least all could experience the delights of Art Nouveau that had swept Paris from railway stations to restaurants.

Impressionism led to further creative movements. Paris became the destination for artists, to learn, to paint and to relish the intellectual freedom and the excitement of the bohemian life of the Paris art scene, not possible in the conservative, restrictive environments most had endured at home.

Henri Matisse returned from northern France in 1891. In May 1904 Pablo Picasso arrived from Spain. That same year Constantin Brancusi walked most of the way from Romania, arriving on Bastille Day, 14 July. He was warmly embraced by the colony of artists. Italian Amedio Modigliani arrived from Italy in 1906, Wassily Kandinsky from Russia in 1906 and Marc Chagall in 1910.

In 1919 French artist Marcel Duchamp presented American arts patron Walter Arensberg with 'something that money couldn't buy', an ampoule of carefully sealed air from Paris, 'air de Paris' that redefined the concept of art. In 1929 Brancussi produced a portrait of James Joyce consisting of three straight lines and a spiral, entitled

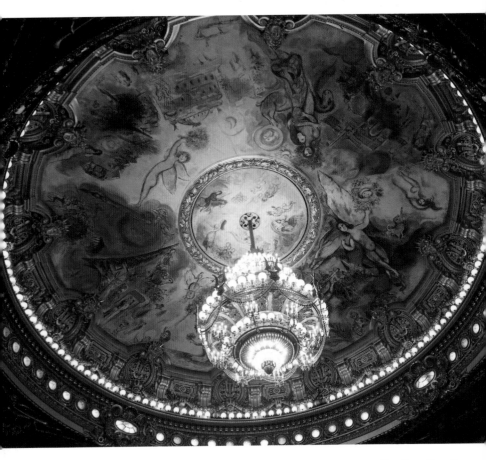

▲ *Marc Chagall's ceiling artwork in the Opera Garnier.* Ruby Boukabou

'Symbol of Joyce' to which Joyce's father commented: 'The boy seems to have changed a great deal'.

The term 'School of Paris' defines the period from about the turn of the century to about 1950.[10]

At the unveiling of Chagall's ceiling artwork for the Opéra Garnier in September 1964, the artist announced to the audience, 'Now I offer this work as a gift of gratitude to France and her *Ecole de Paris*, without which there would be no colour and no freedom.'

After the Second World War, both New York and Paris

embraced experimental and conceptual art. The Paris art scene may have flickered beside the American artistic boom, but it was not extinguished.

Continuing the tradition of French leaders patronising the arts, in 1959 President Charles de Gaulle created the Ministry of Culture to 'maintain the French identity through the promotion and protection of the arts', realising the goals of a right to culture incorporated in the Constitution of France and the Universal Declaration of Human Rights (1948). Successive presidents and mayors have inaugurated museums and supported the arts.[11]

Today Paris is a palette of art – in museums, in the streets, on the walls, in the architecture...

In 2004 France offered Europe's most generous tax breaks for charitable giving and has since sought crowdfunding, termed 'participatory philanthropy'. Private museums continue to spring up. Free entry days to museums, open air exhibitions, free events and the celebration of artists and their old haunts such as Montmartre, and current studios, many in the north east, allow the public to engage in the delights of art of Paris past and present.

And the icing on the cake: Paris has historically been a city for artists in exile. *Today, the unprecedented refugee crisis has brought thousands of people to Europe, and among them, artists of all disciplines. Paris now has a structure to welcome some of them*: the Atelier des Artistes en Exil.

Much is also changing in what's called 'le grand paris' (greater Paris) with fascinating artistic projects happening in the cultural centres outside of central Paris. Paris has also become the global centre for major exhibitions throughout the year.

Today Paris is a palette of art – in museums, in the streets, on the walls, in the architecture ... the legacy of over 400 years of leaders insightful of the legacy of art, dedicated artists and all those who have been touched by the transforming power of art.

But why do we need art anyway? Laurent Le Bon, director

of Musée Picasso answers:

> *Art distinguishes us as human, it makes us understand otherness and diversity; it allows us to see the world in other ways; it makes life more stimulating. Some may say that we can live without art, but that's not true, there's always forms of art in play, especially since the twentieth century – thanks to artists such as Duchamp, we began to look at everything differently. Art, like water, keeps us alive.*

Footnotes

1. Hywell p. 371.
2. Paul F. State, *A Brief History of France*, Checkmark Books, New York, 2010, p. 45.
3. Encyclopaedia Britannica, *Carolingian literature and arts*, Web.
4. Hywell, pp. 338,351, 371.
5. P. F. State, pp. 101–106.
6. *Francis I of France.* http://enacademic.com/dic.nsf/enwiki/31960
7. *Eastern Wisdom and Learning*, G.J. Toomer, Oxford University Press, NY, 1996. pp. 26, 27, Web.
8. Anahita Shafa, 2005-2007, *History of the Impressionist Movement*, 20/01/2018, Web.
9. *The Discovery of Paris; Watercolours by Nineteenth-century Artists*, Wallace collection Exhibition, Web.
10. 'School of Paris'. *Heilbrunn Timeline of Art History*, The Metropolitan Museum of Art, Web.
11. French Ministry of Culture mission statement.

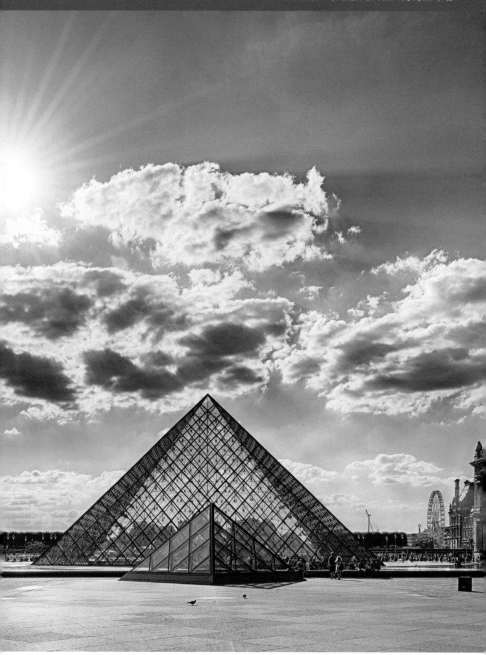

The arrondissements of Paris

Paris is divided into 20 administrative districts called arrondissements that start in the centre and spiral outwards. Their reference is indicated in the last two digits of the postal code. Thus 75001 is the 1st arrondissement, 75010 is the 10th etc.

La Défense

Palais des Congrès

17

Arc de Triomphe

8

Concorde

16

Tour Eiffel

Musée d'Orsay

Roland Garros

7

Parc des Princes

Tour Montparnasse

15

Gare Montparnasse

14

Parc des Expositions

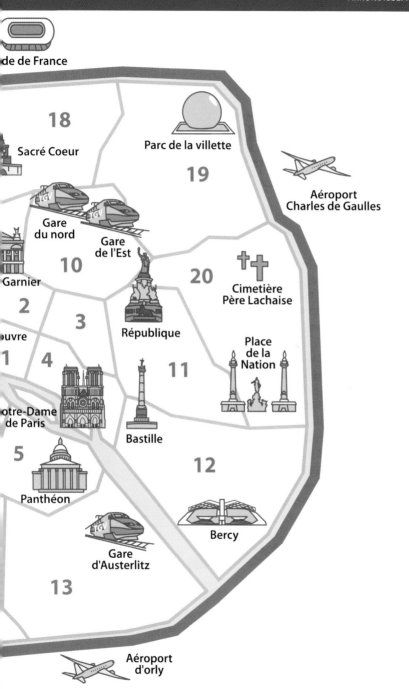

de de France

18

Sacré Coeur

Parc de la villette

19

Aéroport
Charles de Gaulles

Gare
du nord

Gare
de l'Est

10

Garnier

2

3

20

Cimetière
Père Lachaise

République

ɔuvre

1

4

11

Place
de la
Nation

ɔtre-Dame
de Paris

5

Bastille

Panthéon

12

Bercy

Gare
d'Austerlitz

13

Aéroport
d'orly

2

MUSEUMS, FOUNDATIONS & INSTITUTIONS

YOU COULD SPEND a month in Paris and not have enough time to see all the art on offer in the museums. Actually you could probably spend a month in the Louvre alone! The city boasts over a hundred museums that, through carefully curated exhibitions and strong permanent collections, can transport you from the Stone Age to the Renaissance to contemporary Paris.

The Paris Museum pass is a good idea for budgeting and skipping the queues (**http://en.parismuseumpass.com/**), as is pre-booking your ticket online. Major exhibitions can have queues for a few hours so you'll appreciate being in the fast lane.

Museum visits tend to take longer than anticipated. Rather than running from exhibition to exhibition and being unable to see straight by the end of the day, perhaps plan to go to fewer but take your time. Spend longer moments in front of the works to contemplate, read and reflect, taking breaks to sit and ponder, jot a note, take a photo and have time out in the cafés, many of which are quite beautiful. It's also worth getting the audio guide to put the works in context. Having said that, if an exhibition isn't doing it for you, don't feel the need to pretend to be inspired – try a little then move on to something that draws your attention.

Finally, and at risk of sounding like your grandmother, you may want to pack a bottle of water and muesli bars for mini pick-me-ups, as you're set for some inspiring but long days!

NOTE that most museums are closed on Mondays and some on Tuesdays. Many of Paris' best museums have changing exhibits and collections, so make sure to check the official museum sites (listed) to find out exactly what's on, the opening hours and the various admission fees. Some museums have free permanent collections and many are free the first Sunday of each month (obviously the queues will be longer). If you're under 26 you may be able to enter for free at other times.

MUSEUMS & INSTITUTIONS | THE 'BIGGIES'

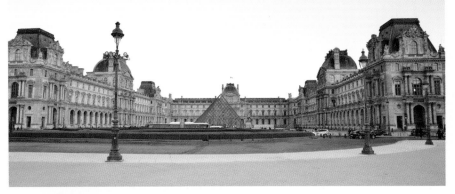

▲ *The Winged Victory of Samothrace.*

A TIP from French gallery owner Charles-Wesley Hourdé: 'check out the **Pavillon des Session** (an outpost of Musée de Quai Branly). Not only are there magnificent works of art from Africa, Oceania, Asia and the Americas, it's quiet and zen!'

THE LOUVRE
rue de Rivoli, 75001
+33 (0)1 40 20 50 50
www.louvre.fr/en

The museum of museums, the mighty Louvre is the epicentre of art and a landmark on the Right Bank in the city centre. Even arriving is an artistic experience – with the majestic sculpture filled Tuileries gardens and the snaking Seine river alongside this once Philippe-Auguste fortress and, later, Louis XIV palace. Departments include Near Eastern antiquities, Greek, Etruscan and Roman antiquities, Islamic Art, sculptures, decorative arts, paintings, prints and drawings. Brave the human traffic to catch a glimpse of Leonardo da Vinci's Renaissance superstar portrait, the *Mona Lisa* (it seems so small after all the hype, but somehow her gaze will rest with you), the Venus de Milo statue from Hellenistic Greece and the dramatic Romantic Raft of the Medusa by Géricault. Then get lost and discover incredible works along seemingly endless corridors. Dive into the Egyptian collection with the statues of Akhenaten, Nefertiti and an Egyptian scribe and be inspired to scribble or sketch your own thoughts.

▲ *Musée de l'Orangerie.*

MUSÉE DE L'ORANGERIE
Jardin Tuileries, 75001
+33 (0)1 44 50 43 00
www.musee-orangerie.fr/en

People have been known to return time and time again to this small but top-notch museum in the Tuileries Garden, between the Place de la Concorde and the Louvre. Why? Monet. Monet. Monet. The famous last work of the impressionist master, the *Water Lilies* ('Nymphéas') painted in the artist's garden at Giverny is engulfing and beautiful. On top of that there's a great collection from dealer/collector Paul Guillaume including Impressionist and post-Impressionist wonders from Renoir, Cézanne, Matisse, and also Modigliani and Picasso.

Claude Monet, Les Nymphéas (The Water Lilies)*, suite of paintings on permanent exhibition at the Musée de l'Orangerie.* ▶

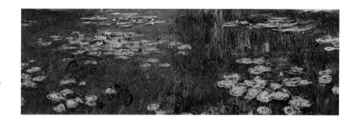

DON'T MISS the gift shop for great souvenirs.

MUSÉE DES ARTS DÉCORATIFS
107 rue de Rivoli, 75001
+33 (0)1 44 55 57 50
www.lesartsdecoratifs.fr/en/

The Museum of Decorative Arts is held in the Pavillon de Marsan, the western wing of the Louvre. Five floors of works boast objects from the Middle Ages to the present and include an Art Deco and Art Nouveau room, a doll collection, jewellery and a restaurant where you can gaze out over the Tuileries and contemplate it all. Past exhibitions have included one on Dior with tens of thousands of visitors arriving in rain and shine to gawk at the glamorous gowns of the French fashion king.

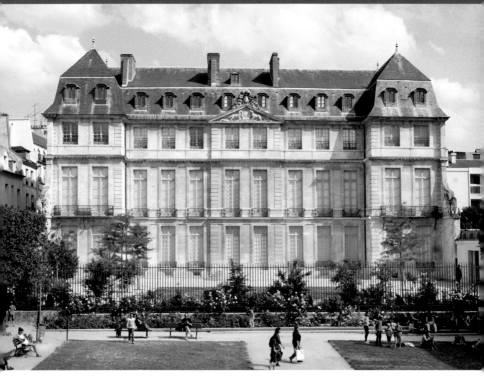

▲ *Musée Picasso.*
Fabien Campoverde

▲ *Musée Picasso.*
Fabien Campoverde

MUSÉE PICASSO

5 rue de Thorigny, 75003
+33 (0)1 85 56 00 36
www.museepicassoparis.fr/en

Child prodigy, Spanish-born master and father of Cubism, Pablo Picasso spent much of his life in the invigorating art capital of Paris where he felt free from the conservative Spain, could visit and be inspired by the Louvre and mix with the likes of Cézanne, Degas and Bonnard. This museum in a seventeenth-century mansion, Hôtel Salé, in the Marais, opened in 1985 and holds the largest collection of his works in the world (5,000 works on display and tens of thousands of archived pieces). 'If you know exactly what you're going to do, what's the good of doing it?' said Picasso whose work created new ways of looking at the world.

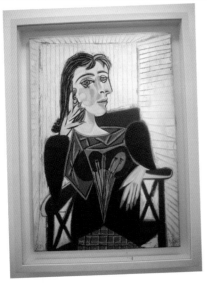

▲ Picasso's portrait of Dora Maar.

Why is Picasso still so famous? According to museum director Laurent Le Bon:

"He makes people dream. When we think 'artist' we think of him. What fascinates people is his way of looking, his diversity. Contemporary artists are still amazed by him. Picasso helps us see the world differently and to understand it. When we want to be a bit simplistic we can say 'I can do that, it's like a child', but Picasso had a real classical base and spent all his life relearning the simplicity – and that's his genius – by always putting himself in question, he continues to surprise."

MUSÉE CARNAVALET
16 Rue des Francs Bourgeois, 75003
+33 (0)1 44 59 58 58
www.carnavalet.paris.fr/en

Occupying two mansions – the Hôtel Carnavalet and the former Hôtel Le Peletier de Saint Fargeau, the Carnavalet Museum delves into the history of Paris. Though the museum is closed for renovations till late 2019, you can still browse their collection online.

MUSÉE COGNACQ-JAY
8 rue Elzévir 75003
+33 (0)1 40 27 07 21
www.museecognacqjay.paris.fr

This museum, now housed within the Hôtel de Donon, with a free permanent collection, gives a taste of upper class eighteenth-century Europe. The collection of Ernest Cognacq-Jay (founder of La Samaritane department store) and wife Marie-Louise Jaÿ, donated to the state, includes furniture, porcelain, jewellery, costume, oil paintings, sculptures and trinkets.

▲ *Ancient Christian text from Christians in the East exhibition.*
Ruby Boukabou

INSTITUT DU MONDE ARABE / THE ARAB WORLD INSTITUTE
1 Rue des Fossés Saint-Bernard 75005
+33 (0)1 40 51 38 38
www.imarabe.org

The IMA is not just a museum but an engaging cultural complex. Honouring the vast Arab world and its arts, the exhibitions are sublimely displayed and the permanent exhibition is also worth visiting. Travel in time and space through books, objects, clothing, ceramics, glassware, carpets and art works. You can't miss the stylish building by architect Jean Nouvel with glass walls and light screens in metal irises filtering the light and heat. Lose yourself in one of the exhibitions until you're hungry then head to the terrace for lunch at the kiosk, or at the pricier but beautiful Lebanese restaurant Le Zyriab with panoramic views of Paris. Then work your way back down to browse the library on the first floor and the bookshop on the ground floor.

> **T**
> Make sure to check the program and if you're lucky you can catch a concert from a talented Oud player or a program of performances curated by the likes of French/Malian hip hop artist Oxmo Pacino.

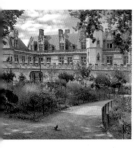

MUSÉE NATIONAL DU MOYEN AGE (NATIONAL MUSEUM OF THE MIDDLE AGES, FORMERLY MUSÉE DE CLUNY)
6 Place Paul Painlevé, 75005
+33 (0)1 53 73 78 00
www.musee-moyenage.fr

History lovers will adore this treasure house in the Latin Quarter which was once the art collection and home of Alexandre du Sommerard (from 1833). The fifteenth-century mansion, the Hôtel de Cluny, also boasts the remains of a circa 200 ad Gallo-Roman bathhouse with remnants of the baths and a gym. On display in the museum are stunning stained glass windows from the Saint Chapelle; the stone heads of the Kings of Judah carved c. 1220; Romanesque and Gothic sculptures; medieval carved wooden altar pieces; manuscripts; ceramics and jewellery, including the Gold Rose of Basel, a wrought iron piece from 1330. Paintings date from the Gallic period until the sixteenth century. The *piece de resistance* is the large wool and silk woven tapestry series 'The Lady and the Unicorn' dating from the 1500s, featuring a beautifully dressed noble lady with a lion and a very charming white unicorn.

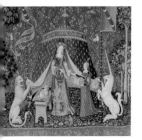

▲ *The Lady and the Unicorn dating from the 1500s..*

MUSÉE DU LUXEMBOURG
19 rue de Vaugirard, 75006
+33 (0)1 40 13 62 00
www.museeduluxembourg.fr

In the heart of the Latin quarter by the glorious Luxembourg gardens, one of France's original public galleries was opened to the public in 1750 and housed many works from the Old Masters (later moved to Le Louvre, L'Orangerie and the Musée d'Orsay). It now produces temporary exhibitions themed around the artistic heritage of France and is one of the popular locations during La Nuit Blanche festival with exhibitions of masters such as Rubens, and chamber music concerts by young, talented musicians.

MUSÉE DU QUAI BRANLY
37 Quai Branly, 75007
+33 (0)1 56 61 70 00
www.quaibranly.fr/en/

Collections from the much loved Musée du Quai Branly feature works originating in non-European civilisations from the Neolithic period to the twentieth century.

The Jean Nouvel inventive post-modern architecture of various shapes and forms serves for an interesting journey on arrival, with a glass wall and a large, dense garden cutting the property from the stress and traffic of the capital. Works of Australian Indigenous artists design the ceiling art (in the offices) and the roof.

▲ *Anthropomorphic sculpture of goddess in Volcanic Rock from Mexico.* Ruby Boukabou

Inside, a staggering 300,000 objects are in the collection with around 3,500 on display at a time, with temporary items arriving for various exhibitions. Among the collection are drums from Vanuatu, giant headdresses from Bolivia, an androgynous statue from Mali (tenth–eleventh century), a head trophy from Nigeria (twentieth century), carvings from Papua New Guinea, dot and bark paintings from Aboriginal Australia, jewellery from North Africa and artwork from the Aztecs and the Incas. Many of the objects are spiritually charged and when you're face to face with a trophy skull or a protective statuette, it can be quite intense!

Sign up for a guided walk with themes from masks to music to architecture. You can even have a visit led by a storyteller with lively anecdotes, song and dance.

Kids' activities include doll and mask making; students have evenings with DJ sets and adults have an 'After Work' apéro. There are also concerts, readings, openings and seminars.

T
Finish your visit with a coffee in the Café Branly or head up for a meal to the swish **Les Ombres** from chef Alain Ducasse for some fine French cuisine with an amazing Eiffel Tower backdrop.

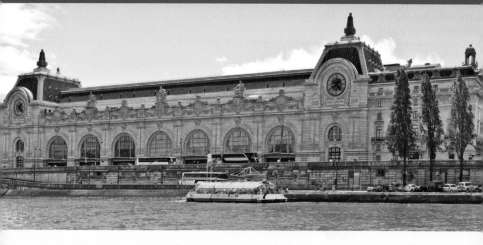

MUSÉE D'ORSAY
1 rue de la Légion d'Honneur, 75007
+33 (0)1 40 49 48 14
www.musee-orsay.fr/en

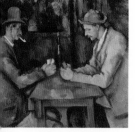

▲ *From the series of 5 of Cézanne's The Card Players, painted early 1890s.*

The Orsay museum is often quite crowded but for a good reason – it's incredible. Once a Beaux Arts railway station on the left bank, the building is a beautiful setting for the artworks. You'll find paintings, sculptures, furniture and photography from various artistic movements including realism, symbolism, and Art Nouveau but it's mostly known as an impressionist and post impressionist heaven. Get face to face with Cézanne's card players, Renoir's *Moulin de la Galette*, Manet's *Olympia* and many other masterpieces from Van Gogh, Pissarro, Degas and friends.

MUSÉE MAILLOT
61 rue de Grenelle, 75007
+33 (0) 1 42 22 59 58
www.museemaillol.com

S Lloyd

Aristide Maillot's model Dina Vierny established this museum featuring both the works of the twentieth-century artist and his fine collection of other works, in a Rococo mansion in

the 7th. Vern sat for Maillot from the age of 15 and was also a model for the likes of Dufy and Matisse, getting a taste and appreciation for the process of making art before opening her own gallery. The works from Maillot, who had studied at the École des Beaux-Arts, include many classical female sculptures and his earlier paintings as well as drawings, terracotta works and tapestries. His collection includes Matisse, Rousseau, Suzanne Valadon and Marcel Duchamp.

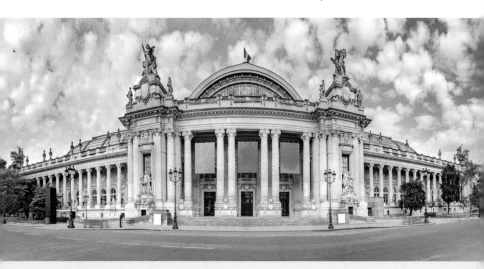

GRAND PALAIS
3, avenue du Général Eisenhower 75008
+33 (0)1 44 13 17 17
www.grandpalais.fr/en

Grand it certainly is, this exhibition and museum complex with its classical stone Beaux-Arts facade and huge Art Nouveau glass roof with bronze statues of chariots and flying horses, built for the 1900 Exposition Universelle. Home to the National Gallery, there are many major shows that run a few months at a time as well as installations, concerts and major art events, including the prestigious international art fair – the FIAC, Art Paris and Paris Photo. Need a break from pacing by the canvasses? Relax and refuel in the elegant modern French 'Minipalais' brasserie.

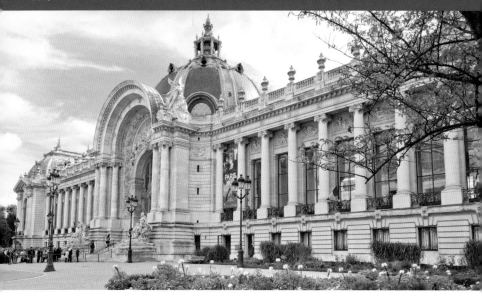

PETIT PALAIS
avenue Winston Churchill, 75008
+33 (0)1 53 43 40 00 (FREE)
http://www.petitpalais.paris.fr/en

Opposite the Grand Palais is the splendid Petit Palais, home to the Paris Museum of Fine Arts. Also built for the 1900 Exposition Universelle, the Beaux Arts building is refined, as are the interiors with dramatic high ceilings decorated with beautiful allegorical paintings. Appreciate paintings by Rembrandt, Rubens, Delacroix, Monet, Gaugin and Courbet as well as porcelain items, clocks, drawings and sculptures. There's also a lovely garden courtyard café. The good news is that the permanent collection is free.

MUSÉE MARMOTTAN-MONET
2 rue Louis Boilly, 75016
+33 (0)1 44 96 50 33
www.marmottan.fr/uk/

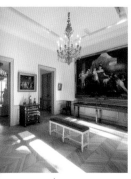

▲ *Musée Marmottan-Monet.* Christian Baraja

Once a hunting lodge of the Duc de Valmy, this museum in the posh 16th features over 300 Impressionist and Post Impressionist works. Monet's seminal painting 'Impression:

Soleil Levant' is housed here. In 1985 the painting was stolen by members of an art theft syndicate and recovered in 1991 in Corsica. There's around 100 more of the master's pieces. Plunge into them as well as hundreds of other Impressionist works by the likes of Manet, Pissarro, Degas, Renoir and Berthe Morisot.

CITÉ DE L'ARCHITECTURE ET DU PATRIMOINE/ MUSÉE DES MONUMENTS FRANÇAIS

1 Place du Trocadéro et du 11 Novembre, 75016
+33 (0)1 58 51 52 00
www.citedelarchitecture.fr

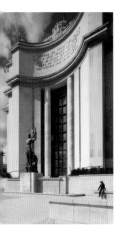

Inside the east wing of the majestic Palais de Chaillot, this museum is dedicated to architecture and monumental sculpture. There are beautiful stained glass windows, replicas of important French monuments and hundreds of plaster casts from the twelfth century through to contemporary times. With deep-red and bright-white walls, high ceilings and skylights, it's a dramatic exploration that begins and finishes in a front-seat view of Paris' most famous monument of all – the real Eiffel Tower!

▲ *Cité de l'Architecture et du Patrimoine.* N Borel

ESPACE DALI

11 rue Poulbot, 75018
+33 (0)1 42 64 40 10
http://daliparis.com/en/

Spanish artist Salvador Dali shook the art world with his surrealism, a movement that drew him to Paris, spanning painting, sculpture, window display and advertising. Dreams and hallucinations came to life in his wild, imaginative artworks with melting clocks and trees with eyes coming from the landscape of the unconscious mind. Close to the Place du Tertre with its buzz of portrait painters and tourist cafés and galleries in the centre of picturesque Montmartre, the Espace Dali exhibits the largest amount of Dali works in France with a collection of over 300 items. Examine the work of the man behind the big moustache – theatrical sculptures, quirky engravings, and various other poetic objects from this unique and endlessly inspired artist who often called Paris home.

MUSEUMS IN ARTISTS' PAST STUDIOS/HOUSES

While it's lovely to see art in pristine museums and spaces created for hanging and appreciating the works of masters, it's also nice to experience the context of the creation. These houses/studios often also have delightful gardens with crawlies, roses or daffodils – very refreshing after you've spent hours pounding the Parisian pavements inhaling carbon monoxide!

ATELIER BRANCUSI
Place Georges Pompidou, 75004
+33 (0)1 44 78 12 33
www.centrepompidou.fr/en/Collections/Brancusi-s-Studio

Romanian born modernist sculpture Constantin Brancusi (1867–1957), creator of the famous serene bronze sculpture series 'La muse endormie' – (sleeping muse), donated his studio and art to the French government, believing that the workshop itself was reflected in the artwork created. Having once worked in the studio of Rodin, he left to break away from classical form and thinking. Originally in Montparnasse, the studio was moved next to the Pompidou centre and opened in 1997.

MAISON DE VICTOR HUGO
6 Place des Vosges, 75004
+33 (0)1 42 72 10 16
http://maisonsvictorhugo.paris.fr/en

Once home of *Les Misérables* author Victor Hugo, this small museum is worth a quick visit to take in Hugo's world via his furniture, sketches, memorabilia, writing desk, collection of porcelain and pictures. It's free entry with a cheap audio guide that will help contextualise what you're looking at. Afterwards, if the sun is out, kick back in the pretty Place des Vosges, the oldest planned square in Paris and visit the various art galleries in the arcades.

MUSÉE ZADKINE
100 Bis rue d'Assas 75006
+33 (0)1 55 42 77 20
www.zadkine.paris.fr

Discover the works of Russian born sculptor Ossip Zadkine (1890–1967) in his house, studio and gorgeous daffodil-filled garden. An artist since his childhood and a student (albeit drop-out) of the Ecole des Beaux Arts in Paris, Zadkine is considered a pioneer of modern art. His hope was for his art to create an emotion in the onlooker. There are examples of his forays into various styles from Cubism to Expressionism. Alongside the many sculptures are his photos, tapestries and drawings. You may also catch interesting contemporary exhibitions held regularly here. Afterwards, head over to the Jardin du Luxembourg for a contemplative stroll.

MUSÉE NATIONAL EUGÈNE-DELACROIX
6 rue de Fürstenberg, 75006
+33 (0)1 44 41 86 50
www.musee-delacroix.fr/en

While many of Delacroix's seminal works such as 'Liberty Leading the People' (symbol of the 1830 Revolution) hang at the Louvre, this museum in the pretty 6th has many works spanning the career of the leader of the French Romantic painters (1798–1863).

The museum is housed in the painter's apartment and garden studio. 'The view of my little garden and the cheerful appearance of my studio always make me happy,' he wrote in his diary on 28 December 1857, just after moving in. Meander through the house, studio and gardens while admiring a selection of paintings, drawings, watercolours, pastels, sketches and letters from friends including French writer Charles Baudelaire.

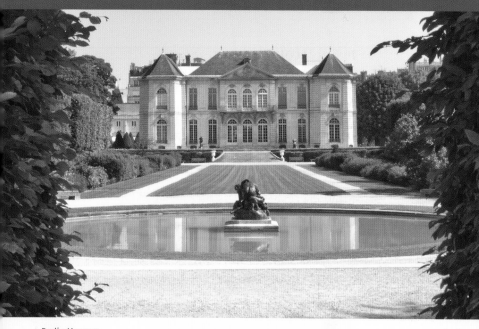

▲ *Rodin Museum.*
Photo Courtesy l'agence
photographique du Musée
Rodin

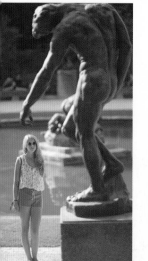

▲ *Rodin Museum Garden.*
Photo courtesy Museum Rodin

MUSÉE RODIN
79 rue de Varenne, 75007
+33 (0)1 44 18 61 10
www.musee-rodin.fr/en

The rose-scented sculpture garden is the highlight of this charming museum, Rodin's former studio and residence, opened in 1919. Inside the restored Hôtel Biron not only are there many sculptures by Rodin and his protégé and lover Camille Claudel, but also the sculpture's art collection including work from Renoir and Van Gogh. The walls certainly have history – Jean Cocteau and painter Henri Matisse once rented rooms here. Enjoy discovering the 'Michelangelo of France', as curator Catherine Chevillot told the *Guardian* on the centenary of his death in 2017, saying his work was the 'turning point from ancient to modern sculpture'. Contemplate emotional works such as 'The Burghers of Calais', 'The Gates of Hell', 'Balzac' and 'The Kiss', in one of Paris' most romantic museum settings, a stone's throw from the Eiffel Tower.

MUSÉE JACQUEMART-ANDRÉ
158 boulevard Haussmann, 75008
+33 (0)1 45 62 11 59
www.musee-jacquemart-andre.com/en

Once home to art collectors Nélie Jacquemart and Edouard André, this mansion in the 8th houses many surprises from Rembrandt to Uccello to Canaletto. Keep your eyes open for 'Virgin and Child' by Pietro di Cristoforo Vannucci (Le Pérugin) in the The Florentine Gallery, 'The Flight into Egypt' by Sandro Botticelli in the The Venetian Gallery and 'The Toilet of Venus' and 'Sleeping Venus' by François Boucher in the Picture Gallery. But there are also many other intriguing works to ponder as well as the elegant house itself with its salons, libraries and music rooms, once the spot for many a chic soirée.

Picture Gallery in the State Apartments. ▶
C Recoura

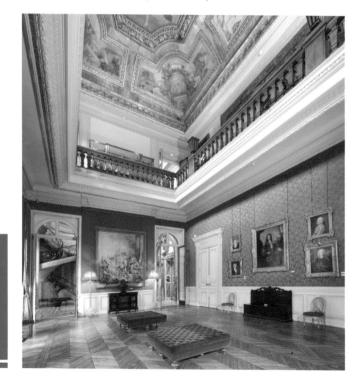

T

End your visit with a hot beverage and a pastry in the delightful tearoom, with ceiling decorations by Giovanni Battista Tiepolo.

T

While you're in the area, make sure to visit the chic Parc Morceau and the street market on rue Poncelet for great cheeses, cured meats and freshly ground coffee.

MUSÉE NISSIM DE CAMONDO

Hôtel Camondo 63 rue de Monceau, 75008
+33 (0) 1 53 89 06 50
www.lesartsdecoratifs.fr/en/museums/musee-nissim-de-camondo/

This elegant house modelled on the Petit Tianon in Versaille was offered to the state by Jewish banker Count Moïse de Camondo and named after his son Nissim, a pilot who was killed in the First World War. Gaze at the chandeliers, silver dining sets, Beauvais tapestries, Chinese vases and needlepoint chairs and glide through the grand bureau, the library, the dining room, the private apartments and garden.

MUSÉE GUSTAVE MOREAU

14 rue de la Rochefoucauld, 75009
+33 (0)1 48 74 38 50
http://en.musee-moreau.fr/

▲ *Musée Gustave Moreau.*

Once teacher to Matisse at the École des Beaux-Arts, Gustave Moreau (1826–1898) was a prolific French Symbolist painter inspired by Romantic artists such as Delacroix. The house/studio is full of paintings, trinkets and furniture. Climb the spiral staircase to discover his major works on the second and third floors. With biblical and mythological references aplenty, your imagination will drift far while gazing at the 1,300 paintings, watercolours and sketches, and around 5,000 drawings.

MUSÉE DE LA VIE ROMANTIQUE

16 rue Chaptal, 75009
+33 (0)1 55 31 95 67
www.vie-romantique.paris.fr/en

▲ *Musée de la Vie Romantique.*
Benjamin Soligny

Something of a society house on the foot of Montmartre with soirée guests including Dickens, Chopin and Delacroix, this lovely little free museum was once home of Dutch painter Ary Scheffer and writer Amantine Lucile Aurore Dupin (nom de plume – George Sand). The works of Scheffer can be discovered alongside the words of Sands. Take in the Romantic portraits, furniture,

and jewellery from the eighteenth and nineteenth centuries then relax in the pretty courtyard tearoom. The museum also offers storytelling for children, art workshops and themed visits.

ESPACE KRAJCBERG

Chemin du Montparnasse
21 avenue du Maine, 75015
+33 (0)9 50 58 42 22 (FREE)
www.facebook.com/EspaceKrajcberg/

This is the workshop of Polish born artist Frans Krajcberg who fled to France, and then Brazil after Second World War traumas. He returned to France during the New Realism movement then travelled to the Amazon where he became passionate about the environment. Discover his fun, tactile works.

MUSÉE BOURDELLE

18 rue Antoine Bourdelle, 75015
+33 (0)1 49 54 73 73 (FREE)
www.bourdelle.paris.fr/en

▲ *The gardens and front of Musée Bourdelle Paris.*
B Fougeirol

Émile-Antoine Bourdelle moved here in 1885, where he worked and lived to the end of his days (1929). Assistant of Rodin, Bourdelle became an accomplished sculptor and painter of his own right. Admire his works in bronze, plaster and marble with no less than 500 items including 'Centaure mourant' (1911–1914) and 'Monument à Adam Mickiewic' (1908–1929). Bourdelle also had a personal art collection that's on display including pieces from Eugène Delacroix, Jean Auguste Dominique Ingres and Pierre Puvis de Chavannes, the co-founder and president of the Société Nationale des Beaux-Arts.

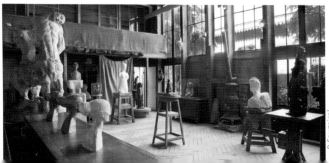

B Fougeirol

MUSÉE JEAN-JACQUES HENNER
43 avenue de Villiers, 75017
+33 (0)1 47 63 42 73
www.musee-henner.fr/en

In a nineteenth-century mansion, once home and studio of painter Guillaume Dubufe (1853–1909), this museum is now dedicated to the work of the painter Jean-Jacques Henner (1829–1905). Originally from Alsace, Henner studied at the École des Beaux-Arts in Paris and his influences include the Italian Renaissance painters such as Raphael and Correggio. Henner won the prestigious Grand Prix de Rome in 1858 with 'Adam and Eve finding the body of Abel', and moved to the Italian capital of art where he was inspired by the landscape and everyday life. His work spans Naturalism to Impressionism to history and religious painting. There's a lovely winter garden and a grand piano where the museum sometimes hosts recitals.

MUSÉE DE MONTMARTRE
12 rue Cortot, 75018
+33 (0)1 49 25 89 39
http://museedemontmartre.fr/en/

▲ Musée de Montmartre.

This delightful museum in the heart of Montmartre was once home to Suzanne Valadon and son Maurice Utrillo as well as André Utter and Auguste Renoir. Art of the bohemian Belle Époque is on the walls and wine in the air with the lovely scent of the bordering vineyard. Book in for a wine tasting, then wander the magical gardens where there's often a pianist and opera singer to accompany your stroll past the swing, a reference to Renoir's Balançoise. Hop up and recreate the photo, then head into the museum where you'll discover the rural history of Montmartre, and original works from Henri de Toulouse-Lautrec, Modigliani, Kupka, Steinlen, Valadon and Utrillo. Be transported into the studios, bars and cabaret of the belle époque; 'Le Bal du Moulin de la Galette' was one of the major Renoir works painted right here.

MODERN AND CONTEMPORARY

While Berlin, London, Brussels and New York often take the headlines for dynamic and fresh contemporary art, Paris holds its own with several major institutions and excellent, accessible private collections with many fantastic temporary exhibitions waiting to be plunged into.

POMPIDOU CENTRE
Place Georges-Pompidou, 75004
+33 (0)1 44 78 12 33
www.centrepompidou.fr/en

▼ *The Pompidou Centre by night, showing the inside out design with escalators.*
Ruby Boukabou

The Pompidou Centre is iconic for its contemporary architecture with an inside-out look designed by Renzo Piano and Richard Rogers – the escalators, ducts and coloured

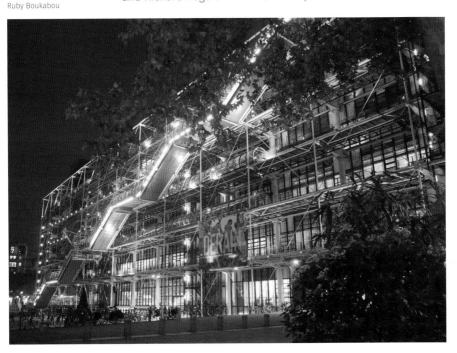

▲ The Salle du Sanglier in the Musée de la Chasse et de la Nature.

engineering workings are boldly placed outside the building and are visible from afar. Inside, it's an art world wonder, housing the Musée National d'Art Moderne with works from 1905 to the present day. Feast your eyes on Fauvist and Dadaist works, Cubism, Surrealism and ultra contemporary propositions. The complex also houses a great library, a bookshop, cinema, a children's workshop, an audio-visual section and a restaurant with a sublime view over the capital. In the square below, portrait painters, buskers and many terraced cafés, including the swish Café Beaubourg, create a constant buzz.

MUSÉE DE LA CHASSE ET DE LA NATURE
62 rue des Archives, 75003
+33 (0)1 53 01 92 40
www.chassenature.org

This 'hunting and nature' museum may not appeal to all, but of recent years they have offered a strong contemporary art program including stars such as Sophie Calle.

FONDATION CARTIER POUR L'ART CONTEMPORAIN
261 boulevard Raspail, 75014
+33 (0)1 42 18 56 50
https://www.fondationcartier.com/

In an airy, light-filled Jean Nouvel building in the 14th, the Cartier Foundation offers many contemporary exhibitions, conferences and various multi-disciplined artistic productions. Dedicated to promoting and raising public awareness of contemporary art, the exhibition program is excitingly eclectic and includes photography, painting, video art, fashion and performance art. Check their site for upcoming dates for their Nomadic Nights and Nights of Uncertainty programs, evenings that open up the building and the gardens to performances, music, screenings and talks.

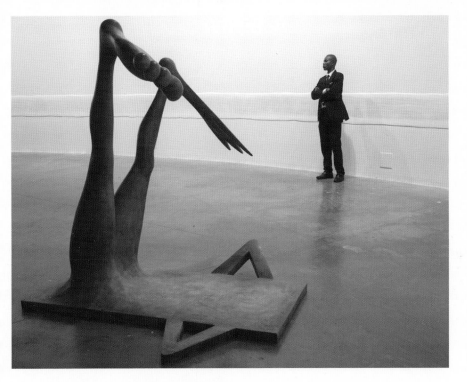

▲ *'Contrology' (bronze) at opening night of her Carte-Blanche, October 2018.* Ruby Boukabou

PALAIS DE TOKYO

13 avenue du Président-Wilson, 75116
+33 (0)1 81 97 35 88
www.palaisdetokyo.com

The western wing of the Palais de Tokyo is dedicated to temporary exhibitions of contemporary art. It's an ultra-hip location open midday to midnight and this is where you'll find cutting-edge contemporary shows, interactive works, installations and performances. You can pick up the latest design anthologies in the bookshop, make friends at the cocktail bar, dine on the terrace of Monsieur Bleu or even go clubbing at The Yoyo with its minimalist concrete backdrop. Attend an opening, hobnob with thousands of contemporary art enthusiasts and finish with a boogie on the outdoor dance floor, overlooking the glittering Eiffel Tower.

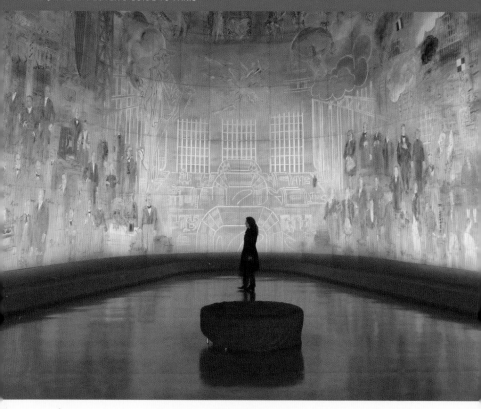

▲ *Raoul Dufy's 'La Fée électricité'.*

MUSÉE D'ART MODERNE DE LA VILLE DE PARIS – MUSEUM OF MODERN ART

Palais de Tokyo 11 ave du Président-Wilson, 75116
12-14 avenue de New York)
+33 (0)1 53 67 40 00 (FREE)
www.mam.paris.fr/en

In the east wing of the Palais de Tokyo is the Museum of Modern Art of the City of Paris.

Open since 1961, the collection now counts over 11,000 works from the twentieth and twenty-first centuries. Lose yourself in a Picasso, Dufy, Modigliani, Derain, Picabia, Chagall, Boltanski, Parreno or Doig. Highlights include the first version of 'La Danse', by Matisse, and Raoul Dufy's huge masterpiece 'La Fée électricité'.

Grab something to read from the bookshop or enjoy a meal and a glass of wine at the modern French restaurant 'Le Frank'.

LOUIS VUITTON FOUNDATION

8 avenue du Mahatma Gandhi, 75116
+33 (0)1 40 69 96 00
www.fondationlouisvuitton.fr/en

Sponsored by the group French multinational luxury goods conglomerate LVMH, the Louis Vuitton Foundation is an incredible museum and cultural centre in the Bois de Boulogne. Designed by Canadian-born American architect Frank O. Gehry (Guggenheim in Bilbao, Cinémathèque Française, Paris), it's an astounding composition of glass leaves in a sort of sailboat design fitting to house a contemporary collection by Bernard Arnault, the CEO of LVMH. This is where you'll get your fix of such artists as Basquiat and Jeff Koons and intriguing installations from artists including George Bures Miller, Sarah Morris and Adrián Villar Rojas.

There are activities for children, multilingual guides and a free app with information on the works, the artists and the architecture. Also check out the dance and musical program for top-notch recitals and performances.

HALLE SAINT PIERRE

2 Rue Ronsard, 75018
+33 (0)1 42 58 72 89
www.hallesaintpierre.org

The Halle Saint Pierre on the foothill of Montmartre holds a museum, a gallery, a library and an auditorium. The museum often presents Outsider Art (self-taught artists outside traditional training), modern art and pop art. Book signings, conferences, debates and concerts are also regular events. Revitalise after with an organic juice in their café.

▲ *Halle Saint Pierre.*

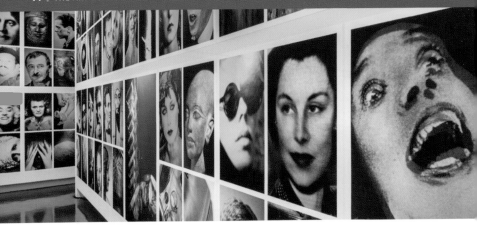

▲ *Le Bal.*
Martin Aryroglo

LE BAL
6 impasse de la Défense, 75018
+33 (0)1 44 70 75 50
www.le-bal.fr/en

Once a Roaring Twenties establishment famous for drinking and dancing, Le Bal now produces exhibitions, publications and happenings centred around the contemporary image in the form of video, photography, film and new media. There are 300 square metres of exhibition space on two levels, a ground floor for installations (covered by an Art Deco glass canopy), a café, a bookshop and a garden.

FRAC ÎLE-DE-FRANCE – LE PLATEAU
22 rue des Alouettes, 75019
+33 (0)1 76 21 13 41 (FREE)
www.fraciledefrance.com

Directed by Xavier Franceschi who runs the Frac (regional contemporary art fund), the Plateau, just above Belleville, may be much smaller than many of the city's contemporary institutions, but the artists are not. Many a career has been launched here with artists including Adel Abdessemed and Loris Gréaud. If the weather is nice, pack a picnic to enjoy in the beautiful Buttes Chaumant. Frac has a second space in a chateau outside of Paris (see 'Arty Day Trips').

MULTICULTURAL

As well as being represented in the Louvre, Musée Branly, L'Institute du Monde Arabe and part of other large collections, here are some of the institutions dedicated to non Western art and various religions.

MUSEUM OF JEWISH ART AND HISTORY
71 rue du Temple, 75003
+33 1 53 01 86 65
www.mahj.org/en

Housed in the Hôtel de Saint-Aignan, a mansion built between 1644 and 1650, this museum depicts Jewish communities from the Middle Ages to the beginning of the twentieth century, representing various religious and artistic movements. You can enjoy works by Chagall, Modigliani and Soutine.

BIBLIOTHÈQUE POLONAISE DE PARIS
6 quai d'Orléans, 75004
+33 (0)1 55 42 83 83
www.bibliotheque-polonaise-paris-shlp.fr

▲ Bibliothèque Polonaise de Paris.

When discovering the charming Île Saint-Louis, one of the two natural islands in the centre of Paris, drop into this Polish cultural institution that includes museums for the poet Adam Mickiewicz, the Musée Boleslas Biegas with paintings and sculpture by Biegas and other artists, the collection Camille Gronkowski and the Salon Frédéric Chopin. There are also temporary exhibitions from various Polish artists such as André Blondel (1909–1949) and David Garfinkiel (1902–1970).

MUSÉE CERNUSCHI
7 ave Vélasquez, 75008
+33 (0)1 53 96 21 50
www.cernuschi.paris.fr

After the Musée Guimet, the most important collection of Asian

art in Paris is in the Musée Cernuschi, a mansion in the 8th inaugurated back in 1898. The 10,000-piece rich collection includes ancient bronzes, burial figures and rare Buddhist sculptures collected by Milan-born Henri Cernuschi, one of the leaders of the Lombard revolution of 1848, a participant of the 'Commune de Paris' and friend of Impressionist patron, Théodore Duret who spent time travelling in Japan and China.

▲ *Maison De La Culture Du Japon.*

MAISON DE LA CULTURE DU JAPON

101 bis, quai Branly, 75015
+33 (0)1 44 37 95 01
www.mcjp.fr

Enjoy a splash of Japan near the Eiffel Tower, with various exhibitions offered. Check their site also for their program of performances, tea ceremonies and classes in calligraphy, ikebana (flower arranging), origami, manga and traditional cooking.

MUSÉE NATIONAL DES ARTS ASIATIQUE GUIMET/ GALERIES DU PANTHÉON BUDDAHTEQUE

6 Pl d'Iéna/ 19 av d'Iéna 75116
+33 (0)1 56 52 54 33 (FREE)
www.guimet.fr/en

This mesmerising museum is a haven of Asian arts spanning all the way from Japan to Afghanistan passing through China, Korea, Pakistan, Cambodia and India. Admire ornamented buddhas, the smiling head of Shiva, contemplate the Wheel of the Law, meditate on the Meditating Bodhisattva and feel humble beneath the painting of dignitary, Cho Man-Yong.

Close by the Guimet museum is the Galeries du Panthéon Buddahteque that houses some of the Guimet collection – many beautiful Japanese paintings and sculptures, traditional gardens and a tea ceremony building.

INSTITUT DES CULTURES D'ISLAM – ISLAMIC CULTURE INSTITUTE
56, rue Stephenson, 75018 / 19, rue Léon, 75018
+33 (0)1 53 09 99 84 (FREE)
www.institut-cultures-islam.org

Contemporary culture in and around the Muslim world is celebrated in the form of exhibitions, workshops, concerts, debates, screenings, literary brunches and much more.

FASHION / COSTUME / OPERA

MUSÉE PIERRE CARDIN
5 rue Saint-Merri, 75004
+33 (0) 1 42 76 00 57
www.pierrecardin.com

Explore three floors of dresses, hats, shoes and jewellery from famous French/Italian avant-garde style 'Space Age' fashion designer under the theme of 'past, present and future'.

PALAIS GALLIERA MUSEUM OF FASHION- MUSÉE DE LA MODE
10 Avenue Pierre Ier de Serbie, 75016
+33 (0)1 56 52 86 00
www.palaisgalliera.paris.fr/en

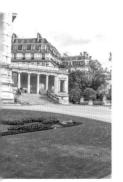

▲ *Palais Galliera Museum of Fashion – Musée De La Mode.*

Be wowed by haute couture and discover eighteenth-century dress, nineteenth-century accessories and contemporary extravaganzas in Paris' fashion museum with its various temporary exhibitions that showcase the artistry behind costume design and fashion. Gawk at garments from Dior, Chanel, Yves Saint Laurent, Galliano and Christian Lacroix and giggle at undergarments such as petticoats, panties and pantaloons. Situated inside the nineteenth-century Palais Galliera in the chic 16th, the building and gardens are a pretty retreat from the somewhat hectic streets of Paris.

FONDATION PIERRE BERGÉ – YVES SAINT LAURENT
5 avenue Marceau, 75116
+33 (0)1 44 31 64 00
https://museeyslparis.com/

Closed for expansion till the end of 2019, but invites virtual visits to its website in the meantime.

In 2017, the former haute couture HQ of fashion icon Yves Saint Laurent opened its doors as a museum to celebrate the life and works of the global style game-changer. Set designer Nathalie Crinière and decorator Jacques Grange have recreated the feel of the fashion house that has permanent and temporary exhibitions to be wowed at.

THE OPERA LIBRARY/MUSEUM
8 rue Scribe, 75009
+33 (0)1 53 79 37 47
http://www.bnf.fr

Managed by the national library, the Opera Museum traces the history of the Paris Opera through model sets, costumes, paintings and props. Entry is via the west side of the theatre, the Rotonde de l'Empereur that was designed for Napoleon III to avoid assassination. Pass the bronze sculpture by Jacques Gestalder of leaping dancer Alexandre Kalioujny to enter the museum which spans three centuries.

Stay on for a tour (self guided or with a guide) of the glorious opera itself, its sweeping staircase, foyers and Versaille-like galleries.

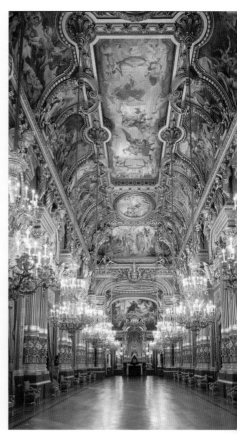

Corridor of the Grand Foyer of the Palais Garnier. ▶

DESIGN, DIGITAL AND CINEMA

Digital Arts (Note: Also see 'Photography' chapter)

Video art and photographic arts have made their way into many of the prominent contemporary institutions, reflecting the times with the museums and institutions eager to provide an interactive experience with the material.

LA GAÎTÉ LYRIQUE
3 bis rue Papin, 75003
+33 (0)1 53 01 52 00
https://gaite-lyrique.net/en

This belle époque theatre has been transformed into a digital culture hub with the focus on wonder, learning and transmission. Here the public can explore digital arts, music, cinema, graphic design and even video games. Check out their program of DJ sets, stand-up comedy, concerts, workshops, debates and screenings and visit the study centre and the bar.

▼ *La Gaîté Lyrique.*
Teddy Morellec

▲ *Fondation D'Entreprise Ricard.* Aurelien Mole

FONDATION D'ENTREPRISE RICARD
12 rue Boissy d'Anglas, 75008
+33 (0)1 53 30 88 00
www.fondation-entreprise-ricard.com/en

With five or six exhibitions held annually, this foundation was created by Paul Ricard to support young French artists to create, exhibit and be part of artistic encounters with the public. Digital arts and art films are presented as well as poetry. The conferences and debates invite philosophers, sociologists, art critics, artists and the general public to become engaged in the very meaning of contemporary art. The *Prix Fondation d'entreprise Ricard*, created in 1999, is a prestigious art prize that awards an artist as the best ambassador of their generation.

LA MAISON DES MÉTALLOS
94 rue Jean-Pierre Timbaud, 75011
+33 (0)1 48 05 88 27
www.maisondesmetallos.paris

Once a (copper) musical instrument manufacturer, the Maison des Métallos is a cultural centre that offers concerts, workshops, theatre and dance performances as well as adventures in multimedia. Their 'café numérique' (digital café) is a series of debates around topics such as the global photographic revolution. Exhibitions include photojournalism and video on themes of identity, society and belonging.

MUSÉE D'ART LUDIQUE
34, quai d'Austerlitz, 75013
+33 (0)1 45 70 09 49
www.artludique.com

Inside the avant-garde and innovative Les Docks building (Cité de la mode et du design), the Musée d'Art Ludique presents several exhibitions a year from 'playful' genres such as manga, cinema, animation and video game. Founded by Diane and

Jean-Jacques Launier in 2013, past exhibitions have included a superhero theme with posters, storyboards and costumes. Signings, conferences, debates and masterclasses take place around the exhibitions.

LA CINÉMATÈQUE FRANÇAISE
51 rue de Bercy, 75012
+33 (0)1 71 19 33 33
www.cinematheque.fr

▲ *La Cinématèque Française.*

In a pretty postmodern building designed by architect Frank Gehry, the museum within the French film archives is a must for any film buff. Discover the vintage cameras, projectors, lighting and other material alongside costumes, accessories, posters and scripts. The cinématèque also hosts events and many retrospectives (from Polanski to American Fringe to Hitchcock) and daily screenings of both classics and recently released films.

3

GALLERIES

IF YOU'VE BLOWN your budget on museums and meals, don't worry, the best thing about the galleries is that they are entirely free with no pressure to buy. And the gallery owners and staff, once you brave the first question, are a wealth of knowledge.

While the galleries are spread all over town, they tend to be grouped in clusters, often in similar genres: contemporary in the Marais, younger and more offbeat in Belleville, African and Oceanic, design and modern in the St Germaine, antique in the 7th and 8th, street art in the 13th and a mash up in between. Below you'll find a small selection from each area. Take them as a starting point and once there, look and ask around. You'll be spoilt for choice.

Also, check these sites which list not only the galleries but the current exhibition and date of the openings (vernissages), a great time

▲ *Courtyard downstairs from vernissage in the Marais.* Ruby Boukabou

to go to meet the artist, gallery owners and their entourage (usually Thursday or Saturday night) over a glass of bubbles: Association des Galeries (Parisian Art Galleries Society) **www.associationdesgaleries.org** and map: **https://www.fondation-entreprise-ricard.com/en/MAP/map**

Note that while some of the galleries are open all day, many close for long lunches and some are open only the second half of the day and week. Check their sites for exact times, or to be safe, go on Thursday to Saturday afternoons.

THE MARAIS (3rd and 4th arrondisements)

The Marais, the location of the Pompidou Centre, is the major hub for contemporary art with more galleries than you can poke an eclair at. Here are a few, but you're going to fall across dozens and dozens of others alongside fashion boutiques, cute cafés and charming public squares.

GALERIE THADDAEUS ROPAC

7 rue Debelleyme, 75003
+33 (0)1 4272 9900
http://ropac.net/

Founded in 1983 by Austrian Thaddaeus Ropac, the gallery focuses on representing and exhibiting international contemporary artists including Georg Baselitz, Daniel Richter and Alex Katz. The original gallery still exists in the Marais and a second space in an old ironworks factory in Pantin opened in 2012 allowing the exhibition of large-scale works (69 Avenue du Général Leclerc 93500). They publish a catalogue and produce events including concerts, performances, talks and screenings.

GALERIE XIPPAS

108 rue Vieille du Temple, 75004
+33 (0)1 40 27 07 16
www.xippas.com

Focused on both French and international contemporary art, this large 650 square metre, two-levelled gallery was open by art trader Renos Xippas in 1990. While there, admire the glass wall and staircase, designed by Barthélémy and Grino architects.

◄ Exhibition *Céleste Boursier-Mougenot chorégraphie, 2012 Pebbles curated by François Quintin.* F. Lanternier

▲ *Galerie Perrotin.*

GALERIE PERROTIN
76 rue de Turenne, 75003
+33 (0) 1 84 17 74 45 (FREE)
www.perrotin.com

In an eighteenth-century mansion with room for two or three exhibitions simultaneously, the gallery Peroration presents well-known contemporary artists such as Takashi Murakami, Sophie Calle, Maurizio Cattelan and Xavier Veilhan.

AGNÈS B – GALERIE DU JOUR
44 Rue Quincampoix 75004
+33 (0)1 44 54 55 90
www.galeriedujour.com

Opened in 1984 by famous French fashion designer Agnès B, Galerie du Jour has a great reputation for top quality exhibitions of paintings, photography and sculpture. The bookshop is well worth a browse with books on artists including Patty Smith and JonOne.

YVON LAMBERT
108 rue Vieille du Temple, 75003
+33 (0)1 42 71 09 33
www.yvon-lambert.com

Since opening back in 1966, Yvon Lambert has become a reference for conceptual and minimalist art and also has its own bookshop.

GALERIE DANIEL TEMPLON
30 rue Beaubourg, 75003
+33 (0)1 42 72 14 10
https://templon.com

Famous in the contemporary art scene, Templon founded his gallery in 1966 at just 21 years of age, and is also the founder of Art Press magazine and a member of the Comité des

Galeries d'Art. There are always interesting artists on display, many delving into conceptual and minimal art. Templon has accompanied many international artists on their debuts in France (Helmut Newtown, Julian Shnabel and even Andy Warhol).

▲ *Galerie Marian Goodman.*

GALERIE MARIAN GOODMAN
79 rue du Temple, 75003
+33 (0)1 48 04 70 52 (FREE)
www.mariangoodman.com

With another gallery in New York, American gallery owner Marion Goodman exhibits pop and minimalist works by dynamic artists such as Steve McQueen, Jeff Wall and Christian Boltanski.

MODUS ART GALLERY
23 place des Vosges, 75003
+33 (0)1 42 78 10 10
www.modus-gallery.com

Founded in 1996, this gallery in the beautiful Place des Vosges offers an eclectic selection of contemporary and modern art from established and emerging artists. Artists you may come across include Isabel Miramontes, Jean Paul Donadini and Ardan Ozmenoglu.

JEAN-GABRIEL MITTERRAND – GALERIE MITTERAND
79 rue du Temple, 75003
+33 (0)1 43 26 12 05
http://galeriemitterrand.com/

Contemporary sculptures are the flavour of this gallery run by the nephew of once president to France, François Mitterrand no less!

SAINT GERMAIN-DES-PRÉS

Paris' chic Saint-Germaine-de-Près was once the stomping ground of artists of all disciplines including Jean-Paul Sartre, Simone de Beauvoir, Pablo Picasso, Ernest Hemingway and Miles Davis. Today the streets are lined with cafés, boutiques and galleries, with a mix of contemporary and design galleries (the prestigious École Nationale supérieure des Beaux-Arts is in the neighbourhood) and many African, Asian, Oceanic and Indigenous ('tribal') art. Check the site of the association Les galeries de Saint-Germain-des-Prés for a full listing. (http://artsaintgermaindespres.com). A good time to visit is in September for the Parcours du Monde fair with its festive ambiance (see 'art diary').

CHARLES-WESLEY HOURDÉ
31 Rue de Seine, 75006
+33 (0)6 64 90 57 00
www.charleswesleyhourde.com

Art is in the blood for Hourdé who was raised in a family of Parisian art dealers and collectors. This consultant for Christie's auction house now has his own gallery specialising

▼ Charles-Wesley Hourdé.
Ruby Boukabou

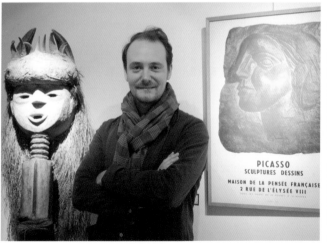

▲ *Hourdé Kran Mask.*

▲ *Galerie Georges-Philippe & Nathalie Vallois.*

in African, Oceanic and pre-Columbian arts and has participated in various international art fairs such as Tribal and Textile Arts Show (San Francisco & New York), Cologne Fine Art and Antiques and Parcours des Mondes. His passion is infectious. There are some particularly stunning masks from Gabon to get face to face with.

GALERIE GEORGES-PHILIPPE & NATHALIE VALLOIS
33 & 36 rue de Seine, 75006
+33(0)1 46 34 61 07
www.galerie-vallois.com

This contemporary art gallery specialising in New Realism and Avant-garde art has two locations on rue de Seine and a must visit when in the area.

GALERIE KAMEL MENNOUR
47 rue Saint-André des arts & 6, rue du Pont de Lodi, 75006
+33 (0)1 56 24 03 63
www.kamelmennour.com

▲ *Kamel Mennour.*
Martin Parr

Algerian-born French art dealer Kamel Mennour has created himself a firm presence in the art world over the years, his passion for contemporary art evident in his constant involvement in international art fairs and events. Mennour got into the industry after selling paintings door to door to pay for his economics degree and now he's a man about town; one moment almost alone with the Mona Lisa and Catherine Deneuve at the Louvre, the next cruising the gardens of the Palace of Versailles (check out his Instagram!). Included in the Artnet's list of 'Europe's 10 Most Respected Art Dealers in 2016', he exhibits many established contemporary artists such as Pierre Molinier, Daniel Buren and Anish Kapoor.

GALERIE KREO
31 rue Dauphine, 75006
+33 (0)1 53 10 23 00
www.galeriekreo.com

Contemporary design lovers must not miss this wonderful gallery that specialised in lighting with colourful and inventive propositions. There's also a strong section of vintage lighting and furniture as well as fun conceptual art.

GALERIE ZLOTOWSKI
20 rue de Seine, 75006
+33 (0)1 43 26 93 94
www.galeriezlotowski.fr

Shop for vibrant works of modern and Avant-garde art of the early twentieth century (and some more recent) with big names such as Le Corbusier, François Morellet, Joaquín Torres-García and Dadaist by Kurt Schwitters.

▲ Galerie Paul Prouté.

GALERIE PAUL PROUTÉ
74 rue de Seine, 75006
https://galeriepaulproute.fr/

Run by the Prouté family for four generations, this charming gallery specialises in buying, selling, and evaluating works of art on paper dating from the fifteenth century to the present.

GALERIE NATHALIE MOTTER MASSELINK
12 rue Jacob, 75006
+33 (0)1 43 54 99 92
www.mottemasselink.com

Here, Nathalie Motter Masselink shares her refined yet eclectic taste from Old Masters to contemporary works. Art History graduate of the École du Louvre and the Sorbonne, and specialist in Old Master European paintings and drawings, Masselink dealt privately before opening this gallery in 2010.

CARRÉ RIVE GAUCHE | (6th and 7th)

Carré Rive Gauche is an antique dealers and art galleries association in the heart of Paris (between the Louvre and Saint-Germain-des-Prés), with many of the galleries having been passed down several generations. Discover fine tapestries, magnificent chandeliers, centuries old restored furniture ... it's like stepping back in time with 7,000 years of art history on display. Grab the guide (in all the galleries) or download online, then explore at your own pace. www.carrerivegauche.com

GALERIE CHEVALIER
25 rue de Bourgogne,
+33 (0)1 42 60 72 68
www.galerie-chevalier.com

On the picturesque Quai Voltaire, opposite the Seine and the bouquinists (green boxes selling second-hand books, classic cabaret posters and trinkets), this gallery specialises in antique, modern and contemporary tapestries, archaeological textiles and fibre art. Four generations of family expertise and passion results in impeccable service and quality.

▲ *Galerie Chevalier.* Lola Reboud

GALERIE ALEXANDRE PIATTI
29 rue de Lille, 75007
+33(0)1 40 20 94 90
www.carrerivegauche.com/fr/galerie-alexandre-piatti

Son of an antique dealer, Alexandre Pati deals in Haute Epoque and medieval art specialising in Italian objects. Objects include beautiful fifteenth-century Italian decorative engagement/ wedding gift boxes.

▲ Galerie Minimasterpiece.
Yann Delacour

GALERIE MINIMASTERPIECE
16 rue des Saints Pères, 75007
+33(0)1 42 61 37 82
www.galerieminimasterpiece.com

Browse some very beautiful and unique jewellery created by renowned French and international artists.

GALERIE ANTOINE LAURENTIN
23 Quai Voltaire, 75007
+33(0)1 42 97 43 42
www.galerie-laurentin.com

From a family of collectors, Antoine Laurentin is passionate about his artists who include word artist Ben, Picasso, Dufy, Zadkine and Chagall!

GALERIE DES MODERNES
13 rue des Saints-Pères, 75007
+33 (0)1 40 15 00 15 (FREE)
www.galeriedesmodernes.art

▲ Galerie des Modernes.

Founded by Philippe Bismuth and Vincent Amiaux, this gallery specialises first and foremost in French master paintings of the twentieth century. Muse over the Modernists with their paintings, sculptures and drawings. Works on paper include artists such as Cocteau, Dufy and Warhol.

LIBRARIE 7L
7 rue de Lille 75007
+33 (0)1 42 92 03 58
www.librairie7l.com

While in the area, pop into the art bookshop created by Karl Lagerfeld specialising in photographs, design and interior architecture and catalogues, all dedicated to fashion art (haute couture, textile, jewellery).

MATIGNON

In the very chic 8th, around the auction houses and the Presidential residence, is a golden area of galleries from Faubourg Saint-Honoré to Avenue Matignon. The particularly plush galleries sell antiques and modern and contemporary art.

DIDIER AARON & CIE.
152, boulevard Haussmann, 75008
+33 (0)1 47 42 47 34
www.didieraaron.com

Find very beautiful furniture, paintings, drawings and objects (candle holders, chandeliers, clocks...) from the seventeenth, eighteenth and nineteenth centuries.

KAMEL MENNOUR
28 Avenue Matignon, 75008
+33 (0)1 79 74 12 20
www.kamelmennour.com

Here's another gallery of Mennour (see above in 'Le Marais'), one of the best known gallery owners of Paris, well worth a visit.

GAGOSIAN GALLERY
4 rue de Ponthieu, 75008
+33 (0)1 75 00 05 92
www.gagosian.com

Be wowed by some of the biggest names of modern and contemporary art in the swish Paris HQ of globally renowned American gallery owner Larry Gagosian.

GALERIE TALABARDON & GAUTIER GALLERY
134 rue du Faubourg Saint-Honoré, 75008
+33 (0)1 43 59 13 57

▲ *A signed Victor Hugo – Burg admidst the waves, 1857.*
Talabardon & Gautier, Paris
Art Digital Studio

Head here if you love nineteenth century art. The gallery was founded in 1992 by Bertrand Gautier and Bertrand Talabardon and is known for an excellent quality and service.

DAMIEN BOQUET ART
4 avenue Hoche, 75008
+33 (0)1 42 67 33 80
www.damienboquetart.com

Damien Boquet Art specialises in Modern Masters from
Impressionism to Post-war and the international Avant-garde
of the years 1920 to 1950 (Dada, Surrealism, Outsiders, Abstract
art...). Appointments only via damien@boquet-art.com.

GALERIE DE LA PRÉSIDENCE
90 rue du Faubourg Saint-Honoré, 75008
+33 (0)1 42 65 49 60
www.presidence.fr

Founded in 1971 by Françoise Chibret-Plaussu, this gallery
shows Masters from the late nineteenth century to the mid-
twentieth century including Boudin, Dufy, Signac and Vuillard.
There's also a permanent exhibition of works by French
artist Marcel Gromaire (1892–1971) and temporary exhibitions
including works of lesser known artists from the Salon de la
Jeune Peinture during the 1950s, including Figurative painters
Bernard Buffet, François Desnoyer and Michel de Gallard.

▼ *Galerie de la
Présidence.*

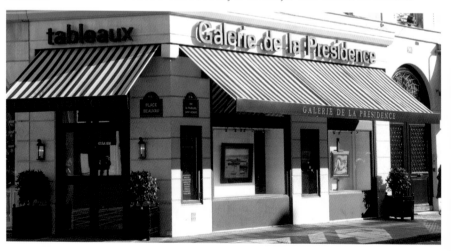

THE 9th

The 9th is not far from the Gare de Nord and people have been known to pop in from the UK and head to a gallery just for a few hours! It's also close to quaint Montmartre...

GALERIE ALLEN
59 rue de Dunkerque, 75009
+33 (0)1 45 26 92 33 (FREE)
www.galerieallen.com

Australian curator Joseph Allen Shea has made good headway with his contemporary gallery set up in association with prize winning Australian artist Mel O'Callaghan. Bilingual Allen is very hands on, always happy to talk to people about the artworks and the concepts behind them, and his openings are always fun.

▼ *Galerie Allen.*

▲ *Galerie AB.*

GALERIE AB
14 rue de la Grange Batelière, 75009
+33 (0)1 45 23 41 16
www.galerieab.fr

Discover classical and modern art presented by Agnès and Odile Aittouarès who founded this gallery in 1989.

GALERIE MATHIEU NÉOUZE
16, rue de la Grange Batelière, 75009
+33 (0)1 53 34 84 89
www.mathieu-neouze.fr

Paintings, drawings and sculptures of the nineteenth and twentieth centuries are on display, with an emphasis on Symbolism, Realism, as well as some Avant-garde art. Artists include Jean Cocteau, Marcel Mouillot and Théophile Alexandre Steinlen.

GALERIE TARANTINO
38 rue Saint-Georges, 75009
+33 (0)1 40 16 42 38
www.galerietarantino.com

Opened in 2007, Galerie Tarantino sells paintings and archaeological objects including marble sculptures, Greek vases, intaglios and cameos as well as sixteenth – eighteenth century Old Masters' drawings. Consider an Etruscan bronze warrior statuette or perhaps an imposing Greek statuette in terracotta.

RUE LOUISE WEISS | 13th

This street has some very nice contemporary offerings. The 13th has also become reputed for street art (in both the galleries and the streets: see also 'Street Art').

TRIPLE V
24 rue Louise Weiss, 75013
+33 (0)1 45 84 08 36
www.triple-v.fr

Vibrant contemporary works fill the Triple V Gallery, open since 2010. Artists represented include Emmanuelle lainé, Michael Scott and Ohad Meromi.

GALERIE LAURENT GODIN
36b Rue Eugène Oudiné, 75013
+33 (0)1 42 71 10 66
www.laurentgodin.com

Contemporary art is explored through various media, often with social themes, at the second gallery of Laurent Godin (the other in the Marais). Artists include Mika Rottenberg, Claude Closky and Alain Sechas.

AIR DE PARIS
32 rue Louise Weiss, 75013
+33 (0)1 44 23 02 77
www.airdeparis.com

Gallery owners Florence Bonnefous and Edouard Merino have a great reputation; their dynamic contemporary program showcasing artists such as Claire Fontaine, Sarah Morris and Leonor Antunes. The gallery name references Marcel Duchamp's 1919 ready made Dada installation 'Air de Paris'.

BELLEVILLE

The galleries of Belleville have the reputation of having fresh, inventive and dynamic works and themes. They mostly promote contemporary art and are run by young gallery owners willing to take risks, which is helped by the fact that rent is still somewhat cheaper than the Marais, while not too far away. Le Grand Belleville association lists them and provides a handy map on their site: legrandbelleville.com.

 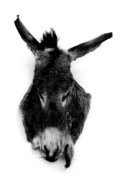

Jean-Marie Perdrix Alpha Bêta Wood, dried donkey skin. Jules Roeser ▶

GALERIE SAMY ABRAHAM
43 rue Ramponeau, 75020
+ 33 (0)1 43 58 04 16
http://samyabraham.com/

Discover a range of contemporary works- paintings, installations, posters and sculptures where conceptual is often the name of the game.

ANTOINE LEVI
44 rue Ramponeau, 75020
+33 (0)9 53 56 49 56
http://antoinelevi.fr/antoine-levi/

▲ *Antoine Levi.*
Ruby Boukabou

Appointments only

This contemporary art gallery has a particular emphasis on Avant-garde and Minimalist art. Why Belleville? 'Not only was

▲ *Galerie Antoine Levi.*
Ruby Boukabou

▲ *Suzanne Tarasieve –*
Loft 19.

Belleville more affordable than Le Marais or St Germain, but also, the other galleries were closer to our vision and universe with dynamic research into contemporary art,' says Levi.

GALERIE JOCELYN WOLFF
78 rue Julien-Lacroix, 75020
+33 (0)1 42 03 05 65
http://galeriewolff.com/

A well-established Belleville gallery (since 2003), Jocelyn Wolff presents an intriguing selection of minimalist art and conceptual pieces.

SUZANNE TARASIEVE – LOFT 19
Passage de l'Atlas, 5 villa Marcel-Lods, 75019
http://suzanne-tarasieve.com/

This is a second gallery for Tarasieve, the other in the Marais (7, rue Pastourelle). A fun place to find installations in a good space with a cosy reading corner to boot.

22,48 M2
30 rue des Envierges, 75020
+33 (0)9 81 72 26 37
www.2248m2.com

Discover innovative video installations, photography and conceptual art in this tiny but welcoming Belleville gallery.

Also in the Belleville area and worth a visit: Marcelle Alix, Balice Hertling, Sultana, Crève-Cœur and Le Plateau galleries.

PHOTOGRAPHY

CAN YOU IMAGINE life without photography? Hardly. Well we can thank France for the creation of the medium that changed the world and the ways in which we see, experience and remember it forever. Joseph Nicephore Niépce from Saint-Loup-de-Varennes near Chalon-sur-Saône, who had been into etching and lithography, started experimenting with paper sensitised with silver chloride, printing using nitric acid. Next, he tried asphaltum and kept trying new methods until producing a heliograph 'sun drawing'. In 1826 he prepared a camera with a plate facing out the window of his home in Le Gras. After a few days of exposure it produced 'View from the Window at Le Gras' which is known as the earliest photo ever taken.

▼ *'View from the Window at Le Gras'. The first successful permanent photograph created by Nicephore Niépce in 1826.*

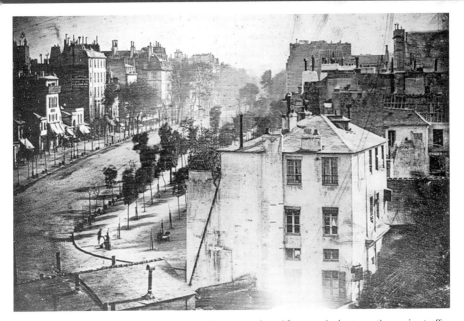

▲ Louis Daguerre's photograph of a busy street. The exposure lasted for several minutes so the moving traffic isn't visible. The two men near the bottom left corner, one of them having his boots polished, stayed in one place long enough to appear on the photograph.

In 1833 Louis Daguerre created the Dageurrotype process which was bought by the French government and commercially introduced to the world in 1839. The rest, as they say, is history. Below are just some of the places that celebrate photography in Paris. Of course you'll also see photography on the streets, in the metro and on the buses in forms of advertising.

November is 'the Month of the Photo' with 'Paris Photo' being the main event held at the Grand Palais with exhibitors from all around the world (**www. parisphoto.com**). There are dozens of other photo events around town at the same time in galleries and venues.

MAISON EUROPÉENNE DE LA PHOTOGRAPHIE
5 rue de Fourcy, 75004
+33 (0)1 44 78 75 30
www.mep-fr.org

'MEP', the European 'house' of Photography should be one of your first ports of calls for photographic exhibitions in Paris. It houses impressive retrospectives, exhibits inspiring emerging photographers and has a great library.

Adrien Che

JEU DE PAUME
1 place de la Concorde, 75008
+33 (0)1 47 03 12 50
www.jeudepaume.org

Once a tennis court, this space was converted into a museum for Jewish family masterpieces plundered by the Nazis (many Impressionist works that were moved to the Musée d'Orsay). Now it's home to an arts centre for modern and postmodern photography and media. After your visit, take time to relax in the delightful Tuileries gardens.

LE BAL

6 impasse de la Défense, 75018
+33 (0)1 44 70 75 50
www.le-bal.fr

This 1920s dance hall (and post Second World War horse-betting establishment) is now a centre for photographic exhibitions. The majority of the photos on display are politically or socially engaged with a documentary take.

LES DOUCHES

5 rue Legouvé, 75010
+33 (0)9 54 66 68 85 FREE
www.lesdoucheslagalerie.com

Based in an old public baths complex near the Canal Saint-Martin, Les Douches presents historic and contemporary documentary photography. Afterwards, stroll down the picturesque canal and be inspired to take some snaps of your own with the colourful street lights reflected artistically in the waters, the bright street art lining the

▼ *Les Douches.*

walls and the local hipsters rolling in and out of the bars and restaurants.

POLKA

12 rue Saint-Gilles, 75003
+33 (0)1 76 21 41 30
www.polkagalerie.com

Polka gallery is dedicated to politically and socially engaged photography. Pick up a copy of their bi-monthly *Polka* Magazine to study the current and previous exhibitions in more detail.

GALERIE PARIS-BEIJING

62 Rue de Turbigo 75003
+33 (0)1 42 74 32 36
www.galerieparisbeijing.com

Discover terrific work from Chinese artists, many of them photographers. You'll encounter the likes of the cleverly disappearing Liu Bolin, the intriguing performance artist who paints himself into camouflage all over the world and is photographed to catch the illusion.

Galerie Polaris.

GALERIE POLARIS
15 rue des Arquebusiers 75003
+33 (0)1 42 72 21 27
www.galeriepolaris.com

In an old gymnasium, the exhibitions at Polaris gallery are always invigorating. Alongside photography there's sculpture, drawings, paintings, video art and installations.

LA GALERIE DE L'INSTANT
46 rue de Poitou, 75003
+33 (0)1 44 54 94 09
www.lagaleriedelinstant.com

This gallery delivers shows with fascinating subjects such as a retrospective of Romy Schneider & Alain Delon or Un Français à New York by the great Jean-Pierre Laffont (beautiful black and whites of Mohamed Ali, Brigitte Bardot, Andy Warhol...).

GALERIE VU'
58 rue Saint-Lazare, 75009
+33 (0)1 53 01 85 85
www.galerievu.com

Contemporary photography is explored in its many facets in this gallery and agency that also has an online boutique. Six exhibitions each year explore both autobiographical and conceptual approaches to the art form.

GALERIE PARTICULIÈRE

11 rue du Perche, 75003
+33 (0)1 48 74 28 40
www.lagalerieparticuliere.com

While not only dedicated to photography,
the gallery often plunges into beautiful
and interpretive photography by talented
local and international photographers.

GALERIE FAIT & CAUSE

58 rue Quincampoix, 75004
+33 (0)1 42 74 26 36
http://sophot.com/

Socially aware photography is
exhibited in this gallery where talented
international photographers turn their
lenses towards inequality and poverty.

SCHOOL GALLERY PARIS / OLIVIER CASTAING

322 rue Saint-Martin, 75003
+33 (0)1 42 71 78 20
www.schoolgallery.fr

Representing astonishing and
mesmerising photographers such as
Vee Speers.

▲ *School Gallery Paris / Olivier Castaing.* Ansgar

◄ *'Butterflies' by Vee Speers
at School Gallery.*

PHOTOGRAPHY TIPS

Whether you're a pro travelling with your professional camera or simply armed with a smartphone, photogenic Paris is waiting for you to capture its classic beauty, quaint backstreets and colourful multicultural neighbourhoods. To help you get the best snaps possible, here are some pics and tips from award-winning travel photographer and videographer, Paris- and London-based Olivia Rutherford.

Where are some of the best places you'd suggest travellers to head to with their cameras in Paris?

Take to the streets, it's all happening out there. I also love to go to less obvious 'Paris' places, like the streets in La Chapelle, Paris's little India. Also, there's hills in Paris. Always good to get a bit of height.

What are the best times of the day or year for good and moody light?

I love to shoot at dusk, when the city lights come on and the sky is electric blue just before dark. And the golden hour that precedes it. Winter light is low and rich with long shadows. Paris in the rain is a beautiful thing: reflections in puddles, glistening cobblestones, and raindrops on windows are very romantic.

How should one think about composition?

Paris is a very photographed place, so a less standard composition of some of the more well-trodden tourist spots can be refreshing. And check your angles, look for a different angle to the standard; getting low is often good.

Is it worth taking a tripod or is it ok to make do with hands and elbows?

Your style of photography will depend on if you should take your tripod or not. If you're shooting on the street and you

want an easy life, don't. If you want epic, clear, sharp night-time images with a small aperture, take the tripod. If you want to concentrate on monuments and lose the crowds of tourists by using a long exposure and making them a blur, by day, take a tripod. At some sites you get moved on however – and there's nothing subtle about it.

Anything to avoid (like sticking your camera in faces of locals)?

On the street, if the shot is candid, grab it. If the person you're aiming your camera at can see you, it's polite to ask.

Etiquette on photographing or videoing buskers?

Alway toss a coin in the hat. It's an exchange. You get a lovely photo and they get some cash. If it looks like a fabulous shot, I often get their email address and send it on.

Your favourite moments of taking photos in Paris?
When I walked around a corner and found a young girl cleverly disguised as a can of drink(!) with the Sacré Coeur perfectly in the background. Or when I met the street artist who wanted to liberate boundaries ... so cuts red and white tape to put on top of metro vents.

For you, what makes a good photograph?
When it has a feeling, a soul.

5

ARCHITECTURE

EARLY ON IN your Paris trip, try to get up high for a panoramic view to understand where some of the major monuments are and how they all sit together. Some of the best views can be found at: The Eiffel Tower, Notre Dame bell tower, the tower of Montparnasse, the Sacre Coeur, the rooftop of the Institut du Monde Arabe (Arab World Institute)

▼ *View from Notre Dame*

and the top floor of the Pompidou Centre.

To get a handle on the city's architecture within a museum setting, head to the Palais de Chaillot to trace Paris' major buildings and monuments from the Middle Ages until today, passing by the Gothic style, Renaissance, Neoclassical, belle époque, Art Nouveau, modern and contemporary (see Cité de l'Architecture et du Patrimonie in 'Museums').

Other than that, just by walking around the capital, along the wide boulevards (created by Baron Haussmann for Napoleon III in their dramatic urban renewal project) through the narrow Latin Quarter laneways or up hilly backstreets of Montmartre under the towering Sacre Coeur, you'll pass an incredible range of architectural styles. Keep your eyes open, off your phone, and look up!

THE LOUVRE PYRAMID (1989)
Rue de Rivoli, 75001

Chinese-American architect I.M. Pei was responsible for the
now iconic glass and metal pyramid in the courtyard of the
Louvre, serving as the main entrance. Twenty-one metres
high and lit up in the evenings, it makes a stunning 'Paris by
night' shot. Commissioned by President François Mitterrand, in
1984, the Pyramid is made up of rhombus and triangular glass
segments. As with the Pompidou Centre and the Eiffel Tower,
there was a bit of a hoo-ha to begin with, many locals thinking
it was in bad taste. But it's now embraced and understandably
so, it gives the square a magical touch.

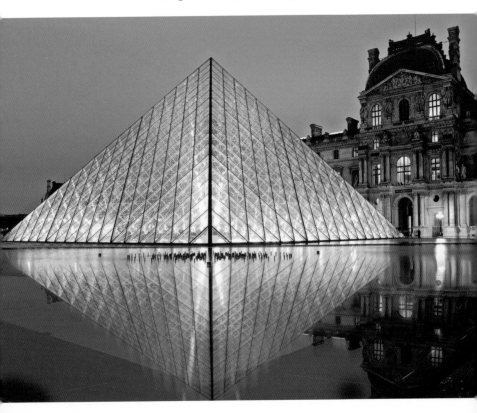

GALERIE VIVIENNE (1823)
5 rue de la Banque, 75002
www.galerie-vivienne.com

Stroll through a pretty nineteenth-century Parisian shopping arcade with covered ceilings and mosaic floors. This registered historical monument is 176 metres long and 3 metres wide and perfect for rainy days with its own cafés and wine bars.

CENTRE POMPIDOU (1977)
Place Georges Pompidou, 75004
www.centrepompidou.fr/en

The massive contemporary art cultural centre with its industrial 'inside out' feel is the work of architects Renzo Piano and Richard Rogers and seen as revolutionary. While many Parisians first hated it, most now love, or at least like, it. The

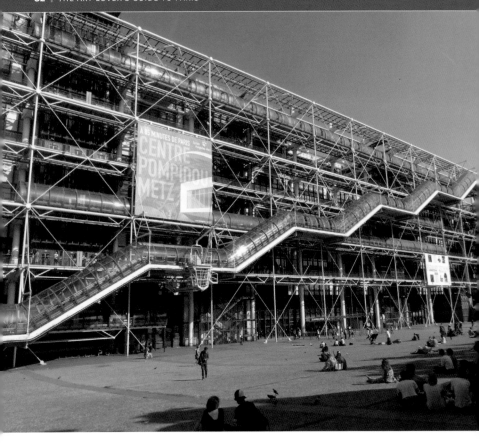

blue, red and green external piping can be spotted from afar. The building has ten floors of 7,500 square metres each, the top floor having one of the best views of Paris around.

MUSÉE NATIONAL DU MOYEN AGE
6 place Paul-Painlevé, 75005
www.musee-moyenage.fr

Originally the house of the abbots of Cluny, from 1334, the 'Hotel Cluny' was rebuilt by abbot Jacques d'Amboise (1485–1510) and opened as a museum in 1843. It is partly built on the remnants of Gallo-Roman baths from the third century, the Thermes de Cluny with a frigidarium 'cooling' room.

Fessy

INSTITUT DU MONDE ARABE (1987)
1 rue des Fossés Saint-Bernard, 75005
www.imarabe.org

This building glistens on the edge of the Seine in the Latin
Quarter and houses the wonderfully active Arab World cultural
centre. A creation of French architect superstar Jean Nouvel,
its construction was the result of a joint funding from the Arab
States and France with the ambition of encouraging dialogue
between the cultures. Steel, aluminium and glass materials
provide a light and reflective exterior and the south façade
displays traditional patterns of Arab geometry with photoelectric
cells and mobile apertures allowing natural light control.

THE PANTHEON
place du Panthéon, 75005
+33 (0)1 44 32 18 00
www.paris-pantheon.fr/en

Inspired by Rome's Pantheon and, for its dome, St Paul's
Cathedral in London, the 83-metre tall neoclassical building
was built in 1790 as a church (Louis XV had it built for Sainte

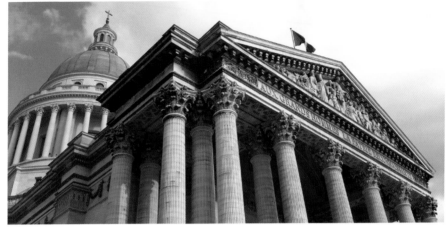
Ruby Boukabou

Geneviève, the patron Saint of Paris, to thank her after
he recovered from severe illness). The work of architect
Jacques-Germain Soufflot, then Guiaumme Rondelet, it
was transformed into a mausoleum during the revolution,
then back into a church. The classic beauty of the building
is amplified by a bold relief of Mother France presenting
laurels to the great men of France. Inside are murals of
the life of Sainte Geneviève and the tombs of the likes of
Voltaire, Dumas, Rousseau, Zola and Hugo. In 2007 President
Jacques Chiraq unveiled a plaque to 'The Righteous among
the Nations', honouring more than 2,600 people who took
risks to save Jews from deportation resulting in many of them
surviving the Holocaust.

THE EIFFEL TOWER (1889)
Champ de Mars, 5 avenue Anatole France, 75007
www.toureiffel.paris/en

Today's international symbol of Paris, the world famous
324-metre tall wrought iron tower was originally built as a
temporary expo for the 1889 Universal Exhibition by architect
Gustave Eiffel and was a controversial object considered

Ruby Boukabou

an eyesore by many. Today it's generally accepted and liked by most Parisians. You can have dinner in it, climb it, sip champagne at the top or just gaze at it from below. Best of all, you don't need to even go there to appreciate it, you'll catch it shooting up from the skyline as you make your way around the capital, a sharp reminder that you're really here in Paris – especially at night with the magical glittering light show on the hour (the backdrop of many marriage proposals!).

▲ Padlocks on the bridge before panels were introduced.

PONT DES ARTS 75006 (1984 MODELLED ON 1804 ORIGINAL)

This pedestrian bridge crossing the Seine is popular for tourists and filmmakers. While it was only inaugurated in 1984, by later president but then mayor, Jacques Chirac, it is a redesign of the first ever metal bridge in Paris, built under Napoleon I between 1802 and 1804. The lovelock craze (lovers padlocking the bridge and throwing the key into the Seine) got to a point of danger due to their collective weight. The government cut them off and created a social media campaign for tourists to take selfies rather than locking their love to a sinking bridge! #lovewithoutlocks Rebellious lovers continued until panels were placed to make it impossible, saving the bridge from collapse.

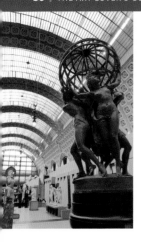

MUSÉE D'ORSAY (OPENED AS RAILWAY STATION IN 1900)
1 rue de la Légion d'Honneur, 75007
www.musee-orsay.fr/en

The throne of Impressionist and Post Impressionist works, the Musée d'Orsay was transformed into a museum from a defunct central train station, the Gare d'Orsay. Its Art Nouveau architecture sits majestically alongside the Seine. The transformation project was won by ACT architecture group and kept in line with the original Laloux architecture while creatively appropriating it into a museum, including transforming the superb glass awning into the entrance of the museum.

MUSÉE DU QUAI BRANLY (2006)
37 quai Branly, 75007
www.quaibranly.fr/en

This innovation by Jean Nouvel was commissioned by President Jacques Chirac. It's a fascinating urban hopscotch of shapes, colours and materials surrounded by a dense garden by the Seine, just across from the Eiffel Tower. A vertical garden, created by botanist Patrick Blanc, climbs the walls and a monumental artwork by Australian Aboriginal artist Lena Nyadbi, based on her painting 'Dayiwul Lirlmim' (Barramundi scales) decorates the roof and can be admired by those climbing the Eiffel Tower. The whole

affair is eccentric and dramatically lopsided and while in the centre of Paris, feels like a world of its own. Discover the building and the thinking behind it by taking an architecture tour.

ARC DE TRIOMPHE (1836)
place Charles de Gaulle, 75008
www.arcdetriompheparis.com

At the centre of the Place Charles de Gaulle at the western end of the Champs-Élysées, the 49.5-metre tall neoclassical *Arc de Triomphe* honours those who fought for France during the Napoleonic Wars. Inside the sculpted arches, there's also the Tomb of the Unknown Soldier from the Frist World War. Decorations include friezes, bas-reliefs and figures from artists James Pradier, Antoine Etex and Jean-Pierre Cortot and a sculpture 'La Marseillaise' by François Rude. You can climb the monument for a good view of Paris.

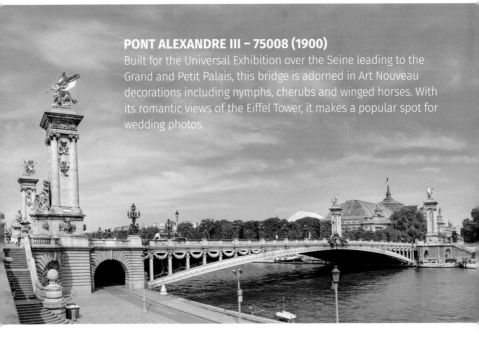

PONT ALEXANDRE III – 75008 (1900)
Built for the Universal Exhibition over the Seine leading to the Grand and Petit Palais, this bridge is adorned in Art Nouveau decorations including nymphs, cherubs and winged horses. With its romantic views of the Eiffel Tower, it makes a popular spot for wedding photos.

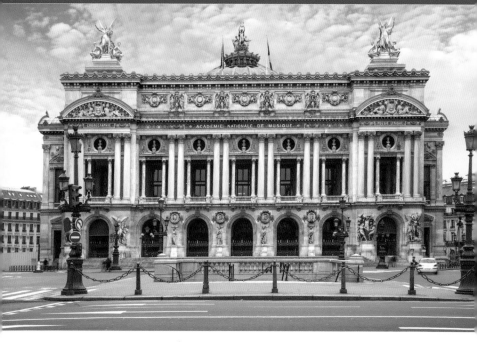

L'OPÉRA NATIONAL DE PARIS GARNIER (1862-1875)
place de l'Opéra, 75009
www.operadeparis.fr

Designed by Charles Garnier for Napoleon III, this stone, marble and bronze classical and Beaux-Arts, Baroque-styled opera house gives a wonderful note of grandeur to music and the performing arts. Opulence is embodied in the marble friezes, formal columns, statues of Greek gods and great composers (including Bach, Beethoven and Mozart). Crowning the masterpiece are two statues of gilt copper electrotype personifying Harmony and Poetry by sculptor Charles Gumery.

The setting of Phantom of the Opera, the amazing belle époque interiors feature a grand central marble staircase and foyer with a dome ceiling and mosaics with magnificent ceilings of angels, clouds, stars and barely clad voluptuous women. If you have the chance to be there when the sun is out it's even more magical, with the gold reflections of the decorations dancing around the interiors. In any weather

T

For your visit, enter through from the left side (when facing the opera).

though, it's stunning from floor to ceiling with balconies in the foyer where you can look down and imagine the sparkling high society audiences that once swept up the staircase below, as much on display as the actors on stage. Take a peek at the spectacular red velvet 1,979 seat auditorium with a grand chandelier and a ceiling piece by Marc Chagall depicting scenes from various operas. Be inspired to purchase a ticket to come back to be transported by an opera or ballet where the costumes and sets are also art works in themselves.

GALERIES LAFAYETTE HAUSSMANN (1912)
40 boulevard Haussmann, 75009
https://haussmann.galerieslafayette.com/en/

A symbol of Paris, the major department store has a sensational dome roof by Ferdinand Chanut and glass artist Jacques Gruber.

CANAL SAINT MARTIN, 75010–75019 (1802)
Dug in 1802, this now trendy part of Paris has been featured in many films (including *Amelie Poulin*), songs (Edith Piaf) paintings (Sisley) with its quaint footbridges and a swing bridge that pivots ninety degrees for passing water traffic.

BIBLIOTHÈQUE NATIONAL DE FRANCE, FRANÇOISE MITTERRAND (1996)
quai François Mauriac, 75013
http://www.bnf.fr/en

Signed Dominique Perrault, the Françoise Mitterrand branch of the national library, by the Seine won the European Union Prize for Contemporary Architecture. The four high glass buildings follow a minimalist design to be read (pun intended) as four open books, reflecting the Paris sky and Seine. There's also a dense internal garden. The library holds not just books but manuscripts, prints, photographs, maps, scores, coins, medals, sound files, video and multimedia documents.

PALAIS DE CHAILLOT (1937)
1 Place du Trocadéro et du 11 Novembre, 75016
https://en.parisinfo.com/paris-museum-monument/118358/Palais-de-Chaillot

The Palais de Chaillot was built for the 1937 Paris exhibition in neoclassical style. It's decorated with sculptures and bas-reliefs with gold inscriptions (by poet/writer Paul Valéry), an ornamental pool, a sculpture of Apollo by Henri Bouchard and Hercules by Albert Pommier. On the terrace you can appreciate the looming Eiffel tower in all its splendour.

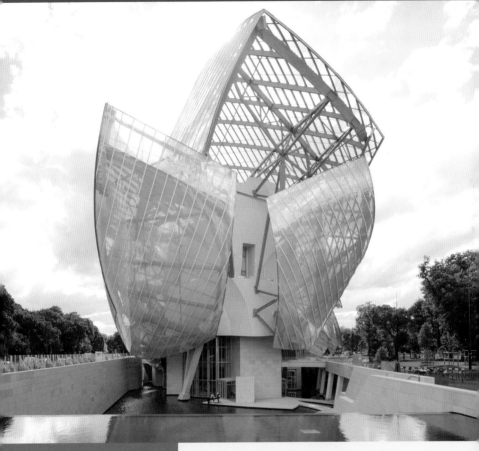

> To reflect our constantly changing world, we wanted to create a building that would evolve according to the time and the light in order to give the impression of something ephemeral and continuously changing.
>
> FRANK GEHRY

LOUIS VUITTON FOUNDATION (2014)
8 avenue du Mahatma Gandhi, 75116
www.fondationlouisvuitton.fr/en

Some 3,600 panels of curved glass create the twelve sails of this magnificent and innovative designed cultural centre signed by the architect Frank Gehry. Inspired by late nineteenth century glass and garden architecture and sitting in the Bois de Boulogne forest, the centre can be seen as a sort of giant iceberg, or a cluster of clouds, playing with the natural light to create a feeling of movement.

PHILHARMONIE DE PARIS (2015)
Parc de la Villette
221 avenue Jean Jaurès, 75019
+33 (0)1 44 84 44 84
https://philharmoniedeparis.fr/en

A design of Jean Nouvel, in the Parc de la Villette and standing at
52 metres high, the Philharmonie de Paris comprises of a 2,400
seated symphony hall, exhibition spaces, educational rooms,
conference rooms and rehearsal spaces as well a café, bar and
restaurant. The various shades of grey sweep the building into
the urban landscape with an innovative and unique angular
aluminium structure. However, Nouvel boycotted the opening,
claiming that the architectural and technical requirements had
not been respected.

PLACES OF WORSHIP

There are literally hundreds of places of worship spread across Paris and even the lesser known can be remarkably beautiful inside and out. Their serene interiors with stained glass windows, sculptures and high ceilings provide sanctuary from the hectic city streets (and good alternatives to overdosing in coffee when you just need to sit down!) Here are a small selection to be appreciated for both their architectures and their artworks within- often by the top artists of the day such as Rubens and Delacroix...

SAINT EUSTACHE
2 impasse Saint-Eustache, 75001
www.saint-eustache.org

All places of worship are free with donation boxes for lighting candles in the churches. Notre Dame and Sacre Coeur are free also unless people want to climb bell towers.

One of the original churches in Paris; a parish church in 1223, construction of the current church spanned from 1532 to 1737. The new construction began in Gothic style and finished with Renaissance neoclassical style, the interior modelled on Notre Dame. The pipe organ is the largest in France with 8,000 pipes. The stained glass windows are from Philippe de Champaigne, founding member of the Académie de peinture et de sculpture.

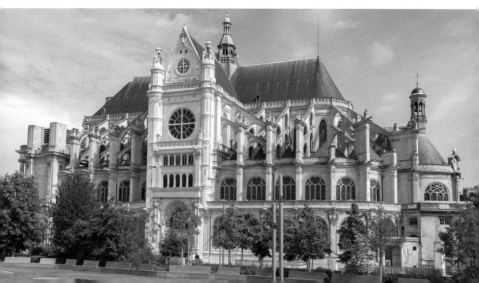

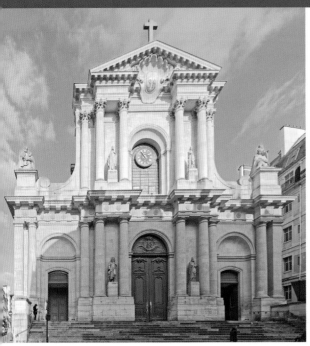

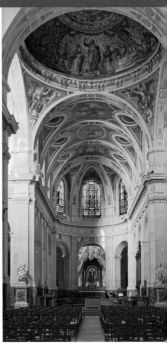

SAINT-ROCH
284 Rue Saint Honoré, 75001
www.paroissesaintroch.fr

From the late Baroque period (built 1653–1740) and one of the largest churches in Paris, Saint-Roch has long been popular for weddings – the Marquis de Sade was married here in 1763. The mural painting above the altar reveals Saint Susanna looking up to God as she runs away from villains. St Roch is invoked against the Plague and is the patron saint of dogs and the accused innocent.

SAINTE- CHAPELLE
8 boulevard du Palais, 75001
www.sainte-chapelle.fr

Built in 1248 in Gothic Rayonnant (vertical and weightless) style, Saint-Chapelle was royal chapel of the Kings' residence until

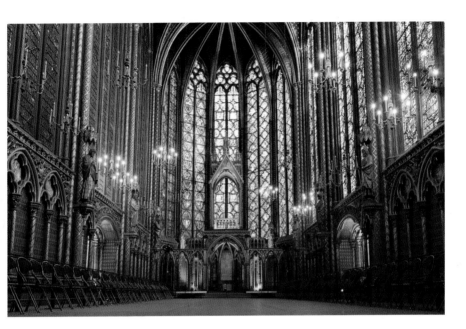

the fourteenth century. The medieval stained glass windows are stunning, with the upper chapel windows depicting scenes from the Bible. High quality classical concerts take place (with musicians such as flautist Jane Rutter on baroque French flute) where the music and the setting can trigger transcendent experiences.

ST-ETIENNE-DU-MONT
place Sainte Geneviève 75005
www.saintetiennedumont.fr

Across from the Pantheon, this part Gothic, part Renaissance style church houses a shrine to Sainte Geneviève, the patron saint of Paris. It has undergone considerable alterations since 1222. Check out the stunning stained glass windows and the tympanum 'The Stoning of St. Stephen' (1863) by sculptor Gabriel Thomas (Prix du Rome).

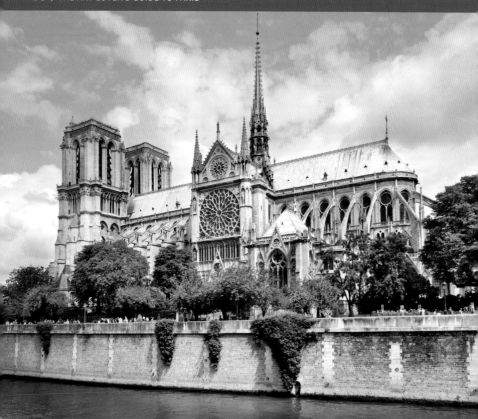

NOTRE-DAME DE PARIS
6 parvis Notre-Dame – Pl. Jean-Paul II, 75004
www.notredamedeparis.fr

Make sure you've read or watched Victor Hugo's *The Hunchback of Notre Dame* before heading to this iconic monument of Gothic architecture. Building began in twelfth century and took 300 years to complete, and thus there are also influences of the Renaissance and Realism styles. Gaze at the stained glass rose windows, the flying buttresses and the intense gargoyles. There's also the possibility to climb the bell tower if you don't mind a bit of a queue. The payoff is a brilliant view of Paris. If lining up isn't your thing though, there is so much to appreciate from the outside in the form and detailed exterior design of the 69-metre high cathedral. Gregorian chant and Medieval music concerts take place on occasions.

SAINT-JULIEN-LE PAUVRE
1 rue St-Julien-le-Pauvre 75005
www.sjlpmelkites.com

One of the oldest churches in Paris, on the ruins of an ancient
Gallo Roman cemetery, Saint-Julien-le Pauvre was a basilica
destroyed by the Norman invaders in 886 and rebuilt in 1165–1220
in Romanesque/Gothic style then again in stages from twelfth
to nineteenth century. The small but charming church has been
a Melkite (Eastern Byzantine Catholic) church since 1889. It is a
delightful venue for chamber music concerts and is just around the
corner from the famous English bookshop Shakespeare & Company.

VAL-DE-GRÂCE
1 place Alphonse-Laveran, 75005
www.valdegrace.org

Founded by Anne of Austria (wife of Louis XIII) in 1621, this Roman
Catholic church designed by François Mansart and Jacques
Lemercier was once a royal abbey. The dome is something of a
landmark and its interior is decorated by Pierre Mignard with his
interpretation of Molière's ode 'La Gloire du Val-de-Grâce'.

MOSQUÉE DE PARIS
2 bis Pl du Puits de l'Ermite, 75005
www.mosquee-de-paris.org

Founded in 1926 as a token of gratitude after the First World War
to the Muslim tirailleurs, the Hispano-Moorish mosque was built
in Neo-Mudejar style. During the Second World War it served as
a secret refuge for North African and European Jews, providing
shelter, safe passage and fake passports. With its dramatic green
and white tiled 33-metre minaret it's to be appreciated, not just
by those worshipping, but by all. If you're visiting in winter, thaw
out in the hammam, the traditional and beautiful bathhouse, or
enjoy a mint tea and delicious sweet pastries in the courtyard
café paved with mosaics (just watch the pigeons don't finish your
baklava before you do!).

SAINT-SULPICE
place St-Sulpice, 75006
http://pss75.fr/saint-sulpice-paris/

This classical Roman Catholic church was built over a thirteenth-century Romanesque church. The new building was founded in 1646. The design was developed by Architect Daniel Gittard with additions continuing with several architects until 1788. The facade, designed by Giovanni Sevamdoni, is quite stunningly the centrepiece of Place St Sulpice with elegant columns and murals by Delacroix (Jacob Wresling with the Angel, Heliodorus Driven from the Temple and St-Michael Killing the Dragon). It stars in *The Divinci Code*.

LA MADELEINE
place de la Madeleine, 75008
www.eglise-lamadeleine.com

This large neoclassical Roman Catholic church was originally a synagogue but seized in 1182 and rebuilt as a church in 1764 and dedicated to Mary Magdaleine. It has a volatile history and has been demolished and rebuilt several times. Its neoclassical temple style includes marble and gilt decorations and sculptures, François Rude's 'Baptism of Christ', fifty-two Corinthian columns and three domes. The foyer serves over 300 lunches each day to encourage people in the neighbourhood to meet and feel valued. In September it is the centre of the colourful festival Le Lavage de La Madeleine, a religious Brazilian tradition involving drumming, dancing and a spiritual cleansing ceremony.

ST-ALEXANDER-NEVSKY CATHEDRAL
12 rue Daru, 75008
www.cathedrale-orthodoxe.com

Consecrated in 1861, this Russian Orthodox neo-Byzantine style cathedral with five golden copper domes was designed by members of the St Petersburg Fine Arts Academy. The interiors feature neo-Byzantine mosaics and frescos. Pablo Picasso married Olga Khokhlova here in 1928 and funerals of Russian artists have been held inside, including Ivan Turgrnev (1883) and Wassily Kandinsky (1944).

GRANDE SYNAGOGUE DE PARIS
44, rue de la Victoire, 75009
www.lavictoire.org

Also known as the Synagogue de la Victoire, the official seat of the chief rabbi of Paris and place of worship for the Jewish community, was designed by architect Alfred-Philibert Aldrophe and inaugurated in 1874. It boasts a Romanesque facade with Byzantine features. Inside are balconies, candelabras, numerous religious inscriptions and stained glass windows representing the Tribes of Israel. Alfred Dreyfus was married here in 21 April 1890.

LA GRANDE PAGODE BUDDHIST TEMPLE
40 bis route de Ceinture du Lac Daumesnil, 75012
www.bouddhisme-france.org

Located in the former 1931 Colonial Exhibition by the lake in the woods of Vincennes in the former houses of Camaroon and Togo, the building covers 800 square metres. It was converted into a place of worship in 1977 and restored in 2015. The 9-metre tall statue of Buddha is the biggest in Europe. It is open to the public during major Buddhist festivals.

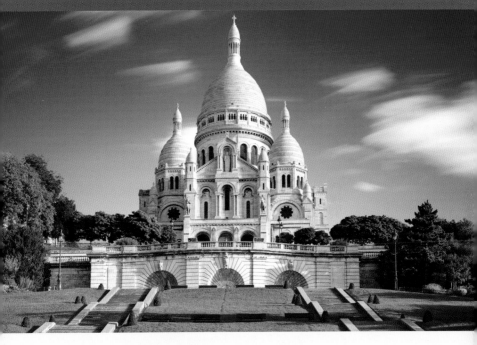

SACRÉ COEUR

35 rue du Chevalier de la Barre, 75018

www.sacre-coeur-montmartre.com

After the defeat of France in the Franco Prussian War in 1870, construction began (1871) and was completed in 1914 then consecrated in 1919. Built on the highest point of the city, the imposing white Romano-Byzantine basilica jets beautifully out of the Paris landscape (if you're taking the line 2 from Nation, as it comes into view it is quite breath-taking). The radiant monument built with Château-Landon stones has a triple-arched portico and equestrian bronze statues of French national saints Joan of Arc and King Saint Louis IX. The ceiling mosaic of Christ created by Luc-Olivier Merson is all engulfing and awe-inspiring. And from the steps in front you have the most sensational view of Paris and a throng of tourists, buskers and photographers making the most of it. From here, sunset over the capital is spectacular.

▼ *The ceiling mosiac of Christ.*

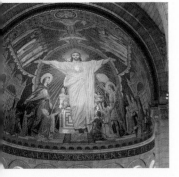

6

ART IN PUBLIC PLACES

IT'S NOT JUST the architecture that you can admire when outdoors in Paris. The city is somewhat of an open museum with installations, fountains, columns and sculptures dotted around to be admired while passing by, used as places of rendez-vous and as memorials.

▼ *'Colonnes de Buren' in the courtyard of the former Royal Palace.*

COLONNES DE BUREN – 2 RUE DE MONTPENSIER, 75001

In the courtyard of the former Royal Palace, discover the modernist installation by artist Daniel Buren with 260 variously sized black-and-white striped columns 'Deux Plateaux' or 'Colonnes de Buren'. The installation finished in 1986 was originally controversial however loved by some, especially children.

METRO PALAIS ROYAL – MUSÉE DU LOUVRE ENTRANCE, PLACE COLETTE, 75001

The 'Kiosque des noctambules' metro entrance doubles as a piece of contemporary art designed by French artist/sculptor Jean-Michel Othoniel in 2000. It's made of aluminium spheres and coloured glass and resembles something between a Christmas decoration and a time machine.

MUSÉE DE LA SCULPTURE EN PLEIN AIR, 11 BIS QUAI SAINT-BERNARD, 75005

This series of outdoor sculptures right on the banks of the Seine was created in 1980. Over 50 works make the visit well worthwhile (pack a picnic if the weather permits). Pieces include works from Constantin Brâncuşi, Jean Arp and François Stahly.

PARC MONCEAU 75008

Originally built in the seventeenth century by the Duke of Chartres, this very chic park on Boulevard de Courcelles, by Metro Monceau, has huge wrought-iron gates embellished with gold, Corinthian columns, Renaissance arcade (from the

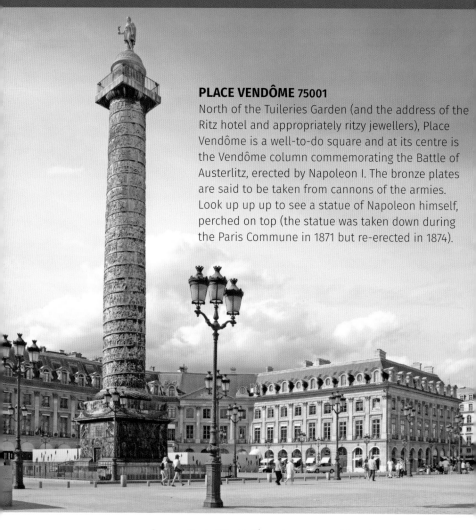

PLACE VENDÔME 75001

North of the Tuileries Garden (and the address of the Ritz hotel and appropriately ritzy jewellers), Place Vendôme is a well-to-do square and at its centre is the Vendôme column commemorating the Battle of Austerlitz, erected by Napoleon I. The bronze plates are said to be taken from cannons of the armies. Look up up up to see a statue of Napoleon himself, perched on top (the statue was taken down during the Paris Commune in 1871 but re-erected in 1874).

former Paris City Hall), a stone pyramid and a rotunda. Stroll through and soak up the posh Parisian vibes.

VARINI'S ANAMORPHIC ILLUSIONS SQUARE EDOUARD VII, 75009

Swiss artist Felice Varini makes anamorphic illusions on walls with shapes, visible when viewed at certain angles. The installation wakes up both the space and your mind.

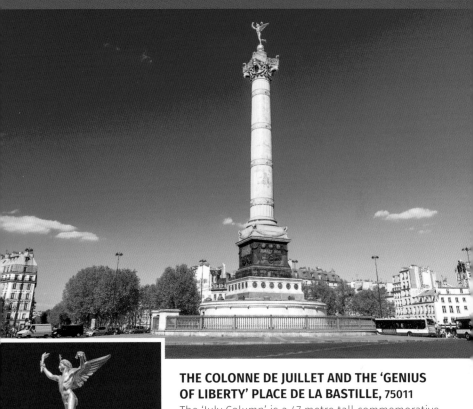

THE COLONNE DE JUILLET AND THE 'GENIUS OF LIBERTY' PLACE DE LA BASTILLE, 75011

The 'July Column' is a 47 metre tall commemorative Corinthian column dedicated to the lives lost on the streets during the Revolution of 1830. It was designed by architect Jean-Antoine Alavoine and constructed by Joseph-Louis Duc (inaugurated in 1840) with a white marble base decorated with bronze bas-reliefs. It also has a crypt holding the remains of over 500 victims of the 1848 revolution.

On top of the column, standing on one foot is the gilded figure of the Spirit of Freedom, the 'Génie de la Liberté ' by Auguste Dumont that glints magically in the sunlight.

Ruby Boukabou

THE 'I LOVE YOU / JE T'AIME' WALL
SQUARE JEHAN RICTUS, 75018

In the garden of Square Jehan Rictus in Montmartre, just
behind metro and place des Abbesses, this wall is dedicated
to love across languages. Created by Frédéric Baron and Claire
Kito, the 40 square-metre artwork is composed of 612 tiles of
enamelled lava, each 21 x 29.7 cm in size. Love is declared in
white with a peaceful blue background. The tradition is for
tourists to have their photo taken in front of their language's
'I Love You' and is obviously popular for lovers and a good
alternative to polluting the Seine and bridges with love
padlocks.

METRO ABBESSES, 75018

To arrive at the 'Je t'aime' wall you'll get out at, or walk by, Metro Abbesses. Admire the Art Nouveau station entrance by Hector Guimard with green wrought-iron arches and twin lamps. This entrance ('édicule') was originally located at Hôtel de Ville and moved to Montmartre in 1974.

Heading back to the metro, instead of taking the lift, brave the 200 spiral stairs down 36 metre (118 ft) below ground (the deepest station in Paris) for the murals that depict Montmartre's brasseries, windmills and fields of flowers.

LA BICYCLETTE ENSEVELIE (THE BURIED BICYCLE) PARC DE LA VILETTE, 75019

In the Parc de la Vilette, near the canal de l'Ourcq, is this intriguing installation by Claes Oldenburg and Coosje Van Bruggen (1990). It's as if a giant bicycle was buried, with parts sticking out of the ground, including a huge handlebar with a large blue bell and a giant peddle.

LA GÉODE, 26 AVENUE CORENTIN CARIOU, 75019

Also in the Parc de la Vilette, this 'geodesic dome', by architect Adrien Fainsilber and engineer Gérard Chamayou, is a giant reflective sphere in the Parc de la Villette opened in 1985 that holds an IMAX theatre. There's something magical about the huge ball reflecting the skies, the clouds and the park.

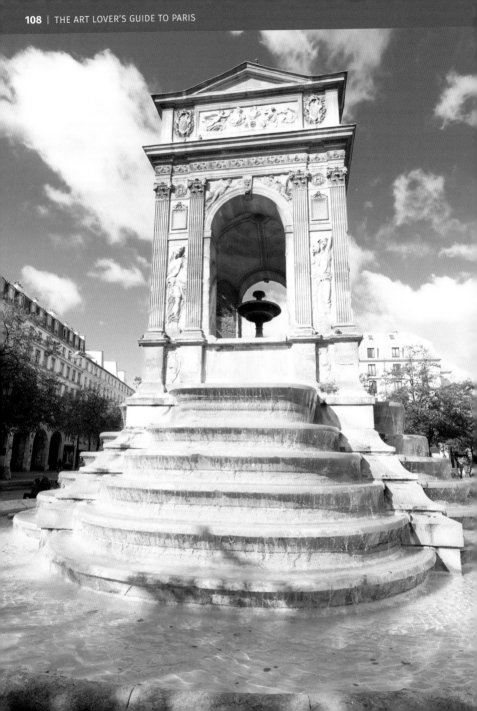

FOUNTAINS

Paris is awash with fountains created for drinking water, washing, displaying victories or designed for pure visual enjoyment. Water has been sourced from rivers, bore wells, aqueducts, canals and pumps.

◄ *The Fountaine des Innocents.*

One of the earliest recorded existing Paris fountains, the Fontaine des Innocents, was designed by François I's Louvre architect Pierre Lescot, with sculptural decoration by court sculptor Jean Goujon. It was built in 1549 on the site of an earlier fountain on the corner of Rue St Denis and today's Rue Berger to welcome King Phllip II. Water was supplied from Belleville masonry aqueducts. In 1787 it was moved away from the cemetery to Marché des Innocents. As a 'masterpiece of French sculpture' it was saved by destruction and moved again to the centre of the square in 1858.

Two famous fountains can be found in Place de la Concorde. The Fountain of River, Commerce and Navigation, celebrating navigation and commerce on the rivers of France, and the Fontaine de la Concorde celebrating maritime commerce and industry of France, completed in 1840, with water flow from aqueducts made possible in 1824 after the completion of the Canal d'Ourcq, begun by Napoleon. In the twentieth century the gravity system was replaced by pumps recycling the water.

▼ *The Fountain of River, Commerce and Navigation.*

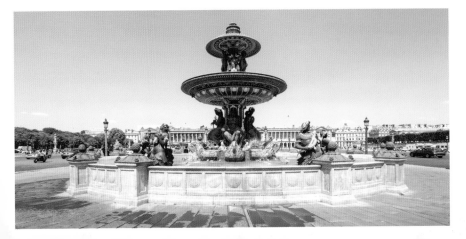

▲ Fontaine du Palmier.

▼ Fontaine Saint-Michel.

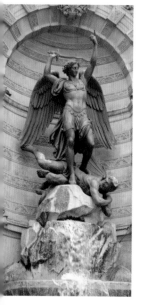

OTHER FOUNTAINS:

Fontaine de la Pyramide du Louvre by the glass Pyramid spurts up water to create a feeling of opulence. **75001**

Fontaine du Palmier, place du Châtelet, **75001**, was designed by architect and engineer François-Jean Bralle in 1806 to provide fresh drinking water to the population of the neighbourhood and to commemorate the victories of Napoleon Bonaparte. This fountain has a circular basin, a column rises in the form of a palm tree trunk and a gilded figure of Victory. It also features figures of Prudence, Temperance, Justice, and Strength.

Fontaine Molière by Louis Visconti and Antoine Vivenel on the corner of rue Molière and rue de Richelieu – **75001**.

Fontaine Stravinsky (1983) beneath Centre Pompidou (**75004**) is a colourful contemporary fountain in fibre-reinforced plastic and steel created by husband and wife Jean Tinguely and Niki de St Phalle. Each sculpture represents one of Stravinsky's compositions such as 'The Rite of Spring'.

Fontaine Saint-Michel is a popular meeting spot in Place Saint-André des Arts by architect Gabriel Davioud and sports a bronze statue of St Michael slaying the dragon. It was constructed between 1858–1860 as part of the Napoleon III's urban redevelopment project by Baron Haussmann. (**75006**).

Fontaine des Quatre Saisons (fountain of Four Seasons) 57 Rue de Grenelle, representing 'the four continents', (Sorry, Australia!) built in 1745 is the best surviving example in Paris of public architecture of the reign of Louis XV by royal sculptor Edme Bouchardon. In 1862 it was classified as a historic monument. (**75007**)

Fontaine Stahly, 1969, is set in a botanical gardens Parc Floral in the Bois de Vincennes. 75012
Fontaine Cristaus, Homage to Bela Bartok 1980, Jean-Yves Lechevallier. **75015**

Fontaine Polypores inspired by mushrooms 1980, Jean-Yves Lechevallier Croisement des rues Saint-Charles, Balard and Modigliani, Rue Saint-Charles. **75015**

Fontaine Versoive 1937, next to the Eiffel Tower, creates spectacular water shows, **75016**

The Wallace fountains were financed by English philanthropist Richard Wallace who sketched designs for Charles-Auguste Lebourg to perfect. They have become one of the symbols of Paris. It was one of the transformative constructions that aimed to lift morale after the defeat of the Franco-Prussian war and the Paris Commune's destruction of most aqueducts and sources of drinking water. As a humanitarian, Wallace saw the need to provide free drinking water, which was dearer than alcohol and often out of reach of the poor. To stay faithful to the Renaissance style, they had to be useful, beautiful and symbolic. The first one was constructed in 1875. They function from 15 March – 15 November to avoid frost damage and yes. you can drink the water!

Wallace fountain locations include: Place Edith Piaf (20th), Place des Abbesses (18th), Rue St Antoine (4th), Place des Invalides (7th), Place de Levis (5th) and Jean-Pierre Timbaud (11th).

A wall mounted fountain can be found at Rue Geoffroy Saint-Hilaire (5th) with colonnades at Rue Cuviera (6th) and Avenue de Ternes (17th).

SCULPTURES

Sculptures are to be found all around Paris and many of them are exquisite. Instead of cruising past them, take a pit stop to read the plaque and admire the public art, often, but not always, a public memorial. Here are some to look out for.

THE CARROUSEL AND TUILERIES GARDEN,
113 rue de Rivoli, 75001

The Tuileries was opened as a private garden under Catherine de Medici in 1564. Catherine commissioned Bernard de Carnesse, a Florentine landscape gardener to build an Italian Renaissance garden including faience (tin-glazed pottery) with plant and animal images. In 1664 under Louis IV, Andre le Notre re-landscaped the gardens to a formal French style. In 1667, Louis IV opened the gardens to the public (except soldiers, servants and beggars). In 1719 two large equestrian statues by Antoine Coisevox were placed at the west entrance of the garden, with more statues placed on the Grand Allee.

Today these gardens are a delightful place to pass an

▼ *Tuileries Garden*

hour – you can sit to contemplate by the ponds, inhale the perfumes from the glorious flowers and relax in one of the garden cafés. High on floral scents, investigate the outdoor gallery with over 200 statues and vases from the seventeenth to twenty-first centuries. These include: Rodin's 'Le Baiser' (The Kiss) – a 1934 cast of the marble 1829 original, 'Arcs de cercles complémentaires' by François Morale; 'L'Arbre des voyelles' by Giuseppe Penone and twenty sculptures by Aristide Maillol (1861–1944) in the Carrousel Garden. Most of the originals are in the Louvre but the copies are still wonderful. During the FIAC in October there are often temporary contemporary art installations scattered about.

HENRI IV STATUE
Place du Pont Neuf, 75001
Pont Neuf is the oldest bridge in Paris, begun under Henri II in 1578 and inaugurated in 1607 by Henri IV. The commemorative statue of the latter depicts the king in armour on horseback on a pedestal.

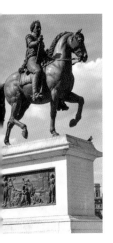
▲ *Henri IV statue.*

'PYGMALION'
Forum des Halles, 75001
This wooden artwork of five women on a marble pedestal is by Julio Silva, constructed in 1979.

JARDIN DES HALLES
Renee Cassin Square, 75001 In front of St Estache next to Les Halles

• Henri de Miller's 'L'ecoute' (Listen), 1986. A head resting on a hand and made of sandstone, is eye-catching and popular with small children.

• 'Cadran solaire', a huge sandstone sundial using rays of sunlight.

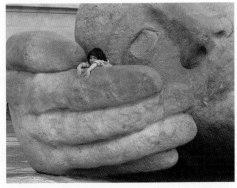

▲ *Jeanne d'Arc.*

GILDED STATUE OF JEANNE D'ARC (JOAN OF ARC)
Place des Pyramides 75001

Frémiet's gilded bronze equestrian sculpture of Roman Catholic Saint Joan of Arc, inaugurated in 1874, is impossible to miss as is shines brightly above the Place des Pyramides, close to the Tuileries.

SAINTE GENEVIEVE
pont de la Tournelle, 75005

Paul Landowski's 1928 statue portrays Sainte Genevieve, the patron Saint of Paris, protecting Paris, personified as a small child.

LUXEMBOURG GARDENS, 75006

The lungs of the left bank, this gorgeous park surrounding the Luxembourg Palace was created from 1612 by Marie

▲ *Luxembourg Gardens.*

de Medici, wife of Henry IV. It now has a lovely octagonal pool with miniature sail boats, holds a seventeenth-century baroque fountain and fish pond and over 100 statues, among them a bronze bust of Delacroix by sculptor Jules Dalou, 'Liberty Enlightening the World' (commonly known as the Statue of Liberty, first model, by Frédéric Bartholdi, 1870), 'Georges Sands' by Francois-Leon Sicard, 1904 and 'Ludwig van Beethoven' by Antoine Bourdelle.

It's a romantic stroll and the sort of place you may feel like reading poetry or writing a thoughtful letter...

'BRONZE CENTAURE'
Place Michel-Debré, 75006

César Baldaccini's 5-metre tall bronze centaur is a tribute to Picasso, with the head of the sculptor, an auto- portrait of Baldaccini himself.

LE BON MARCHÉ
24 rue de Sèvres, 75007
+33 (0)1 44 39 80 00
www.24sevres.com/en-au/le-bon-marche

Yes ladies and gentlemen, in Paris, contemporary art works can even be appreciated while shopping. La Galerie, La Passerelle and de l'Entrée are curated by Romain Tichit from Galerie YIA (Young International Artists). And on the second floor of the department store founded in 1838, in the design department, you can often find stimulating design exhibitions by young creators.

GALERIE DES GALERIES
40 boulevard Haussmann, 75009
+33 (0)1 42 82 81 98
www.galeriedesgaleries.com

▼ *Monument to Balzac.*

Heir to the the luxury department stories Galeries Lafayette, Guillaume Houzé presents the Galerie des Galeries on the first floor dedicated to exciting contemporary artists, often playing with fashion and design with the expert eye of grandmama Ginette Heilbronn Moulin (majority shareholder nonetheless).

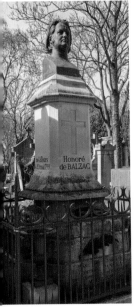

MONUMENT TO BALZAC
Corner of boulevard du Montparnasse and boulevard Raspail, 75014
Rodin's sculpture of the French novelist and playwright is considered one of the first examples of modern sculpture, seeking to represent Balzac's personality. It was cast in bronze two decades after Rodin's death and placed in its current location.

OISEAU LUNAIRE (1966) LUNAR BIRD BY JOAN MIRÓ
Rue Blomet, 75015
Catalan artist Joan Miro created this abstract sculpture representing a mythical bird's cosmic connection between earth and sky.

STATUE OF LIBERTY ÎLE AUX CYGNES (SWAN ISLAND) 75015

You probably know that the iconic New York Statue of Liberty was a present from France in 1886. But did you know that the Americans gifted Paris a smaller version of the statue in 1889? The occasion was the centennial of the French Revolution. It's located on the Île aux Cygnes (an artificial island built in 1827) accessed via either the Pont de Grenelle or the Pont de Bir-Hakeim.

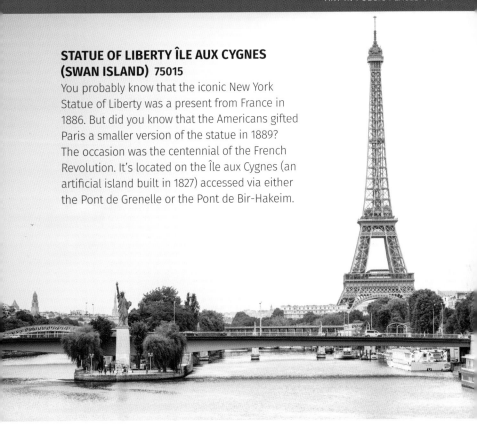

EQUESTRIAN STATUE WITH GEORGE WASHINGTON,
Iéna, 75016

This equestrian statue with George Washington, sword raised, is by American sculptor Daniel Chester French, a gift of the 'women of the United States of America in memory of the brotherly help given by France to their fathers in the fight for Independence' and sits in the middle of the roundabout, raised gracefully above the traffic.

◄ George Washington.

Marshal Ferdinand Foch on horseback. ▶

▲ 'Dalida' bronze.

MARSHAL FERDINAND FOCH ON HORSEBACK
Place de Trocadéro, 75016
This bronze statue of Marshal Ferdinand Foch on horseback leading the Allies to victory in 1918 was constructed by Robert Wlérick and Raymond Martin in 1951 and sits in the majestic Place de Trocadéro.

'DALIDA' BRONZE BUST
Place Dalida Montmartre, 75018
Yolanda Cristina Gigliott AKA Dalida was an Egyptian/Italian/French singer and actress (1933–1987). The commemorative bust in the charming backstreets of Montmartre has sparkling breasts from being polished in a tradition from passers-by!

PARVIS DE LA DÉFENSE
92400 Paris La Défense
Situated in the business district of La Défense, sixty artworks are dotted among the highest skyscrapers in France including Raymond Moretti's 'La Cheminée' – a 3-metre high 'chimney' made up of hundreds of coloured tubes and César Baldaccini's 12-metre model of his own thumb, literally sticking out of the ground. 'Le pouce'.

CEMETERIES

▲ *Oscar Wilde sculpture with lipstick kisses from fans.*

PÈRE LACHAISE

In Paris' most prestigious final resting place, the tombs range from artistic to elaborate to quirky. You can also pay your respects to artists of all disciplines buried here including Balzac, Chopin, Jim Morrison, Marcel Proust, Sarah Bernhardt, Marcel Marceau, Théodore Géricault, Victor Noir (there's a life-size statue of the nineteenth-century journalist by Pierre Bonaparte, cousin of Napoleon III) and Oscar Wilde (sculpture by Jacob Epstein and covered by lipstick kisses from fans).

MONTMARTRE

While in Montmartre, visit the early nineteenth century cemetery and say bonjour to La Goulue (Louise Weber) original French cancan-dancer of the Moulin Rouge; painters Edgar Degas (1834–1917), Victor Brauner (1903–1966), Horace Vernet (1789–1863), Václav Brožík (1851–1901), star Dalida (1933–1987) and sculptor; Aimé Morot (1850-1913).

MONTPARNASSE
3 Boulevard Edgar Quinet, 75014

Navigate through various styles of tombstones to pay respects to the many artists, writers and publishers here: existentialists Jean Paul Sartre and Simone de Beauvoir; tomb and monument to Charles Baudelaire, Antoine Bourdelle, Constantin Brâncuşi, Samuel Beckett and Man Ray among other luminaries. You'll also find a version of Romanian Modernist sculptor Constantin Brancusi's 'The Kiss' and 'The Génie du Sommeil Eternel', a bronze angel of Eternal Sleep by Horace Daillion (1902).

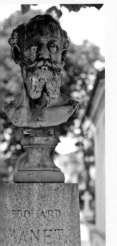

▲ *Edouard Manet's grave in Passy cemetery.*

PASSY CEMETERY
2 Rue du Commandant Schloesing, 75016

Painter Edouard Manet, composer Claude Debussy and Alexandre Millerand (1859–1943), President of France are among those buried in this small but much visited cemetery in the 16th.

7

MONTMARTRE

ON A HILL IN the north of Paris, Montmartre was originally outside the city walls and a quiet rural area. Back in the eighteenth century George Michel historically made landscape its own rightful subject with rustic paintings of the hill such as 'Aux Environs de Montmartre' (around Montmartre) that now hangs in Le Louvre. Jean-Baptiste Corot later painted the 'Moulin de la Galette' – now in Musée d'Art et d'Histoire in Geneva, way before it became a famous guingette (festive bar). Prominent romantic painter Géricault and Academy painter Horace Vernet also lived by here, as did Symbolist Gustave Moreau, from 1852.

But it wasn't until the 1860s that a new generation of painters formed themselves here and made the hill internationally famous. Breaking away from academic tradition, their subjects were real people – often from the streets, dance halls and even brothels of the area and the art wasn't seeking religious or historical anecdotes, but real-life reflections of scenes and landscapes, as seen at a glimpse with new techniques and brush strokes. The invention of the easel and paint tubes allowed them to paint outdoors and concentrate on painting rather than mixing colours and the play of light was most important. Montmartre gave them a sense of freedom and the quality of light and air was better than central Paris. Their work, mostly rejected by the Salon, finally hung in a Salon de Refusé where many of the public came to laugh. The proud painters continued their own style, living with poverty and passion, and together created movements that changed art forever. Some of them would be recognised during their lives but others, such as Van Gogh, not until after their deaths. Realism, Impressionism, Nabis,

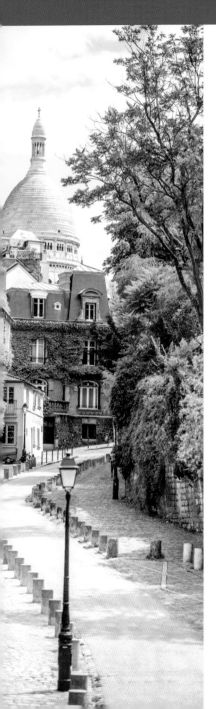

Cubism, Futurism... Montmartre was their cradle.

While you'll find the works of these Impressionists, and Post Impressionists in Musée d'Orsay, Musée d'Orangerie, the Louvre and Musée Marmottan-Monet, Picasso and Braques in the Musée Picasso in the Marais and the other artists in various of the larger museums around the capital, coming to Montmartre will allow you to literally walk in their steps and visit the scenes of their lives and their artworks. Monet, Renoir, Cézanne, Sisley, Degas, Vardon, Toulouse-Lautrec, Cassatt, Morisot, Van Gogh as well as Severini, Seurat, Signac, Modigliani, Braque, Juan Gris, Picasso ... it's quite incredible.

It's true that the central parts of Montmartre today are full of tourists and that the type of artists who made the hill famous by passionately living, creating and socialising in the apartments, studios, cafés and cabarets could no longer afford the rent here. But Montmartre hasn't lost its charm and once you get off the main streets you can find quieter cobblestoned alleys and trip back in time. To imagine and celebrate the period that swept the world and changed the face of art forever, it's easy to get among it by foot. While exploring the past of Montmartre you can discover today's pretty laneways, panoramic views, colourful street art and breathe in the fresh(er) air.

Make sure you're not rushed so you can go at your own pace and with the hilly, cobblestoned streets, good shoes are a must!

PART ONE

1. LE MOULIN ROUGE

82 boulevard de Clichy, 75018 (opposite Metro Blanche)

After their defeat to the Prussian army, Parisians needed to forget their woes. Around the foot of the hill of Montmartre, dance halls opened where the Bourgeoisie could let their hair down and mix it up a bit. In 1889 an old ballroom reopened as the 'Moulin Rouge' with a soon-to-be iconic (fake) bright red windmill. The French cancan found its home here and the whole flamboyant scene was immortalised by the talented Henri de Toulouse-Lautrec. Lautrec,

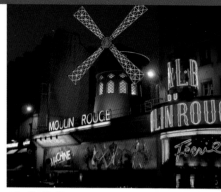

▲ *Le Moulin Rouge.*

stunted in growth from aristocratic inbreeding (a direct descendent of the Count of Toulouse), was a regular here and in many of the other cafés and cabarets where he found his inspiration. La Goulue, a cancan dancer who debuted the finalé of the splits (to a screaming crowd) was a favourite in his work as was Jane Avril, whose fame spread thanks

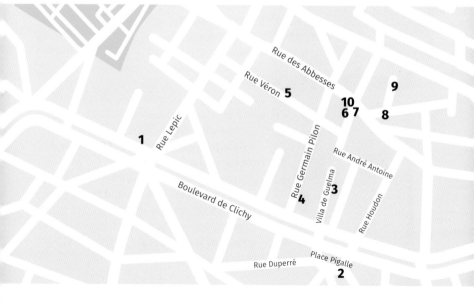

to the Lautrec posters. This poster art, with art as advertising, was well received by the public who recognised them as collectable art and actually ripped them off the streets. Today you can pick up a print from many tourist shops around Montmartre, or at the lovely green bouquinist stalls along the Seine.

The Moulin Rouge is also depicted in the works of Pierre Bonnard, the creator of the famous France Champagne poster (1891 now at the Bibliothèque National Paris) that fit his Nabis objective to bring art to everyday life.

Today's cabaret review shows at the Moulin Rouge feature long-legged dancers doing the cancan and other dances with elaborate historic costumes and some comic crowd-pleasing guest acts. There's no regular ball or social event so that part will have to be in your imagination, but it is something of a moving, dancing museum of dazzling light, colour and costume.

Walk east along the Boulevard de Clichy until you reach...

2. PLACE PIGALLE

Pigalle is Paris' red light district (but also has music venues and more recent trendier bars and restaurants opening up). The artists would once go and pick up girls (and boys) – not for sex but for models (well, sometimes both...). The Marché aux Modèles, the Model Market, took place around the fountain. Rodin was among those who went model

shopping here, and this was where Manet found his Olympia – Victorine Meurent, simply known as Laure. The painting that shocked the 1865 Paris Salon as the nude Olympia stared daringly out to the viewer is now a star attraction at the Musée d'Orsay.

CAFÉ DE LA NOUVELLE ATHÈNES

Also at Place Pigalle, at number 9, was the famous Café de la Nouvelle Athènes that became a spot for drinks and debates for the artists (Manet, Monet, Degas, Pissaro, Van Gogh) as well as journalists and writers and where Erik Satie would play the piano. Set here was Degas's 'Absinthe', painting of a woman and a man drinking – side by side but in alcoholic solitudes. Also, probably, Manet's 'La Prune', a woman looking vaguely into the air, head resting on hand with a cigarette in the other hand. The place was later a strip club visited by Nazis soldiers and then a music venue, finally closing in 2004.

Cross the street to...

3. 5 VILLA DE GUELMA – THE EX STUDIOS OF BRAQUES, SEVERINI, DUFY...

Here were the studios of Georges Braque, Gino Severini and Suzanne Valadon. Painter Raoul Dufy also lived here from 1911 (see his monumental 'The Electricity Fairy' 10m x 60m at the the Musée d'Art Moderne).

As you're entering the villa, look up for

Ruby Boukabou

Ruby Boukabou

the colourful 'Space Invader' street art on the corner.

Back up to the boulevard and turn into the next street Rue Germain Pilon.

4. CORNER OF RUE GERMAIN PILON AND BOULEVARD DE CLICHY

Look up at the corner to see the once home and studio of Bulgarian painter Jules Pascin (later known as the Prince of Montparnasse), marked with a plaque. Before that, painter and caricaturist

Ruby Boukabou

Honoré Daumier originally from Marseille, lived and worked here.

Check out the pretty Restoration-era buildings on the left as you walk up the street from number 7 with gardens, motifs and greenery. Number 13 has a romantic double staircase and was home to poet Bernard Dimey (1931–1981).

Notice also some of the street art; on the right a 'Mass Toc' (a parody of 'Miss Tik') stencil art (while Miss Tik depicts slim, big breasted femme fatales, Miss Toc's women have a heavy body and a no-messing stare). Look up and about for more pieces of street art. (http://missticinparis.com/, www.urbacolors.com/en/artist/mass-toc)

5. RUE VÉRON (5)

Turn left into the rue Véron and you'll find some Miss Tik originals and some fun street art of hanging washing, that you'll find around Montmartre (see Street Art). There were also two galleries dedicated to urban art – Joel Knafo Art –

Circus', unfinished before his death (from angina he supposedly caught at the Salon!).

Climb the stairs of this quaint street and come out into the heart of Abbesses.

7. SAINT JEAN CHURCH

Sit down for a breather in this church with a reinforced concrete facade that is quiet and simple, albeit with beautiful stained glass depictions, murals of Christ and statues of angels. Designed by architect Anatole de Baudot it was opened to the public in 1904.

at 21 and 24 stocking posters of 'Obey', and prints of street-art couple Janas and JS (you'll see their auto portrait art around the next corners too), and book signings, for example with Miss Tik (don't mention Mass Toc though – it's a delicate subject!) but the gallery has moved to 182 Rue du Faubourg Saint-Honoré, 75008 that you may want to visit on another occasion...

Back up rue Véron, snap the Janas and JS images you pass and other fresh works, then turn left at the end into rue André Antoine.

6. GEORGES SEURAT'S PLACE
39 rue André Antoine

This was where Seurat lived (from 1890) and painted 'The Chahut' (The Heckling), a café with live music dance and 'The

Ruby Boukabou

8. ABBESSES METRO

Just across from the church is metro Abbesses. This original metro entrance was designed by Hector Guimard in an Art Nouveau style (another is at Place Dalphine). Originally used for the Hôtel de Ville metro, it was transported here in 1970. The staircase, descending 36 metres below ground, depicts visions of Montmartre: windmills, poppy fields, hills and cafés.

9. THE JE T'AIME WALL

Square Jehan Rictus, place des Abbesses

This now famous wall is a monument to love from writer/composer Frédéric Baron and calligraphy artist Clair Kito. Over 300 languages read 'I love You' or 'Je T'aime'. The tradition now is for tourists to find their language and happy snap in font of it, or for couples to pose cutely in front of the blue and white art wall.

10. SAINT JEAN BRASSERIE

You'll be thirsty by now, so stop off at the bakery café Coquelicot (24 rue des Abbesses) or the Saint Jean brasserie opposite (16 rue des Abbesses) that has its own funny legend. The owner used to drink his guests under the table. One night, he drank too much and collapsed. He was nailed into his coffin and hours later there was knocking: he had been in an alcoholic coma! Luckily he was still above ground and was let out and back to life. Toast (perhaps a non alcoholic beverage) to that!

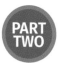

PART TWO

1. PASSAGE DE ABBESSES

Opposite the Saint Jean there's a street-art stencil of a girl crouching, taking a photo. Snap her back if she's still there – street art being quite ephemeral – and walk up the passage de Abbesses that's both a bit grotty and quite colourful with wall art. At the top of the stairs you'll come out onto rue des Trois Frères directly opposite the grocery shop from the film Amélie (at number 56).

(2) *Continue up rue Androuet and take a left onto rue Berthe and with any luck the pink flamingos are still striking a pose on the wall to your left. You'll soon come out into the tree lined Place Emile-Goudeau.*

3. LE BATEAU – LAVOIR

Place Emile Goudeau – 13 rue Ravignan

In the pretty Place Emile Goudeau is the cradle of Cubism and abstract art.

▲ *Grocery shop from the film Amélie.*

Ruby Boukabou

▼ *Rue Berthe.*

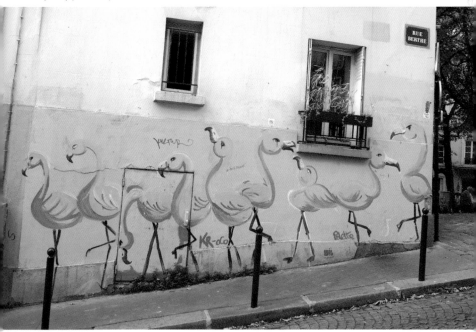

Ruby Boukabou

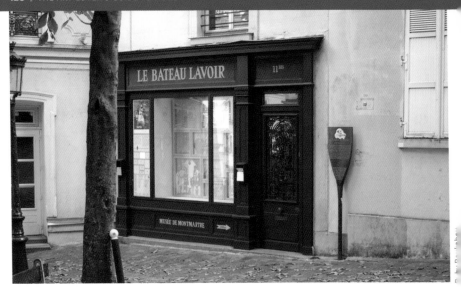

Inspired by Monet, Renoir and friends, the Impressionists, artists from Spain, Italy and Holland flocked to Paris and to Montmartre to get a taste of the artistic air and Bohemian lifestyle. While their pockets were often empty their heads were full of art and a sense of freedom gave them drive and ambition. Nicknamed the Wash Boat by Max Jacob (with its narrow hallways, small back window and hanging laundry it resembled, he thought, a laundry boat on the Seine), it was a place to live, work and socialise despite poor lighting and heating, and only one tap and toilet. Gaugin, Modigliani, Juan Gris and van Dongen all laid their heads here. Picasso arrived at the age of 23 in 1904 during his blue period and he moved onto his rose period here inspired by circus and street performers. Here he painted the seminal cubist work 'Les Demoiselles d'Avignon'

in 1907. Many other writers and artists would make regular visits.

The Bateau-Lavoir burned down in 1970 and was rebuilt in concrete in 1973 serving as just studios. You can't enter but there's a pretty interactive window display depicting the life and times of Picasso and the gang.

Take a seat on the benches to drink it all in for a few moments as you imagine Picasso and friends coming in and out of their shabby but profoundly productive studio home.

(4) *Walk uphill and look down rue d'Orchampt* where, at number 2, you can see the only studios that survived the 1970 fire and have been maintained by the widow of artist Armand Laurenco.

Continue up rue Ravignan until you hit rue Gabrielle where, at number 49, Picasso had his first (and cheap) studio, in the back of the building. **(5)**

Step back towards rue Ravignan and up into Place Jean Baptiste Clément.

(6) Look up at the end to number 7 to see the once home of Italian painter and sculptor Amedeo Modigliani whose work you'll recognise from the elongated faces and sober expressions. Modigliani was one of the artists who received most of his recognition after his life…

Turn left onto rue Lepic until you reach the corner of rue Girardon. Gaze up at the windmill and drift back in time.

7. LE MOULIN DE LA GALETTE
People would come to the Moulin de la Galette to drink wine, eat bread 'galette' made from the windmill and enjoy their popular animated dances with accordion music. The festive 'guinguette' was also a great spot for the Impressionists where they could arrive on foot with their easels, set up and observe real people in movement. 'The Bal' (dance) was captured by Van Dongen and Pissarro but most famously in 'Bal du moulin de la Galette' by Renoir (1876), one of his masterpieces, now at the Musée d'Orsay that show his friends among the crowd socialising, drinking and dancing, with experiments of light and shadow.

It's now a chic restaurant where you can try French cuisine and choose from a large wine cellar. There are often painters outside with easels or sketch pads trying their own hand on the famous location.

Walk up rue Ciradon and turn right

into rue Norvis past Le Passe-Murale sculpture **(8)** of a man coming out of a wall inspired by the story by Marcel Aymé. You've hit central touristic Montmartre with cafés, art shops with prints of the famous impressionist paintings and a buzz of tourists. *Continue to Place de Tertre.*

Look up rue de Saules on your left to see…

LA BONNE FRANQUETTE
18 Rue Saint-Rustique, 75018
http://en.labonnefranquette.com/
Now the Bonne Franquette with a motto of 'Love, Eat, Drink and Sing', this was a stop off drinking spot for Pissarro, Renoir, Monet, Cézanne, Suzanne Valadon and son Utrillo, called 'At the Wooden Billiards'.

In 1886, Van Gogh painted 'La Guinguette' (Terrace of a Café on Montmartre) here. Today's menu is simple, traditional French dishes with a large selection of French wines.

Continue rue Nervine to…

9. PLACE DU TERTRE
This tree-lined square in the heart of Montmartre is a hive of painters and portrait sketchers. Rain or shine, summer or winter, they arrive early, set up their easels and hope for business. While it is literally packed with tourists, the ambiance is relaxed and lively. Get among it and check out who you think are the best and immortalise your trip. It may at first seem a little cliché, but avoid putting your nose up and realise that these

Ruby Boukabou

classic impressionist paintings, but it's so much nicer getting among the artists.

At number 2, 'La Bohême du Tertre' was once Hotel – Restaurant Bouscarat and a hang-out for Picasso, Max Jacob, Modigliani and friends.

Pop into the Montmartre tourist office with a branch located here (7 Rue Drevet) to pick up leaflets on current exhibitions and other artistic activities to check out.

At the other side of the Place du Tertre you'll catch a busker or two and a stunning view over Paris with plenty of colourful street art lining the walls of the stairs. Instead of going down, turn right and visit the Espace Dali **(10)** to find out about the man behind the big moustache and surrealism (11, rue Poulbot 75018 – see also 'museums').

artists are indeed talented and during a twenty-minute break from walking you can have a chat and get a portrait. Or take in a photo of a friend or family member that can serve as a present a little more personal than an Eiffel tower trinket. Talk to some of the painters and pick up some great artwork at affordable prices.

Jean Jacques Duverger, for example, paints beautiful tactile floral works that you can bring home to brighten your walls. You can even pay with credit card! There are many small galleries nearby where you can pick up prints of the

CHEZ PLUMEAU

It's time for a pause. Pull up a seat on the terrace of Chez Plumeau under the vines next to Espace Dali and with a view over Paris. There's a village atmosphere with a good mix of locals and tourists and often live music.

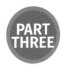

PART THREE

Head back through the Place de Tertre, down rue Mont Cenis and left into rue Azais.

1. THE SACRÉ COEUR

Brave the tourists and head to the steps of the Sacré Coeur for the panoramic view over Paris (that's even more dazzling if you climb the 300 steps of the Dome). Street performers, photographers, lovers and friends gather to gaze over the city and back up in awe at the Sacre Coeur, which was constructed between 1875 and 1923 and dedicated to the sacred heart of Jesus to make amends to God after the disastrous Franco-Prussian war.

The artists of the Bateau Lavoir were around during the construction and there are cubist depictions of it by

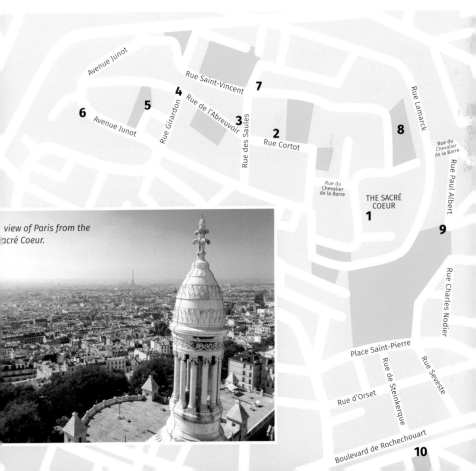

view of Paris from the acré Coeur.

both Braque and Picasso. Despite the mass of people, once inside you'll find it a breath-taking experience whether you're religious or not, with the dynamic, enormous mosaic on the ceiling 'Christ in Majesty' by Luc-Olivier Merson.

Take the side street, rue du Cardinal Guibert for another stunning view of the exterior and past wandering sketchers, *left into rue du Chevalier de la Barre*, past the gift store galleries and *right into rue Mont Cenis* to the water tower then *swing left onto rue Cortot.*

2. MUSÉE DE MONTMARTRE (see also 'museums')

12 rue Cortot, 75018
www.museedemontmartre.fr

Drink in the history of Montmartre and the artist colony while breathing in the sweet air from the neighbouring vineyard at this gorgeous museum.

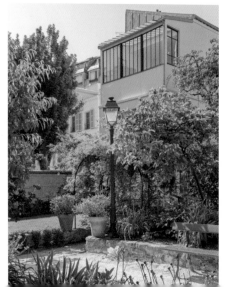

Continue to the end of rue Cortot a lovely photo of cobblestoned quaint Montmartre above the vineyard and across from the Maison Rose pink walled restaurant and charming rue de l'Abreuvoir. **(3)**

Walk down rue de l'Abreuvoir to ...

4. PLACE DALIDA

In this cute square is the bust of Italian-Egyptian singer–actress star Dalida (Yolanda Gigliotti). Follow the tradition and polish her breasts as you pass to keep them golden!

Take the tiny Allée de Brouillards – number 6 was once the house of Renoir (from 1890) and it was here that he raised son Jean (born 1894), an important French filmmaker (French Cancan is a lot of fun).

Turn left into the little park with beautiful Plane trees and children's equipment that make you feel like you're in a village on the French Riviera. There's a statue **(5)** of Saint Denis with his head in his hands; bishop of Paris in the third century, he was decapitated but legend has it that he just picked his head up and walked on preaching.... You'll find other sculptures of him all over town.

At the other side of the park, turn right into rue Junot.

6. AVENUE JUNOT

Check out this pretty avenue with Art Deco-style cubic mansions and the large studio windows where many artists once worked and lived including

Francisque Poulbot (no. 13) and, (at no. 15) modernist artist Greta Knutso and her Dadaist husband Tristan Tzara.

Continue along avenue Junot, which then becomes Place Constantin Pecqueur and then down rue Saint Vincent until you get to rue des Saules.

7. AU LAPIN AGILE

22 rue des Saules, 75018
+33 (0)1 46 06 85 87
http://www.au-lapin-agile.com/

Once the 'Cabaret des Assassins' with paintings of famous killers hanging on the walls and a boisterous and rather rough clientele (gun shots were

Lapin Agile. Ruby Boukabou

not an unfamiliar sound), one of the oldest cabarets in Paris, opened in 1795, is iconic in the history of artistic Montmartre. The cute pink cottage became 'The Agile Rabbit' after the painting of local cartoonist André Gil, with the image of a rabbit escaping the cooking pot with a bottle of the local drop. Renoir, Van Gogh and friends were regulars and it became a popular hang-out for artists when taken over by the popular Montmartre character, the guitar-bearing Father Frédé, and became a haunt for Utrillo, Modigliani, Braque, Apollinaire and Picasso. The clients would debate, drink, sing and dance into the night. It's also where the painting hoax by critic Roland Dorgelès originated in 1910. Wanting to show up, and make a joke of the new wave of more abstract art that was making waves with Picasso and friends, Dorgelès presented 'Sunset Over the Adriatic' by the 'Genoese painter Joachim Raphaël Boronali' at the Salon des Indépendants claiming it the new 'Excessivism Movement'. It was in fact the work of Frédé's donkey to whose tail he tied a paint brush that created the painting as he offered vegetables in front of his nose to provoke the swishing tail.

Picasso famously paid a tab with a piece of work at Le Lapin Agile, sold by Sotheby's auction house for $41 million in 1989 (a little more than the tab!). A copy is now up and Le Lapin Agile is still open for business with simple tables and chairs and singers of French chansons belting out favourites until late with clients joining in. (Tuesday through Sunday, 9pm-2am +33 (0)1 46 06 85 87)

Across is the vineyard, above is the Musée de Montmartre and straight along rue Saint Vincent are enviable plant clad houses.

Continue along Rue Saint Vincent. Cross through the adorable Square **(8)** *Marcel Bleustein Blanchet* with its Pétanque field (historic French bowling game), *take the stairs down to rue du Chevalier de la Barre and turn right into rue Paul Albert* that ends at a square **(9)** that serves as a good spot to stop for a drink on a terrace café.

Drink in the atmosphere and congratulate yourself on a tour that wove you between past and present.
When you're ready, continue down the stairs and head downhill. Turn right onto Place Saint Pierre, and then left down Rue de Steinkerque to arrive at metro Anvers. **(10)**

Other Places to know about in Montmartre...

LE CHAT NOIR (no longer there)
at 84 Boulevard Rochechouart, moved to 68, Boulevard de Clichy

Sadly the original Chat Noir, one of Paris' first cabarets, has long closed its doors. But the name, still used for bars and music venues the world over is famous, not just because the artists would come to socialise here, but because of the poster art by Théophile Steinlen

included Degas, Monet, Renoir, Sisley, and Cézanne; the writer Zola was also a regular. They would drink and debate on art. Monet famously slapped art critic Edmond Duranty over an article he found unsupportive which led to an actual sword fight in the St Germaine forest. After this fit of passion, they made up like schoolboys. Look up for the sign next door of the once paint shop where the artists bought their supplies.

VAN GOGH'S HOUSE
54 rue Lepic, 75018

Dutch artist Van Gogh lived with his brother on third floor from 1886–1888. He painted 'View of Paris' from the window. Greatly influenced by the Impressionists, he started to mix with them and painting with brighter colours. Unfortunately his fight with mental illness had him in almost permanent states of anxiety, so he couldn't appreciate the beauty of his work as much as people do today, long after his suicide.

CAFÉ DES DEUX MOULINS
15 rue Lepic, 75018

For lovers of the 2001 film *Amélie* – this is the café! The film reminded the world of the quaintness of Montmartre and the cuteness of the local characters. Pop in for a coffee and a photo if you're in the area and a fan.

(1859–1923) a local of Montmartre (born in Switzerland) who was commissioned to design it. The black cat perched on the sign bearing the name of the owner Roldolphe Salis stares out of the poster boldly and defiantly as the public is invited to the next show. The Chat Noir opened in 1881 and closed in 1897 after Salis passed away. There was also a Chat Noir magazine from 1892 to 1895 with news, reviews, poetry and satire from the cabaret and Montmartre.

CAFÉ GREBES (no longer there)
9 Avenue de Clichy

Café Guerbois was where the Impressionists, led by Manet met. They

8

BELLEVILLE

IN THE NORTH EAST of Paris and once a village with vineyards and farms, Belleville became part of Paris proper in 1860 and now straddles four arrondisements: the 10th, 11th, 19th and 20th. With working-class roots, it later became the second little Chinatown (after the 13th) which it has remained today along with a culturally diverse habitation – along with the Asians are Africans (North and Sub Sahara), many other internationals as well as French hipsters (Bobos). While rising, prices are still remarkably cheaper than in the centre of Paris and the bar scene is vibrant, the mishmash of people invigorating. And there are a few hundred artists sketching, sculpting, etching and painting behind the scenes.

Flashback to the 1980s – Belleville, still a marginal area (lots of crime films were set here), wasn't overly frequented by the central Paris population, particularly after dark. Things began to change and artists arrived en masse with many places available for them to live and work – either cheap enough to buy or rent, or empty and so possible to squat. The squats were soon homes of many visual artists and musicians (including the group Les Garçon Bouché who formed here).

Plans for a commercial development were met with local resistance. The association 'Bellevilleuse' was formed to defend Belleville as was the 'Artistes de Belleville', formed in 1989 who created the 'Portes Ouvertes' (open workshop festival) to attract media attention. 'The AB was created to say "we exist, we are here, come and see us,"' explains the association's cultural coordinator Loïs Pommier. The initiative was an immediate success with both the press and public. The first year, in 1990, there were 40 artists, it grew later to 80, 90, 150 and now 250 with 50,000 visitors.

During the Portes Ouvertes people walk from studio to studio down hidden alleyways, under grape vines and into large houses and gardens.

▲ *Delphine Epron in her studio.* Ruby Boukabou

'While there are artists everywhere in Paris, there is a certain presence of the artists in Belleville,' says AB president and artist Delphine Epron. 'They're emerged. And the multicultural public know about the local artists and engage with them.'

The AB work on exchange schemes, with Japan and various countries, offer courses from their artists, events and maintain a small gallery in permanence at the association (gallery open Thursday to Sunday 14h–20h, closed in August and public holidays).

http://ateliers-artistes-belleville.fr/
1 rue Francis Picabia, 75020

rue Dénoyez, the famous graffiti and street-art street. This now famous street was occupied by squatters in the early 2000s. The council made an agreement with them so they could stay, paying a token rent for a few years while development plans were finished. Many artists left after five to ten years with the council proposing other projects and places, some remained.

PLATEAU URBAIN

Since 2013 the association Plateau Urbain has organised the use of buildings during their redevelopment in Belleville and all across town. Spaces become available to artists creating cultural centres of sorts with concerts, expos and parties livening them up.

LA FORGE/ LA VILLA BELLEVILLE

La Forge was a large and important artist squat between rue de Belleville and rue Ramponeau. Now called La Villa Belleville, the large space is managed by Curry Vavart, a multi disciplined collective who organise and develop cultural spaces and activities.

There are temporary residences for artists, mostly young graduates of the Fine Arts schools. But they also have workshops and material available for artists to come in and

▲ *rue Dénoyez flower pot.* Ruby Boukabou

use for free, through making a booking, which allows artists who don't necessarily have all the materials for woodwork, engravings, screen printing etc. The airy, light space is inspiring. There are expos and courses to attend, and there are fabulous neighbours to bump into and chat with, such as mosaic artist and resident since 1978, Catherine.

www.villabelleville.com

The newer contemporary galleries have another vibe again with younger gallerists' dynamic works and have popped up mainly post 2012 (see 'Galleries'). Belleville is also famous for its outdoor urban art. (See 'street art')

Ruby Boukabou

9

STREET ART

HAD ENOUGH OF MUSEUM queues, entry tickets, trampling tourists and tight security? Want to breathe in art in the open air while feeling the pulse of daily Paris? You're in luck. Once seen as vandalism to be cleaned off, many graffiti-art and street-art works are now considered major pieces that are not just tolerated but even sometimes commissioned with dozens of the artists, many now world renowned, exhibiting both on the street and in the galleries.

Street art and wall art has existed for centuries in various forms, but the contemporary phenomena, in Paris, began partially in the forms of slogans on the walls and posters of the Fine Arts students during the student riots of May 1968, and with artists such as Daniel Buren, who pasted stripes over advertisements at metros to demonstrate that art can exist anywhere and will create a conversation.

During the 1970s the ('pre-') street art further evolved with the use of stencils, (enabling a quick getaway), aerosols, posters and murals and silk screening on site-specific locations. A striking moment was in 1971 when Gérard Zlotykamien covered the walls of the demolished Les Halles buildings to depict the horrors of Hiroshima, followed by Ernest Pignon-Ernest and Arthur Rimbaud shining a light on injustices and the marginalised.

Subsequent artists employing their own style and their signifying symbols continued to work illegally through the 80s, taking inspiration from the States, primarily the New York graffiti scene.

Punk street art collective 'Les Musulmans Fumants' (the smoking Muslims) was formed with

▾ *An angel in the maris.*
Ruby Boukabou

artists including Tristam Diquatrostagno who took the streets, had expositions and even appeared at the FIAC (1983).

In the 90s the spots in Paris included Stalingrad, the docks of the Seine, les Halles and around la Chapelle as well as around Pont Neuf and Le Pont du Carrousel and the names included Bando, Blitz, Lokiss, Scipion, Ski and Americans Futura 2000 and JonOne.

The authorities were determined to clean up the 'eyesores', but by the new millennium Parisians had been seduced by glorious, beautiful, challenging and provocative art works that gave meaning to their beloved city, especially because being site-specific, the locals could in a sense 'own' them.

The scene grew and Paris began to boom with art with a strong environmental element alongside erotic, humorous, political and social statements.

Today, street art has a strong place in the city. The physical, sometimes confronting, engagement with the public brings a liveliness to the walls where the works can touch all members of the public, not just an elite group who visit the galleries. You can take in the art while sipping your morning café crème, walking to the markets, heading out to meet friends or waiting for a bus. Whether it has a political message, adds a splash of colour, makes you laugh or pushes you to think, it introduces a dynamism and vitality to the city that is often criticised for being conservative and grey.

As for the artists, the urban canvas of Paris is vast and their styles wide. Colourful but quick tags take your attention in some parts while sassy stencils impress on café windows; commissioned murals decorate whole walls while provocative portraits loom from higher buildings and stickers brighten footpaths and windows. Above all, a freedom of expression unlike any curated gallery quickens the pulse of the city.

In 2016 the city of Paris put budget towards creating street-art walls all through Paris and since then dozens of galleries and some museums have sprung up making it clear that Parisian street art is as legitimate a form of expression as any other. Here's a selection of the talent:

▼ *Police on ostriches.*
Ruby Boukabou

JEF AÉROSOL
www.jefaerosol.com

Originally from Nantes, stencil artist Jean-François Perroy has been leaving his mark on the urban landscape of Paris since the 80s. His work appears all over the world (including on the Great Wall of China). He portrays both anonymous figures of the street like children, musicians and passers by, and celebrities (Elvis, Hendrix, Gainsbourg). Discover his Indian dancers, djembé players, accordion players and a recurring sitting kid with red arrows. Inspirations come from 60s pop art,

album covers and everyday life.

Check out his huge stencil of 22 metre high by 14 metres covering an area of 350 square metres 'Chuuuuttt' (Shhhhh) on the wall at Place Igor-Stravinsky opposite the fountain by Centre Georges-Pompidou; the black and white self portrait, finger to lip making a hush sign to inspire people to listen to the birds, kids, languages...

NEMO
Since the 90s, the buildings and streets of Paris, particularly around Ménilmontant and Belleville, have been

▼ *Shh, Jef Aerosol.* Ruby Boukabou

▲ *Nemo near metro Ménilmontant.* Ruby Boukabou

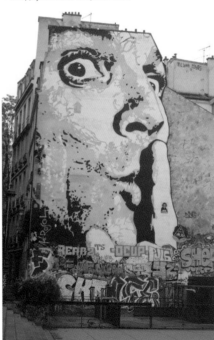

Ruby Boukabou

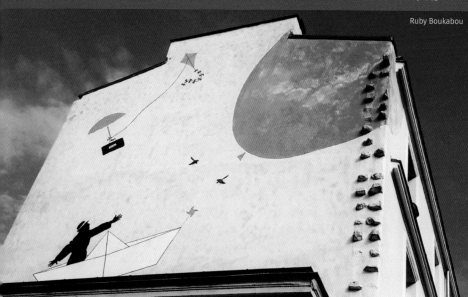

beautifully animated with classic picture book images of a silhouetted man in trench coat and hat, red balloons, black cats, suitcases, kites and mini sailing boats. Nemo is the artistic name of Serge Fauri and means 'nobody' in Latin.

(Exiting Ménilmontant metro – look up and you can't miss one.)

BLEK LE RAT
http://blekmyvibe.free.fr/

Blek Le Rat, the artist name of Xavier Prou, was one of the first street artists in Paris. When he was a student of fine art and architecture at the Beaux-Arts in Paris, a trip to New York inspired him to start creating his own. His stencil art first appeared in the early 80s and featured rats and large scaled human figures. His work has since influenced many,

including Banksy. He created a series on the homeless beginning in 2006 to bring awareness to a global problem. Le Rat's work has been featured in streets and galleries across the world, including London, Melbourne and LA.

JÉRÔME MESNAGER
http://jeromemesnager.com/

The skeletal white figures of Mesnager have been moving and dancing from Paris to the Red Square in Moscow since 1995. Representing 'light, strength and peace', they are often visible higher up on walls in Ménilmontant, most notably half way up the steep rue de Ménilmontant (corner of rue Sorbier) where they dance in a circle à la Matisse titled 'C'est nous les gars de Ménilmontant' (we're the guys of Ménilmontant).

MISS.TIC
http://missticinparis.com/

A star of street art, Miss Tic began stencilling her signature dark headed pin-up style women, often accompanied by a few words of poetry, in 1985. She is still active today, represented in galleries and in international Art Fairs. Her work has also been appreciated by the fashion world and in 2007 she designed the poster for the Claude Chabrol film 'La Fille coupée en deux'. You can find her work around Montmartre and in the 20th and 13th.

SPACE INVADER
www.space-invaders.com

There's something delightful about glancing up and spotting a Space Invader in the middle of the city, and this was one of the aims of the anonymous artist who has placed well over 1,000 tiled mosaic artworks, inspired by the 1980s video game, around the world since the 90s. 'I like the concept of de-contextualising art to bring it to the streets, to surprise everyday people' says the artist who defines himself cheekily as a UFA, an Unidentified Free Artist. 'It is first of all about liberating Art from its usual alienators that museums

▼ *Miss Tic.* Ruby Boukabou

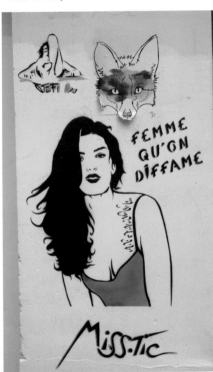

▼ *Space Invader.* Ruby Boukabou

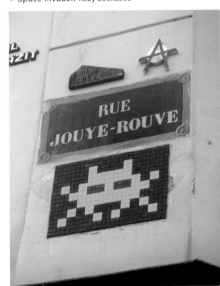

or institutions can be. But it is also about freeing the Space Invaders from their video games TV screens and to bring them in our physical world,' he says.

But the invasion isn't only in Paris. Non. They are all over the world, with the highest being 2,362 meters at a ski lift in Anzère, Switzerland and 35km above ground in the International Space Station, and the lowest visible to scuba divers in the Cancun Bay in Mexico!

SPEEDY GRAPHITO
http://speedygraphito.free.fr/

Shortly after graduating from the School of Art Estienne in Paris in 1983, Olivier Rizzo became Speedy Graphito, making his first stencils on the street with the group X Moulinex. Ever since, he has experimented with pop culture across forms of stencil art, painting, sculpture, installation, video and photography. His works are ironic, fun and colourful. Graphito was responsible for the graphic identity of the Halle Saint Pierre, the logo for the Altair space mission and the painting of the barge Europodyssée. He has major solo exhibitions around the world.

JONONE
http://jonone.com/

New Yorker John Andrew Perello started tagging as a teenager in his apartment block. After the guardian had a harsh word with his mother, he took to exploring the streets, tagging in his neighbourhood.

Meeting artists on his path, he began being invited to art exhibition openings, and, inspired, experimented with his own creations. In 1987 he came to Paris. After tagging around town, JonOne acquired a workshop and entered the world of the galleries. His pieces celebrate colour and movement with a freshness, vitality and enthusiasm that is always uplifting. He has designed the bottles of Clement Rum and Cognac Hennessy and is a respected artist around the world, especially in France.

MONSIEUR CHAT
www.monsieurchat.fr

Big yellow Cheshire-cat-like felines smile down to passers-by around Paris since

Ruby Boukabou

and fashion – you don't know how long it's going to last so you need to make something and be ready to abandon it and move onto the next thing. The American artist, known for his large blue, red and black images (there's a famous one supporting Obama), spends a lot of time in Paris, often for commissioned works. Since 2001, Obey has been a streetwear brand with slogans such as 'make art not war'. Obey was involved in the Occupy movement and is engaged in climate change awareness. In 2012 he painted a huge mural in the 13th to a crowd of enthusiastic Parisians. The documentary 'Obey Giant' traces his art and life and the concept of art for social change.

KASHINK
www.kashink.com

Street art isn't just for boys but cheeky girls – one of the most active being Kashink, who counts Frida Khalo as one of her influences and likes to sport a false moustache. Kashink splashes bright pieces around Paris with four-eyed creatures from far away times and places. Her 2013 gallery shows 'Gayffiti' and 'Paganism' were a big success and she's worked in Canada, the US, the UK and around Europe.

You'll find lots of examples around Ménilmontant and the 20th – rue de Pyrénées, rue de Maraichers and in Montreuil.

1993 thanks to Swiss artist Thoma Vuille. He nearly faced three months in prison for tagging work panels at Gare du Nord and got off with a 500 euro fine, even after declaring he was just bringing art to an ugly part of a train station. His work can also be found in places as far flung as Hong Kong, New York, Tokyo and Sarajevo.

Two examples: Point Éphémère 200 Quai de Valmy, 75010, Albatros studios 52 Rue du Sergent Bobillot, 93100 Montreuil.

OBEY
https://obeygiant.com/

Artist and skater Shepard Fairey is 'Obey'. Shepard often talks about the ephemeral nature of street art

Seize Happywallmaker.

SEIZE HAPPYWALLMAKER
ttp://seizegraff.free.fr/

Raphaël Aline's vibrant geometric patterns based on the idea of networks and connectivity are arresting in their deceptive simplicity. 'I use the energy from the colours as a therapy', he says.

HYDRANE
ttp://hydrane.fr/

Architecture graduate French/Peruvian artist Hydrane creates intriguing small and large scale art, one of her themes drawing from her Peruvian heritage with inspirations from the Nazca lines, pre-ancient etchings in the desert sands (also see 'art close and personal').

CHANOIR
During his studies at the Beaux-Arts de Paris, Franco-Colombian Alberto Vejarano

gave drawing classes to a young girl. One day she presented him with a design of a cat. He loved it. Deciding the cat and his friends were good company, he began spraying cats of all colours over the walls of Paris and around the world. They're often in sunglasses, t-shirts and caps and have cute expressions and colourful clothing. His cats have even featured on Samsung phone covers.

FRED LE CHEVALIER
http://fredlechevalier.blogspot.fr/

Mostly, but not only, in the Marais, Chevalier's figures are black, white and red with cartoony faces and chic demeanours, often considered Tim Burton-esque.

▼ *A Fred Chevalier work in Belleville.* Ruby Boukabou

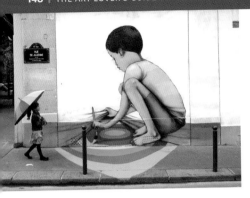

SETH
http://seth.fr/

Julien Malland, aka Seth or 'Globepainter', originally from Paris has also left his mark on China, Vietnam and Mexico. His fun children give the illusion of moving through the walls and gazing out windows. In Paris his work can be found in Belleville (above the park de Belleville), in the 13th and around town.

Examples can be foung on the wall at 2 Rue Emile Deslandres, 75013 and Parc de Belleville 75020.

JR
www.jr-art.net

French 'photograffeur' Jean-René works on large scale black and white photography that he places on the walls, starting out in Paris. After winning the TED Prize in 2011, JR began an 'inside out' project, where he helped people create portraits to display in public as a form of communication, with incredible effects around the world and a Face To Face project with his portraits of Israelis and Palestinians doing the same jobs pasted side by side on both sides of the wall. Today he is considered an urban activist, a recent project being a huge picnic on either side of the US/Mexico barrier. There's an interesting interview with him to check out on Al Jazeera's YouTube channel and see his TED talk on how art can change the world.

SHAKA
Graduate of the Sorbonne and influenced by the likes of Van Gogh and Francis Bacon, Marchal Mithouard was founder of the DKP Paris graffiti crew in the 90s and went on to develop his own style that creates colourful graphics with exaggerated human facial expression for dramatic effects.

HOPARE
www.hopare.com

Explosions of colour and form give the viewer the impression of speed and dynamics in the graphic abstract murals of Alexandre Monteiro, once student of Shaka, and who has been exhibited in places such as the legendary Montparnasse artists' brasserie, Le Coupole. Often faces come out of the graphics with intense gazes that invite an engagement with the work.

Others to look up include:
Artiste-Ouvrier, C215, André Saraiva, Philippe Hérard, Nelio, Levalet, Mister Pee, eL Seed, Zeus and Belleville Zoo Project, Janaundjs, RAF Urban, Zabou, Sarcé & Mecca, Zaira, Urbansolid & Kan/ DMV ('street pointillist').

POPULAR STREET ART SPOTS

You're bound to come across some intriguing works on your way around town in the forms including stencils, collages and monumental murals, but if you're on a mission, here are some places to head to:

MÉNILMONTANT/ OBERKAMPF

An area rich in street art.
Along Rue Saint-Maur.
Le Mur 107 Rue Oberkampf, 75011

Around once a fortnight since 2007, a different street artist paints over the 3 metre by 8 metre requisitioned billboard on Rue Oberkampf in the east.

BELLEVILLE

Belleville is beaming with street art. Rue Dénoyez is a famous street full to the brim and constantly covered and recovered, just by Belleville metro. The street area is in redevelopment so things may change soon, but Belleville is bright with other spots all over including the Parc de Belleville, Rue Rampaneux and Rue Bichat. Place Fréhel with a huge work by Ben Vautier (1993) of a worker hanging sign 'Be careful of words' and a detective by Jean Le Gac.

▼ *Street Art wall on the rue de la Fontaine au Roi in Belleville.* Ruby Boukabou

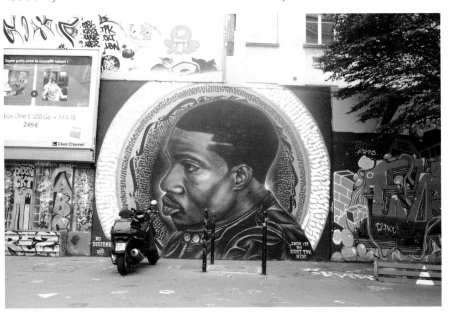

✳ **Rue Jean-Pierre Timbaud** – a beautiful (commissioned) fresco from New Zealand artist Sarah Wilkins (by Cité Ribot).

✳ **Along the Canal Saint Martin** including the wall at 11 Rue Jean Poulmarch, 75010

✳ **Stroll or ride** down the canal of Ourcq (75019) from Jaures to Parc de Vilette for a pleasant street art ballad (DaCruz, Psy, Marko 93).

✳ **Rue des Cascades** one of the most charming backstreets in the 20th Rue Laurence Savart, 75020

✳ **Rue d'Aubervilliers** (19th) a very long mural (nearly 500 m) (Kashink, Combo and JonOne)

✳ **The Marais to Les Halles**
Plenty of spots and examples including Monsieur Chat, Jef Aérosol (Place Igor-Stravinsky as mentioned above) and Fred le Chevalier.

✳ **On rue de Verneuil** once home of the late French singer Serge Gainsbourg is covered in various forms of art in hommage of the star.

✳ **Montmarte** around the backstreets and by Abesses metro.

13TH ARRONDISSEMENT

Thanks partly to a supportive mayor, the 13th has become a great location for street art, often giant murals. Check out Rue Jeanne d'Arc and Boulevard Vincent Aurio. Obey and Space Invader are among many.

✳ **Butte aux Cailles**
Little villagey area of the 13th full of stencils, collages, posters etc

✳ **Les Frigos**
Rue des Frigos Paris 75013
Artists work and live in this space, covered in graffs and street art...

✳ **Vitry-sur-Seine**
If heading to the Mac/Val art centre (see 'Greater Paris'), take the time to walk around as there are plenty of works to appreciate (for example by Kouka and Pixel Pancho).

✳ **FLUCTUART**
www.fluctuart.fr

Flucuart is a floating urban art centre on a 850 square-metre barge that won a competition of projects to reinvent the Seine. Under the guidance of street art specialist and collector Nicolas Laugero Lasserre this is set to open in Spring 2019.

STREET ART IN GALLERIES

While the essence of street art is evidently on the streets, certain galleries expose the form regularly. There are dozens around Paris. Here are a few:

Art 42
96 boulevard Bessières 75017
www.art42.fr

A street art and post-graffiti museum by Porte de Clichy, founded by Xavier Niel with over 150 artworks from the private collection of Nicolas Laugero Lasserre, with major street artists including Bansky, JR and Obey.

Itinerrance
24 boulevard du Général d'Armée Jean Simon, 75013
+33 (0)1 44 06 45 39
http://itinerrance.fr/

Discover the crème de la crème at this gallery exposing artists such as Seth.

Wallworks
4 rue Martel, 75010
+33 (0)9 54 30 29 51
www.wallworks.fr

Celal
45 rue Saint Honoré, 75001
+33 (0)1 40 26 56 35
www.galeriecelal.com

Cabinet d'amateur
12 rue de la Forge Royale, 75011
+33 (0)1 43 48 14 06
www.lecabinetdamateur.com

Backslash
29 rue Notre Dame de Nazareth, 75003
+33 (0)9 81 39 60 01
www.backslashgallery.com

Gallery Magda Danysz
78 rue Amelot, 75011
+33 (0)1 45 83 38 51
http://magdagallery.com

◀ Alex is the gallerist of Loft 34 (alongside his parents).
Ruby Boukabou

Loft du 34
34 rue du Dragon, 75006
www.loftdu34.fr

Onega
+33 (0) 9 50 47 94 03
60 rue Mazarine 75006
www.galerie-onega.com

Pioneers of Urban Art including Crash, Blek le Rat, Quik, Konny.

Brugier-Rigail
40, rue Volta 75003 P
+33 (0)1 42 77 09 00
www.galerie-brugier-rigail.com

10

HOW TO ATTEND AN ART AUCTION

▲ *Design auction at Sotherby's.*
Ruby Boukabou

WE'VE ALL SEEN art auctions in film and on TV with antiques and famous artworks going for millions in a rush of adrenaline inside a room full of eager bidders, egged-on by the dry wit of the auctioneer (watch Geoffrey Rush in *The Best Offer*). But is it as exciting as all that, and on a practical note, how does one attend and participate?

Well it can be, depending on the sale, and it's easy. If you can, go and check out the pieces up for sale that are on display the day(s) before and online, then register at the reception any time before the sale. You'll need some ID and your bank account details and they'll give you a little white sign and a buyer's number. If you don't want to buy but just absorb the atmosphere, you can turn up without registering. It's OK to arrive and leave during the auction, don't feel obliged to stay for all of it, although things tend to heat up later in the sale. If you get an outrageous impulse to bid and you haven't registered, don't worry, you still can by waving your hand and they'll quickly sort out the registration if you win the bid. Try to avoid coughing or playing with your hair!

Grab a seat, obviously the further back, the more you can get a sweep of the action. There are catalogues you can use to follow the sales and the objects are also displayed on a screen and live, set up on a stand brought in and out by a string of young, slick staff resembling fine dining waiters generally in white shirts and gloves.

The bidders are in the room, on the phone and online.

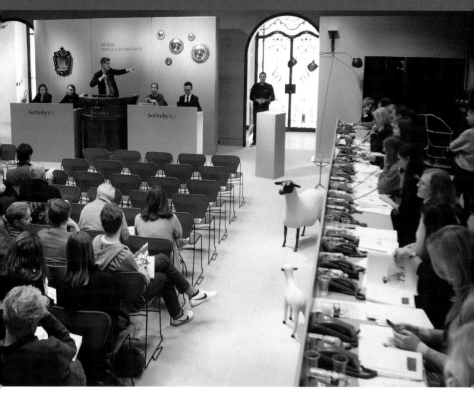

Understandably, more and more are happening on the telephone and online, but there's still action in the room which gives the sale a bit more of a perk. If the bidding rises quickly and competitively and a type of ping pong begins to happen, the tension is palpable and sometimes finishes in a round of applause when a high price is achieved.

You'll also notice that the auctioneers tend to have a sense of humour. Jeremy Durack, Finance and Operations Director / Company Secretary of Sotheby's Paris says:

'Actually all the auctioneers have their own style. They have a witty repartee as auctions can go on for three or four hours and if it's monotone, people can nod off! They need to maintain the room, change their tonalities, wake people up and maintain the momentum of the auction – it's really important and adds value to the auction.'

You don't need to have the finances to buy a Picasso.

Some books and object, or pieces from a whole house collection, can go for a few hundred euros. Give it a go (just don't forget it's not monopoly money and read the back of the catalogue for the conditions as there may be additional taxes etc), or just watch the cyclonic bidding and have fun imagining who is buying, for whom and why.

Here are the top places:

Ruby Boukabou

SOTHEBY'S
76 rue du Faubourg Saint-Honoré, 75008
www.sothebys.com

This British auction house was founded in 1744 and became the first international auction house when it opened in New York in 1955. There are now eighty offices in forty countries, the Paris office opening in 2001 after the French law changed to allow international competition. It's located opposite the Palais de l'Élysée, official quarters of the president. They also host conferences, events and cocktail parties for registered collectors.

CHRISTIE'S
9 avenue Matignon, 75008
www.christies.com

Also British, Christie's auction house was founded in 1766 by James Christie and is now owned by François-Henri Pinault's Groupe Artémis. It famously sold Da Vinci's Salvator Mundi for a record $450.3 million in 2017 (New York) for the Louvre Abu Dhabi. Its Paris HQ, opened in 2001, is refined and elegant and also in the 8th in the triangle d'or of auction houses and antique dealers.

ART CURIAL
7 Rond-Point des Champs-Élysées, 75008
www.artcurial.com

In the Hôtel Marcel Dassault, an 1844 neoclassical building (renovated by architect Jean-Michel Wilmotte in 1952) this French auction house on the Champs-Élysées, is the third largest in Paris after Christie's and Sotheby's.

Ruby Boukabou

Make sure to check out the incredible art bookshop, one of the largest in France and reserve a table at the fine Italian restaurant, decorated by Dorothée Boissier and Patrick Gilles.

DROUOT
9 rue Drouot, 75009
www.drouot.com

Drouot is the most active auction house with independent auctioneers hiring over seventy sales rooms. Founded in 1852, it is now owned by a subsidiary of BNP Paribas. It's traditional and steeped in history where the French auctioneers are well known for finding precious objects and it's a bit of a treasure trove for collectors.

▼ *Cocktail party pre sale.* Ruby Boukabou

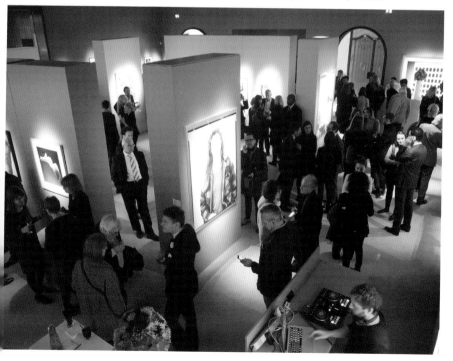

11

ARTY CAFÉS, RESTAURANTS AND HOTELS

SINCE THE SEVENTEENTH century, Parisians have used cafés, brasseries, restaurants and hotel bars as places to meet, network, relax, write, gossip and graze. Today there are thousands of them in all shapes and sizes and many are magnificently decorated, some like time capsules and others refreshingly inventive in their design. Here are some establishments to visit while in town.

LE PROCOPE

13 rue de l'Ancienne Comédie, 75006
+33 (0)1 40 46 79 00
www.procope.com

The oldest café in Paris, founded in 1686, this Left Bank establishment, close to the Comédie-Française, was once a haunt for (male) theatre types, writers and intellectuals including the likes of Russeau and Voltaire. It helped make coffee a popular drink, launching the ever-booming coffee culture. Benjamin Franklin and Thomas Jefferson joined in on the social and political debates that took place within. Napoleon was also a client.

On the second floor, Voltaire's desk is on display and one of the house specialities is his much loved hot chocolate (he supposedly also had forty cups of coffee a day – no wonder he wrote so much). Dose up on either while admiring the crystal chandeliers, the chestnut furniture, black and white tiled floors and golden framed portraits.

CAFE LA PALETTE

43 rue de Seine, 75006
+33 (0)1 43 26 68 15
www.cafelapaletteparis.com/en

Once visited by Cézanne, Picasso and Braque and, later, Ernest Hemingway

▲ *Café de la Paix.*

and Jim Morrison, the Palette, opened in 1913, is both bar and bistro and has artists' palettes hanging from the ceiling, rich wooden panelling and large painted murals creating a suitable location for artists, gallerists, dealers and art students to take time out, socialise and sometimes even sketch. The service is hit-and-miss but the cheese and meat platters are delicious. Glance to the left of the terrace as you enter – it's said to be reserved for elite gallerists and people of note in the 'hood.

CAFÉ DE LA PAIX
5 place de l'Opéra, 75009
+33 (0)1 40 07 36 36
www.cafedelapaix.fr/en/

Opposite the Opera Garnier and designed by architect Alfred Armand, the Café de la Paix, opened in 1862, has a sumptuous interior with bronze, marble, leather and gold. Mosaics and fine decorative touches create a plush ambiance for theatrical debate or philosophical pondering after visiting the opera, or just gazing across at it. Famous clients have included Émile Zola, Guy de Maupassant, Romantic composer Jules Massenet and the Prince of Wales.

▲ *Le Grand Véfour.* Michel Langot

▼ *Le Train Bleu.*

LE GRAND VÉFOUR
17 rue de Beaujolais, 75001
+33 (0)1 42 96 56 27
www.grand-vefour.com/en

The first grand restaurant in Paris, opened in 1784, Le Grand Véfour is a celebration of eighteenth-century decorative arts with a shock of gold and red velvet to get your heart pumping. Fine dine under chandeliers among neoclassical frescoes with pretty floral motifs and allegories.

LE TRAIN BLEU
Paris Gare de Lyon
Place Louis-Armand, 75012
+33 (0)1 43 43 09 06
www.le-train-bleu.com

Created for the 1900 Exposition Universelle, Le Train Bleu inside the Gare de Lyon is one of the most beautiful railway brasseries around (in 1972 it became an

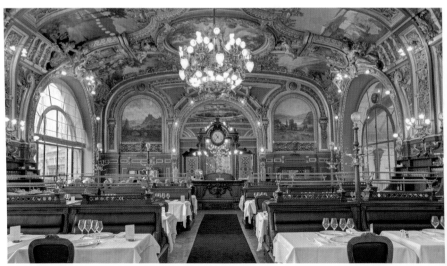

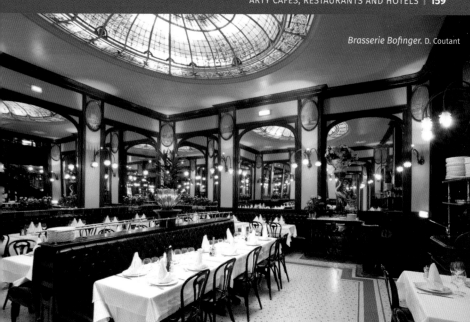

Brasserie Bofinger. D. Coutant

official historic monument). Forty-one paintings on canvas were created by artists including François Flameng, Gaston Casimir Saint-Pierre and René Billotte with views from trains travelling through Paris, Lyon, Monaco and various other destinations. Make sure to come early for your train out of Paris to enjoy a coffee or a meal in this historic location once visited by Colette, Brigitte Bardot and Coco Chanel.

BRASSERIE BOFINGER
5-7 Rue de la Bastille, 75004
+33 (0)1 42 72 87 82
www.bofingerparis.com/en/

Founded in 1864 this is about as classic as Parisian brasseries get. The red awning with a large B can't be missed on the rue de la Bastille and inside, the piece

de resistance is a delicate glass dome above the central dining room. Upstairs is decorated with landscapes of Alsatian artist 'Hansi' (Jean-Jacques Waltz) and there's use of glass, mirrors and brass throughout the belle époque décor. You once would have bumped shoulders with Gene Kelly, Maurice Chevalier or Johnny Halliday here, and it has been a regular address for French presidents and their entourages.

CAFÉ BEAUBOUG
43 rue Saint-Merri, 75004
+33 (0)1 48 87 63 96
www.cafebeaubourg.com

Simple and chic, the Café Beauboug, opened in 1987, was designed by architect Christian de Portzamparc (Cité de la Musique, Parc de la Vilette) who

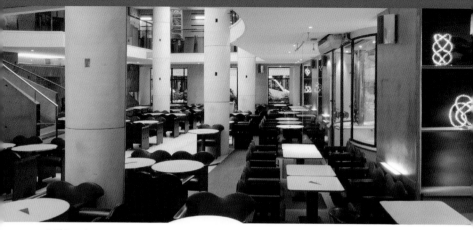

▲ Café Beauboug.

later went on to receive the prestigious Prix Pritzker. With a red and white colour scheme and undertones of industrial interiors meets Art Deco, it attracts a mixed crowd from tourists to theatre goers; Pompidou visitors to art dealers.

MAXIM'S

3 rue Royale 75008
+33 (0)1 42 65 27 94
http://maxims-de-paris.com/en/

Founded in 1893 and now classified as a historical monument, Maxim's is synonymous with elegance, charm and celebrity since the belle époque. A temple of the sensual Art Nouveau style, the elegant interiors of flowers, butterflies, leaves and dragonflies enliven the restaurant, once cabaret. Past clientele includes Marcel Proust, Brigitte Bardot, Jeanne Moreau, Greta Garbo, Marlène Dietrich, John Travolta and more recently Dita Von Tease, Lady Gaga and Kylie Minogue.

CAFÉ MUSÉE JACQUEMART-ANDRÉ

158 boulevard Haussmann 75008
+33 (0) 1 45 62 11 59
www.musee-jacquemart-andre.com

With crystal chandeliers, a Tiepolo ceiling fresco, a carved Louis XV console and eighteenth-century tapestries, this tearoom is in the original dining room of the 1875 mansion which houses the Musée Jacquemart-André is a delightful pit stop for a tea and a pastry.

LE CRISTAL ROOM

Museum Baccarat
11 place des États-Unis, 75116
+33 (0)1 40 22 11 10. 11
http://cristalroom.com/

Within the museum Baccarat (fine French crystal) is the Baccarat and Starck designed restaurant Le Cristal Room. French superstar designer Philippe Starck's marks are clear with dramatic contemporary ideas meeting classic flirtations (pink plush cushions, exposed

brick wall, old fashioned candle holders). Crystal chandeliers and high ceilings extend the opulence. Diners get a free tour of the museum.

LA COUPOLE
102 Blvd du Montparnasse 75014
+33 (0)1 43 20 14 20
www.lacoupole-paris.com/en

This famous Parisian brasserie, opened in 1927, is a bold example of Art Deco style with marble-like pillars decorated with artworks, Cubist-inspired mosaics, glass chandeliers, a dramatic central bronze statue of a man and a woman joined in

La Coupole. Salle Verticale

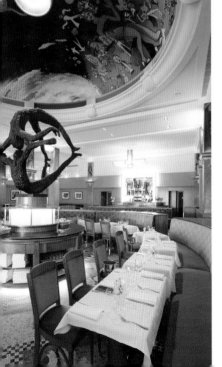

an arch by Louis Derbré (1925–2011) and theatrical ceiling. Many artists used to eat and drink here including painters Soutine, Man Ray, Matisse and Picasso. Josephine Baker and Mistinguett made entrances, Camus and Jean-Paul Sartre were regulars and Gainsbourg and Birkin would come for Sunday lunches.

LE GRAND COLBERT
2 rue Vivienne, 75002
+33 (0)1 42 86 87 88
www.legrandcolbert.fr/

A historic monument, named after Louis XIV's famous minister, somewhat of an expert of French cuisine, Le Grand Colbert is classic, elegant and well frequented. It was made into a restaurant in 1900 from a covered passageway created in 1825. Pompeian-style paintings and relics such as sculpted pilasters decorate the large room. The floor has classic mosaic tiles and the lamps, plants and high ceilings give a sense of grandeur and comfort.

LE KONG
1 rue du Pont Neuf, 75001
+33 (0)1 40 39 09 00
www.kong.fr

Elegant, chic and completely original, this top contemporary, (2003, renovated 2013), French-Asian fusion restaurant (really, you can order snail Dim Sums!) from Laurent Taïeb offers, sensation views of the Pont Neuf and Paris. With

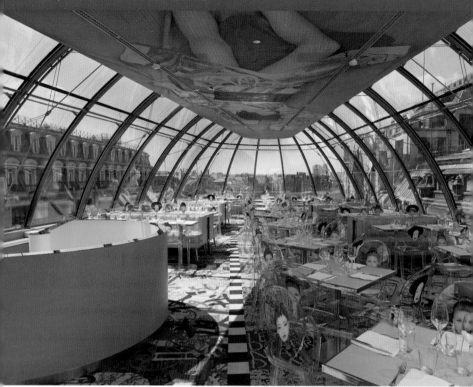

▲ *Le Kong.*

Philippe Starck in the design seat, expect a striking collision of colours, materials and prints. After your meal visit the large terrace that boasts Louis XVI style furniture, golden lamps, leather seats and a fake fireplace.

CHEZ LAURENT
41 avenue Gabriel, 75008
+33 (0)1 42 25 00 39
www.le-laurent.com

If you're feeling flush and like the idea of eating at an exclusive restaurant where auctioneers and art dealers head to dine, be seen and look for clients, treat yourself to lunch here. Laurent Paris was originally Louis IV's hunting lodge and restored in 1842 by German architect Jacques-Ignace Hittorff who was commissioned by King Louis Phillipe to develop the Champs-Élysées. Make sure to book a table in the adorable back courtyard garden if weather permits.

HOTELS

Hotels are making a comeback in Paris as fancy places to meet for a hot beverage or a cocktail. You'll find both the classic and luxurious, where you can sit back with an out-of-this-world hot chocolate (it may cost a fortune, but the experience is worth it) and the newer chic establishments that are vibrant with inventive contemporary design. Some even boast their own art concierge.

DRAWING HOTEL
17 rue de Richelieu, 75001
+33 (0)1 73 62 11 11
www.drawinghotel.com

A concept hotel by Carine Tissot, director of the Drawing Now art fair, in collaboration with NIDO architects, the Drawing Hotel offers forty-eight rooms that celebrate contemporary design with six designers given carte blanche – Lek & Sowat, Abdelkader Benchamma, Clément Bagot, Françoise Pétrovitch and Thomas Broomé. The results are intriguing. There is an Art Concierge for hotel clients for the latest on exhibitions and so forth and the D bar, open to all, has a lovely modern-chic style good for long afternoon teas or early evening cocktails.

THE RITZ
15 place Vendôme, 75001
+33 (0)1 43 16 30 30
https://ritzparis.com/en

Opened in 1898 by César Ritz, this French luxury hotel has remained the epitome of elegant French style and was once

▲ *The Ritz.* Vincent Leroux

haunt of Coco Chanel, Audrey Hepburn, Marcel Proust and Ernest Hemingway. Marble, gilding, oak woodwork, wrought iron and delicate silks are part of the fine materials used in the princely frameworks.

▲ *The Ritz.* Vincent Leroux

A redesign signed Thierry W. Despont was aimed to polish up the luxury. The famous wood sculpture representing the swordfish in restaurant L'Espadon was restored in London, the chandeliers removed and brightened, and linden trees in Versailles planter-boxes added with atmospheric climbing ivy. While it may set you back a little, a cocktail in the Hemingway bar is a beautiful treat or you can set up with tea and cake, or a scotch by the fireplace in the Salon Proust, and check the time on the Louis XVI clock in wood and gilt bronze. And while the coffee is also at a five star price, the

service is impeccable and the attention to detail of the décor is applaudable by all standards.

LA MAISON FAVART
5 rue de Marivaux, 75002
+33 (0)1 42 97 59 83
www.lamaisonfavart.fr

This boutique hotel renovated in 2011 pays homage to eighteenth-century opera darlings Monsieur et Madame Favart (Charles-Simon, a writer and librettist and his much admired performer wife Marie-Justine) who were forced to separate when the powerful

Count of Saxony took a liking to Marie-Justine. Inspired by this love story, designers Laurent Jean and Laurent Bardet and decorators Thierry Martin and Thibaut created a theatrical romantic hotel, appropriately just behind the Opéra-Comique overlooking Place Boieldieu.

The thirty-four rooms have dramatic themes 'La lecon de danse' (the dance lesson), 'Les Toits de l'Opéra' with an attic-above-the-opera feel and 'Voyage en Chine' (Chinese Travels). The décor is poetic and guests can unwind with

a sauna, massage and a splash in the (blue-lit) swimming pool.

LES BAINS
7 rue du Bourg l'Abbe, 75003
+33 (0)1 42 77 07 07
www.lesbains-paris.com/en/

Marcel Proust was one of the clients of the bathhouse, opened in 1885, at 7 Rue du Bourg l'Abbe that later transformed (in 1978) with the help of designer Philippe Starck into a nightclub that became the place to be in the 80s (Andy

LE MEURICE
228 rue de Rivoli, 75001
+33 (0)1 44 58 10 10
**www.dorchestercollection.com/en/
paris/le-meurice**

Sip champagne listening to live piano and trumpet playing jazz in exquisite eighteenth-century-style grandeur. The Louis XVI style decorations revived by Philippe Starck and artist daughter Ana, in 2016, are just splendid.

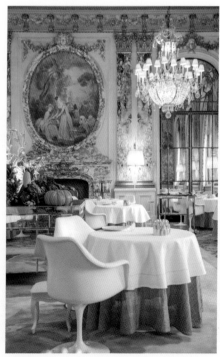

▲ *Le Meurice.*

Warhol, Yves Saint Laurent, Bono, Prince, David Bowie and Mick Jagger all partied here).

Today it has kept the majestic Hausmannian facade but inside, since 2010, is an exquisite thirty-nine room boutique hotel, restaurant, bar and club thanks to French hotelier and filmmaker Jean-Pierre Marois (whose father bought the establishment in the 60s).

The spacious design, from architect Vincent Bastie and interior designers Tristan Auer and Denis Montel, weaves antique and contemporary elements including a Salon Chinois, dimly lit rock-star corridors (with floral motif carpet inspired by Serge Gainsbourg's bathroom as seen in photos), a sound-proofed private dining room in the old reservoir and bright, beachy, chic rooms with cool, retro dial-up phones, balconies and hammams.

Have a drink on the patio to check out works of artists who were once in residence, including graffiti artists Futura and Space Invader and a jade sculpture in wood by Sambre (Sylvain Ristori).

HOTEL NATIONAL

243 rue Saint-Martin, 75003
+33 (0)1 80 97 22 80
www.hotelnational.paris/en/

The Haussmannian facade gives grandeur to this beautiful design hotel in the Marais signed Raphael Navot. The Italian Trattoria restaurant lies under a glass atrium, a refreshingly leafy L'Herbarium bar and terrace offers innovative and divine cocktails and the rooms are made to measure contemporary design where everything is exceptionally pleasant on the eye. Italian influences abound.

▼ *Hotel National.*

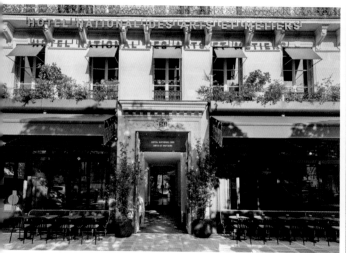

such as 'Minstinguett' (mirrors and antique furniture including a Jean-Gabriel Domergue clock), and a neo-Gothic 'Viollet-le-Duc' and the large suite boasts Napoleonesque restored furniture and a postcard view over Paris from the terrace. Book a table at Michelin-starred Le Restaurant, a spa treatment by the heated underground pool and steam room, or why not finish a left bank gallery tour in the decadent cocktail bar?

LE ROYAL MONCEAU RAFFLES PARIS
37 avenue Hoche, 75008
+33 (0)1 42 99 88 00
www.raffles.com/paris

This Parisian palace hotel is actually dedicated to contemporary art. Opened in 1928, it has kept its historic facade but inside it's a dazzle of light and design with

L'HOTEL
13 rue Des Beaux-Arts, 75006
+33 (0) 1 44 41 99 00
www.l-hotel.com

Built in 1828, on the spot which was once Queen Margot's Pavillon d'Amour (she supposedly met with secret lovers here), this hotel later catered to guests such as Salvador Dali, Frank Sinatra, Serge Gainsbourg and Oscar Wilde (notably, his final address). An interior six-floored lightwell stayed in place when refurbishment took place in 1967 by Jacques Garcia with a lush, intimate design. The twenty rooms have themes

▲ *Art gallery inside the Royal Monceau Raffles Paris.*

its Philippe Stark makeover (2008–10). 1930s elegance meets contemporary flair with chandeliers, fat pinstriped corridors, grey brick walls and delightful rooms with their own artworks. There's also an art gallery, a cinema and an art concierge: specialist Judith Benyayer, who writes a weekly art newsletter and assists clients in finding the best galleries, museums and openings as well as advising those wishing to purchase art. Madonna filmed the music video to 'Justify My Love' here and star guests have included Josephine Baker, Hemingway, Mistinguett and Michael Jackson.

HOTEL PARISTER
19 rue Saulnier, 75009
+33 (0)1 80 50 91 91
www.hotelparister.com

The hotel and its restaurant 'Les Passerelles' has a slick and original contemporary design, with art borrowed by the famous gallerist Kamel Mennour with ceramics by Karen Swami and fine creations by jeweller Aude Lechère. Close to the Opera Garnier!

HOTEL BRISTOL
112 rue du Faubourg Saint-Honoré, 75008
+33 (0)1 53 43 43 00

You may recognise this haven of a hotel from *Midnight in Paris*. It's utterly divine and both very classical and ultra luxurious. The hot chocolate is so rich,

▲ Hotel Bristol.

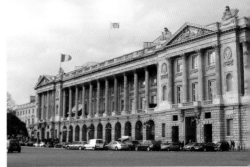

HÔTEL DE CRILLON
10 place de la Concorde, 75008
+33 (0)1 44 71 15 00
www.rosewoodhotels.com/en/hotel-de-crillon

it will keep you going for hours and the pastries are artworks in themselves. Original artworks decorate the public and private spaces including busts of Louis XVI, a portrait of Marie-Antoinette and Fa-Raon, the resident white Burmese cat, is part of the décor. A fairy-light installation in the stairs both delights and prevents vertigo. You may never want to leave.

This eighteenth-century private mansion and hotel since 1909 has attracted the likes of Sophia Loren, Peggy Guggenheim and Orson Welles. It features sculptures by Coustou and dramatic Corinthian columns. The interior, once of the most opulent in Paris, had a three and a half year overhaul by Aline d'Amman with help from Tristan Auer, Chahan Minassian, Cyril Vergniol, and Karl Lagerfeld. While keeping the eighteenth-century extravagance, a royal residential vibe has been recreated with modern and classic touches including a cloudscape above Les Ambassadeurs bar, crushed-velvet sofas, a new horseshoe bar with chandelier and a pretty Jardin d'Hiver tearoom. Residents can relish in original artworks and marble bathtubs – there's even seventeenth-century marble fountains transformed into bathroom sinks.

12
GREATER PARIS

THE CLOSER PARIS suburbs also have their own cultural centres, museums and art initiatives of interest. And while many Parisians gasp at the idea of heading outside the perimeters of central Paris, if not heading to the airport, it doesn't mean that you should!

MUSÉE PAUL BELMONDO
14 rue de l'Abreuvoir, 92100 Boulogne-Billancourt
+33 (0)1 55 18 69 01
www.museepaulbelmondo.fr

You're more than likely to know of French film star Jean-Paul Belmondo, but did you know that his father was a prestigious sculptor? Born in Algiers and studying at the Ecole des Beaux-Arts (until the First World War got in the way), he continued studies in Paris, won the Grand Prix de Rome in 1926, the Grand Prix artistique of Algeria in 1932 and the Grand Prix of the city of Paris in 1936. In 1956 he became a professor at the École nationale supérieure des Beaux-Arts de Paris.

While you can find two of his bronzes (Jeannette and Apollo) in the Tuileries Gardens, there are plenty of other neoclassical sculptures, medals and drawings of the artist, donated by his children, in this museum inside the château Buchillot de Boulogne-Billancourt.

LA GALERIE
1 rue Jean-Jaurès
93130 NOISY-LE-SEC
+33 (0)1 49 42 67 17 (FREE)
http://lagalerie-cac-noisylesec.fr/

A cultural centre in Noisy-le-Sec, La Galérie has a good reputation for engaging contemporary exhibitions and its youth and kids' program. Collaborating with various other local cultural organisations, the centre also offers projections, concerts and performances.

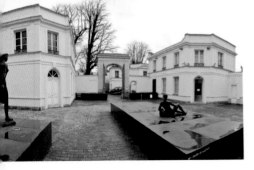

LA FERME DU BUISSON

Allée de la Ferme, 77186 Noisiel
+33 (0)1 64 62 77 00
www.lafermedubuisson.com

Circus, song, contemporary art, theatre and cinema are on the program at this cultural centre in a nineteenth-century farm building. If the season is right, after checking out the current art on display, kick back in a deckchair for a cinema under the stars.

LE CUBE

20 Cours Saint-Vincent, 92130 Issy-les-Moulineaux
+33 (0)1 58 88 30 00 (FREE)
lecube.com

Digital art and its innovations is what it's all about at Le Cube in Issy-les-Moulineaux, opened in 2001. Not only are there exhibitions from talented digital artists such as Christophe Luxereau and Hugo Arcier, but also artists in residence

MAC/ VAL

Musée d'Art Contemporain du Val-de-Marne
Place de la Libération, 94400 Vitry-sur-Seine
+33 (0)1 43 91 64 20 (FREE)
http://www.macval.fr/english/

This large contemporary art centre holds works from 1950s to today and is visited by all ages thanks to a strong permanent collection (Annette Messager, César, Sarkis) and plenty of activities such as concerts, experimental film projections and performances.

with their own presentations, conferences, workshops and activities for all ages.

MARCHÉ AUX PUCES DE SAINT-OUEN

Information Point, 124 rue des Rosiers
93400 Saint Open
+33 (0)1 55 876 750 (FREE)
www.marcheauxpuces-saintouen.com

Close by Porte de Clignancourt with a few thousand traders, this is one of the biggest flea markets in the world. Make your way through covered and open air stands and past the bric-a-brac and clothes to find the antiques. Take cash to avoid waiting for the ATM and be prepared to bargain, after all, that's half the fun. If you're patient, or lucky, you could find some lovely ceramics, nineteenth-century furniture, designer lamps, vintage cameras and much, much more. Just be careful of your wallet. Rue des Rosiers is the main strip but then there's many adjoining markets including Marché Vernaison, Marché Dauphin and Marché Paul Bert.

LE CRÉDAC
Contemporary Art Centre of Ivry –
Crédac
La Manufacture des Oeillets, 1 Place
Pierre Gosnat, 94200 Ivry-sur-Seine
+33 (0)1 49 60 25 06 (FREE)
https://credac.fr/v3/

The mission here is to create a
dialogue between contemporary artists
and the public through site-specific
creations, exhibitions, conferences,
debates and even artistic lunches.

MAINS D'OEUVRES
1 rue Charles Garnier, 93400 Saint-Ouen
+33 (0)1 40 11 25 25 (FREE)
www.mainsdoeuvres.org

A bustling cultural association in Saint-
Ouen on the border of Paris and by the
famous flea markets, Mains d'Oeuvres
offers four floors of activities including
contemporary exhibitions, workshops
and conferences. There's even a music
school, rehearsal studios, a performance
space and a bar/restaurant.

LE 6B
6-10 quai de Seine – 93200 Saint-Denis
+33 (0) 1 42 43 23 34 (FREE)
http://www.le6b.fr/

The 6B is a space by the Seine in Saint
Denis for artistic experimentation. As well
as visual artists, you'll find musicians,
filmmakers, dancers and actors- working
away on creations and presenting them in
regular exhibitions and performances. You
can sometimes even check in for open air
classes such as Aikido – Japanese martial
arts to unify your energies before hitting
the next art opening!

MICRO ONDE
8 bis avenue Louis-Bréguet, 78140 Vélizy-
Villacoublay
+33 (0)1 78 74 38 60
www.londe.fr

In a striking urban architecture by Claude
Vasconi, artistic residencies lead to

GALLERY CONTINUA
Le Moulin 46 rue de la Ferté-Gaucher,
77169 Boissy- le-Châtel
+33 (0)1 64 20 39 50
www.galleriacontinua.com

A country space for Gallery Continua, in a former factory of 10,000 square metres, allows the exhibition of monumental art works by top artists from all across the globe.

Intriguing site-specific creations and bold contemporary art pieces, with debates and conferences around various themes such as 'can art save the planet?', 'art isn't serious' and 'mémoires of war and the power of images'. Stay for a film or a live show (from dance to comedy) as the name of the game here is multidiscipline.

'116' MONTREUIL/ CENTRE TIGNOUS D'ART CONTEMPORAIN
116, rue de Paris, 93100 Montreuil
+33 (0)1 71 89 28 00 (FREE)
**www.facebook.com/
CentreTignousdartcontemporain**

While it's officially outside Paris, Montreuil is sometimes dubbed the 21st arrondisement by Parisians and it's accessible by metro. The 116, a cultural centre, opened under the direction of the much respected Marlène Rigler, is a nineteenth-century townhouse revisited by architect Bernard Desmoulins. The re-naming of the space in 2017 to Centre Tignous paid homage to Bernard Verlhac (aka Tignous), a local cartoonist who was killed in the Charlie Hebdo shootings. Expositions, workshops, guided visits and conferences take place around the diverse range of art on display.

GALERIE THADDEUS ROPAC PANTIN
69 avenue du Général-Leclerc, 93500 Pantin
+33 (0)1 55 89 01 10 (FREE)
www.ropac.net

With another gallery in the Marais and spaces in London and Salzburg, the established gallery owner is enjoying having more space in the new 'Brooklyn of Paris'. Expect top quality international contemporary art.

13

ART CLOSE AND PERSONAL

AFTER MARVELLING AT the museums, wandering through the glorious galleries and gawking at the well-groomed brasseries and cafés, there will come a time where you will want to mix things up and become part of, or closer to, the artistic action. Roll up your sleeves, sharpen your pencils and prepare your palette (or at least your Parisian parole!). Here are some ways you can either create some art yourself or have encounters with the artists and art industry of Paris present and future.

ACADÉMIE DE LA GRANDE-CHAUMIÈRE

Pop In Sketch Sessions with Live Models
14 rue de la Grande Chaumiere, 75006
+ 33 (0)1 43 26 13 72
www.grande-chaumiere.fr/en

Inspired by all the great works and want to get sketching? Professionals and first timers can both benefit from these drop-in sessions with live models all through the week. It's also a good excuse to visit the historic artist area of Montparnasse. The Academy de la Grande Chaumière was founded in 1904. While three hours may sound daunting if you're a beginner, time flies as you grip your pencil and try to capture the various poses that last between about ten minutes and half an hour. There's an art shop across the road but in case it's not open, you may want to bring a sketch pad, pencils and eraser.

There's no need to register, just pop in: Monday, Tuesday, Thursday, Friday from 12.15 to 3 p.m. and from 3.15 to 6 p.m., Wednesday from 7 to 10 p.m. and Saturday from 1 to 5 p.m. Cost is currently €19.

MEET THE ARTISTS | SEE THEIR WORKSHOPS

Ruby Boukabou

CITÉ DES ARTS
www.citedesartsparis.net

Since 1965 the French government has invested in two large artist-in-residence complexes, one in the Marais and one in Montmartre. Over 300 multi-disciplined

Cité Des Arts.

artists live and create here and include French pianists, Russian painters and Chinese sculptures. Check their site for the program of exhibitions, performances and other occasions to meet the artists. The gallery is situated on the corner of rue Geoffroy l'Asnier opposite the charming l'Île Saint-Louis with a great view over the Seine.

PORTES OUVERTES FESTIVALS – OPEN DOOR/STUDIOS

After visiting the major galleries, the slick contemporary art spaces and the refined theatrical eateries, you will be ready to meet artists in the midst of creation. Paris has associations of artists from the various

areas who since 1990, starting with Belleville, have produced a brilliant event called the 'Portes Ouvertes' – the 'open door' festival during which the artists open up their studios to the public. Equipped with a map found in the local cafés, or online, discover the back streets and quirky spaces that you would never otherwise have access to, or even know existed. There's a festive vibe and always interesting characters and talented artists to meet. You're also likely to find a unique and affordable piece of art.

▲ *The back streets of Ménilmontant are full of intriguing artists' studios.* Ruby Boukabou

PORTES OUVERTES BELLEVILLE (MAY)
ateliers-artistes-belleville.fr

Organised by the Ateliers d'artistes de Belleville (see also 'Belleville'), this is the largest of the Portes Ouvertes with over 120 studios and over 250 artists in the dynamic cross-cultural hub that is Belleville. Between the street art colouring the walls of this corner of town, you will enter large, light workshops, tight backstreet territories and luminous lofts.

PORTES OUVERTES MÉNILMONTANT (LATE SEPTEMBER)
www.artotal.com/orga/Ateliers-Artistes-Menilmontant-Paris.htm

Ménilmontant is just down the boulevard from Belleville with hundreds of bars, small music venues and plenty of buzz. Discover converted churches, green alleyways, performances under grape vines and beautiful, hidden houses.

LES ATELIERS DU PÈRE LACHAISE ASSOCIÉS
(Twice a year generally in March and November)
http://www.apla.fr/blog

Keep going past Ménilmontant and you'll reach Père Lachaise that has an open studio festival twice a year. Make sure to visit the famous cemetery while you're there.

MONTREUIL (October)
While officially outside of Paris, Montreuil is still accessible by metro. However it has more of a village vibe with the smell of log fires and brighter stars. 'It's a little

corner out of town that's a bit special and very pleasant', says pop culture artist Tristan Diquatrostagno,

> It used to be a bit rough. We'd come, but just to go to the club, then head back quickly to Paris... Then the factories closed down so many artists came and bought spaces at affordable prices. For the Portes Ouvertes you can spend the whole three days discovering – there is so much – arts companies, small factories, artists' ateliers and homes of both people who make pottery as a hobby on the weekend and who sells a piece for 20,000 Euros. It's vast!

Make sure to stop off at Albatros Studios at this occasion, or for other events listed on their site: **http://www.espacealbatros.fr/**. Once Pathé cinema studios, the studios were bought by Lucien and Lily Chemla after the death of their son, Michael, whose last wish was for them to open a theatre named after him. The centre is much more than that

with a few dozen artists in residence and workshops, cinemas, theatres (Marcel Marceau once made an appearance), film sets, exhibition and rehearsal spaces.

MONTMARTRE AUX ARTISTES
(October)
189 rue Ordener, 75018
montmartre-aux-artistes.org

An initiative of councillor Jean Varenne in 1924, Montmartre aux Artistes is a complex of studios built for artists to live and work. Low rent allows them to concentrate on their creations and the intimate environments leads to collaborations and community. Once a year, a few dozen residents open their doors to the public. Enter their intimate studios and take the time to talk to them about their process and works ... while admiring the views of Sacre Coeur. You may even find yourself staying for a tea or glass of wine and leaving with a signed artwork. Artists include painter Monique Journod (Prix de Rome), painter/engraver Médéric Bottin, photographer Vincent Dufrêne and painter/calligrapher Luc Lynski.

LYNSKI. Ruby Boukabou

Médéric Bottin outside his studio with a view!
Ruby Boukabou

LES FRIGOS (LATE MAY)
19 rue des Frigos, 75013
les-frigos.com

Exhibitions and concerts take place in this old refrigerated railway depot built in 1921 that has been a home to artists and their studios since 1980 (first a squat and later an official residence with artists paying some rent). Meet the painters, sculptors, photographers, potters, architects and costume makers. There are also various exhibitions and events during the year that you can find out about on their site.

FONDATION VILLA MARIE VASSILIEFF
21 Villa Marie Vassilieff, 75015
+33 (0)1 43 25 88 32 (FREE)
www.villavassilieff.net

Once the museum of Montparnasse, the Villa Marie Vassilieff is now a centre of art and research with a gallery that invites artists to create works that have a historical link to Montparnasse. Works reference the artists that haunted the area which became the new hub for artists post

Montmartre: Picasso, Matisse, Modigliani, as well as the lesser known African, Indian and Russian artists including Marie Vassilieff who created the space in the early twentieth century (and provided a canteen for many of the artists during the war). Today, artists from China, Japan, Cuba and other countries are invited to live and work in the space for a few months, ending their stay with an exhibition.

LE VIADUC DES ARTS
1-129 avenue Daumesnil, 75012
+33 (0) 1 44 75 80 66
www.leviaducdesarts.com

The Viaduc des Arts was created in the 80s, just by Bastille and Gare de Lyon, in an old railway line, to house shops and workshops of fifty-two arts and crafts designers of various forms, often working with rare and precious materials. Carpet makers, jewellers, furniture designers, porcelain painters and sculptors are among them. You can go in at any time, but it's always livelier during the regular themed exhibitions and for their participation in events such as Paris Design Week. There are dining options for time out

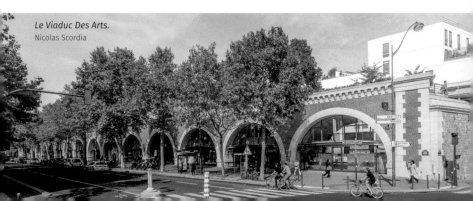

Le Viaduc Des Arts.
Nicolas Scordia

and a bar with concerts – (jazz brunches, latin music nights … **www.leviaduc-cafe.com**). When you're done browsing or brunching, discover the wonderful 'promenade plantée' on the top of the building, a lush and leafy walk through from Bastille to Bois de Vincennes along the old rail line.

LE 104 (CENTQUATRE)
5 rue Curial, 75019
www.104.fr/en

The 104 is a vibrant and dynamic multi discipline cultural urban project with plenty of activities including talks, exhibitions and movement classes (from Qigong to street dance). You'll likely come across the artists in residence with hip hop dancers training in the courtyards and painters in the garden. Have lunch at the café and check the site for the various festivals, artist talks, exhibitions and happenings including a dance hall 'Bal Pop'.

LAFAYETTE ANTICIPATION FROM GUILLAUME HOUZÉ
9 rue du Plâtre, 75004
http://lafayetteanticipation. squarespace.com/

The heir of Galeries Lafayette, Guillaume Houzé has initiated a permanent art foundation 'Lafayette Anticipation' opened in 2018 in a nineteenth-century building revisited by architect Rem Koolhaas 'To satisfy our thirst for creativity, we must drink from its

source—close to the artists,' says Houzé. 'Their work pushes us to exercise freely our judgment, and forever alter our view of ourselves, and of the world.' The five-storey building includes 800 square metres of exhibition space with innovative mobile platforms and studios for artists across the disciplines from design to music and performing arts.

DOC PARIS
26 rue du Dr Potain, 75019
https://doc.work/

Originally a high school, then, once abandoned, a squat, DOC is now a multidiscipline art space where around a hundred artists spend their days painting, carving, etching, rehearsing and editing. The cheap rent allows them to concentrate on their work and there's a strong sense of community that's helped

▼ *Doc Paris.*

with a shared garden, kitchen and large terrace. DOC is open to the public for art openings, poetry readings, theatre performances, screenings and concerts.

LA COLONIE
128 rue Lafayette, 75010 (FREE)
www.lacolonie.paris

Ruby Boukabou

Ready for a drink or a boogie among engaged, artistic minds? Head to La Colonie in the 10th.

Winner of the prestigious Marcel Duchamp prize, (2016), the passionate French contemporary artist of Algerian heritage Kader Attia created La Colonie to 'assemble different types of people outside the institutions'. A space for artistic and social debate and exchange with projections, readings and concerts, it was important to the artist and his business partner Zico Selloum to have a space that has direct access from the street, and free entry. The space is independent, funding itself from the bar during great DJ sets at night. Attia says:

I think that French society is more and more fragmented now and it needs to be repaired with these kind

of public/political debates which include free speech and free minds discussing what has never really been treated. Post-colonial issues in France are a big taboo – so this is the idea of La Colonie – a space that is about sharing art and knowledge while having a great time.

LE CARREAU DU TEMPLE
2 rue Perrée, 75003
+33 (0)1 83 81 93 30
www.carreaudutemple.eu

A former clothes market in a large Napoleon III building in the Marais, the Carreau du Temple has been a cultural centre since 2014. Many artistic events take place throughout the year and a bar area offers an excuse to mingle with the artists present for the various fairs, expositions and sessions.

POINT ÉPHÉMÈRE
200 Quai de Valmy, 75010
+33 (0)1 40 34 02 48
www.pointephemere.org

A funky arts & entertainment centre on the Canal Saint-Martin, Point Éphémère has

▼ *Kader Attia.* Ruby Boukabou

residency programs, exhibitions as well as rehearsal spaces, concerts, screenings (street art documentaries and more) and a café/bar with a relaxed urban vibe.

KADIST ART FOUNDATION
19bis/21 rue des Trois-Frères, 75018
+33 (0)1 42 51 83 49
http://kadist.org/paris/

Kadist is a non-profit organisation based in Paris (and San Francisco) with a collection of socially engaged works on global issues. The works and surrounding events encourage the international artists in residence to engage with the public. You can attend an exhibition but also performance art shows, book readings, concerts and debates.

RÉSEAU TRAM
http://tram-idf.fr/

'Réseau Tram' is an association promoting contemporary art in and around Paris. They work in association with the various art institutions and communities to offer art excursions to various spaces and some walking tours that you can find on their site.

ÉCOLE NATIONALE SUPÉRIEURE DES BEAUX-ARTS
14 rue Bonaparte, 75006
+33 (0) 1 47 03 50 00
www.ensba.fr

Brush shoulders with the next generation of French artists at the National Fine Arts school by attending an exhibition, conference, seminar or attending an art documentary.

59 RIVOLI
59 Rivoli 75001
www.59rivoli.org

Open to the public Tuesday – Sunday 1–8 p.m.
A celebration of art in the centre of Paris, the 59 Rivoli artists' squat/studio is bold and colourful with five floors full of artists in the midst of creation. Wander about, meet the artists, buy some work and stay for the seemingly spontaneous parties and concerts. The thirty artists are made up of fifteen in residence from three to six months and fifteen permanent. Once a real squat, the artists Kalex, Gaspard, and Bruno (comically calling themselves 'the KGB') got good press and the promise from candidate Bertrand Delanoë that if elected, he would make 59 a legal art squat and gallery. It happened, and in 2005 the city bought 59 Rivoli and, after renovations, reopened to the artists and the public with a lease renewable every three years.

In return for the cheap rent, the artists offer the City of Paris a vibrant location in central Paris. Be a little sensitive if an artist is in deep concentration, but you'll get a gist on who's in the mood for a chat. And if you love someone's work, now is the moment to find out more about the process and the artist.

There are events and expositions (on the ground floor) and every weekend there's

▲ *Linda McCluskey with her works in a Parisian Café.* Ruby Boukabou

live music from around 6 p.m. to 9 p.m.

Three of them share their stories:

Linda McCluskey

American Linda McCluskey came to Paris on a study abroad exchange in 2002 as an excuse to change her environment after losing her partner and love of her life in a motorbike accident. She had always loved Paris and decided it was the best way to move forward. Her class met in cafés, went to the Louvre and other museums, 'it was amazing'.

At her first group exhibition, Linda was expecting to just have the works shown. They all sold. 'I said "are you kidding me??" then kept painting and painting'.

She discovered 59 Rivoli by accident while walking past but was too timid to enter. 'So I joined a Meet Up ground on Facebook and signed up for a visit.' But arriving an hour early by mistake, she entered, climbed a few floors, met some artists chatting and drinking wine, joined them and forgot all about the group – who finally came up to find her looking as if she belonged there. She soon did. In 2010

she moved her studio here which became a rendez vous for weekend parties with concerts and hours of artistic banter between friends and strangers.

'What I really loved about Rivoli was that with 2000 people a week coming through, all of a sudden I realised that just because one person hadn't liked my painting, it doesn't mean anything – somebody else is going to like it. So the only one who has to really like it is me. 59 let me not care and get that essential freedom an artist needs.'

She left six-and-a-half years later, in January 2017, and now spends her time in the south east of France, travelling regularly to Paris for expos. Look her up to order a pretty Parisian distorted landscape. **www.lindamccluskey.com**

James Purpura

Originally from Ohio, James Purpura came to Paris for a cultural emergence program. Back in the States he was studying urban planning but knew that it wasn't really for him. He started painting his first work 'Blue Dream'. Half way

▲ *James Purpura in his studio at 59 Rivoli.*
Ruby Boukabou

through the painting he got stuck, having never taken an art class in his life, 'I was playing Bolero and started to see the music so I started painting the music – it was the weirdest thing but it helped me finish the piece. I went onto another piece with the same music and did another one'. James was later discovered to have synaesthesia, hearing music and seeing images that has vibrant results.

After having painted half a dozen works, he was encouraged by friends to continue, sold a work – to his huge surprise – and had a show.

James, like Linda, found 59 Rivoli by accident when walking down the street. He is now permanent and on the commission that chooses the new artists.

'This place is unique. If you go to a museum ninety nine per cent of the artists are dead; if you go to a gallery, you may meet the artists if you go on the opening. But here, you get to see the artists and the works being made. And for my part I love to see how people react to my work.' **www.jamespurple.com**

Hydrane

'It's easier to work here than at home when you're distracted easily,' admits French-Peruvian urban artist Hydrane. 'I'm learning also to present myself and talk about my work.'

Hydrane began drawing lines and patterns as a child. An exchange program organised by the Association d'Ateliers de Belleville took her to Brazil where she learnt how to paint on walls (before she had been printing her work then pasting it up). She designed on a fisherman's favela wall, a French school, and started experimenting with painting on the floor, also inspired by her Peruvian heritage with The Nazca Lines – pre-Colombian etchings in the sand seen from the air.

Hydrane takes stock of her artistic and physical voyage on her Instagram 'Hydrane' and continues to attend street art festivals, take private commissions and go out on the street with new experimentations. **http://hydrane.fr/**

▼ *Hydrane.* Ruby Boukabou

14

ARTY DAY TRIPS

WHILE THERE'S SO much on offer artistically that it's easy to fill all your days and evenings inside Paris (and its close suburbs), in around an hour by car or train you can be strolling through richly decorated palaces, gasping at private collections and hanging out on the gorgeous lake setting of Monet's Water Lily paintings. The countryside air will also give your step a spring when you return to the pavements of Paris.

Ruby Boukabou

LE SILO

Private Collection of Françoise and Jean-Philippe Billarant
route de Bréançon, 95640 Marines
lesilo@billarant.com

In a former 1940s grain silo less than an hour's drive north east of Paris lives the private collection of Françoise and Jean-Philippe Billarant. And live it does. Instead of keeping their magnificent collection of conceptual and minimal art to themselves, the Parisian couple open the doors of the Silo to the public, on

▼ *Françoise and Jean-Philippe Billarant lead personal tours of Le Silo.* Ruby Boukabou

Le Silo.
Ruby Boukabou

appointment, for free. Having handpicked their pieces for over four decades, they have collected some real treasures and developed relationships with the artists. Their passion for the works is infectious, their sense of presentation and mise-en-scène brilliantly balanced between the dramatic and the zen. There are over 100 works (over two large floors, a mezzanine and a top room as well as an installation in the stairwell) and many other works not on display (they redesign the space every two years.) Among the artists are François Morellet, Peter Downsbrough, Felice Varini, Krijn de Koning and Carl Andre. Numbers for each visit are limited so reserve in advance for this incredible occasion.

CHÂTEAU DE FONTAINEBLEAU
77300 Fontainebleau
+33 (0)1 60 71 50 70
www.musee-chateau-fontainebleau.fr

Head south east to this large French royal château with medieval origins (only a forty-five minute RER trip and short bus trip or walk). The palace was first built in the twelfth century, later reconstructed by François I and other leaders including Napoleon (Bonaparte) and today is a UNESCO World Heritage Site. During the French Renaissance, the French and Italian artists employed here

▼ *Château De Fontainebleau.* Jerome Schwab

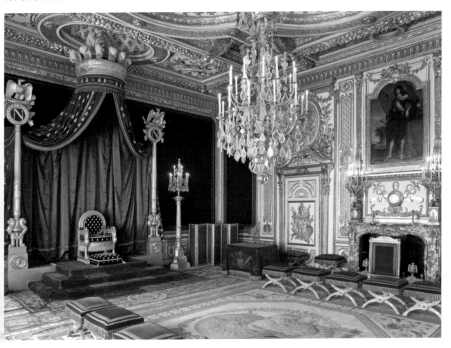

were the top of their class. The palace is full of fine frescoes, tapestries, paintings and historic furniture dating back to the Renaissance. Wander through the Galerie François I (the audio guide explains the allegories from the king's life painted by Italians Il Rosso and Francesco Primaticcio), the Second Empire Salon and the Chinese museum of the Empress Eugénie. Then stroll around the splendid French and English gardens with Napoleon's pavilion on the lake. Wander five minutes into the small town centre for a meal or coffee at the pretty Place Napoleon Bonaparte.

GALERIE ART FONTAINEBLEAU
10 rue des Trois Maillets
+33 (0)6 07 06 10 28
www.artfontainebleau.net

While in town, pop over to the modern and contemporary gallery 'Art

▼ *Galerie Art Fontainebleau.*

Fontainebleau' to browse their latest exhibition or pick up something from 'word artist' Ben, iconic stencil street-artist Miss Tik, or abstract painter Jean Miotte.

CHÂTEAU DE VERSAILLES
Place d'Armes 78000, Versailles
+33 (0)1 30 83 78 00
http://en.chateauversailles.fr/

This Unesco World Heritage listed palace is breath-taking in its pomp and glory inside and out. The enormous palace was built for Louis XIV when he'd had enough of living at the Louvre in Paris. Architects on board were Louis Le Vau and Jules Hardouin-Mansart and the magnificent interiors were designed by Charles Le Brun, with much of the art depicting Louis as the sun king himself. Be wowed by the hall of mirrors with the crystal and silver chandeliers, vaulted ceilings, statues of Greek gods and busts of Roman

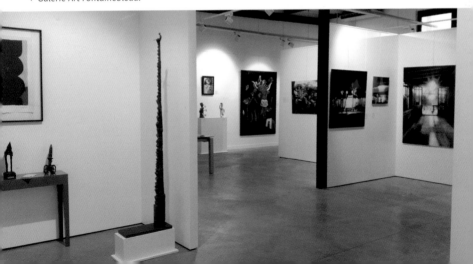

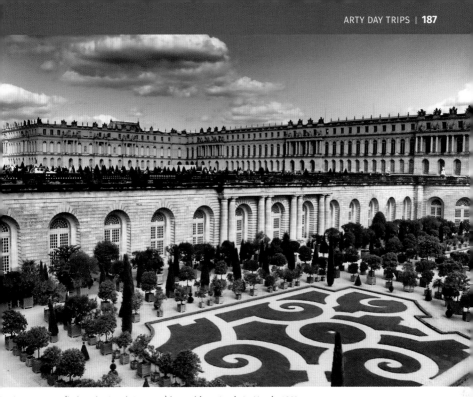

▲ *The Orangery (below the South Parterre) by architect Louis Le Vau in 1663.*

emperors. Unfortunately yes, there are crowds. Get some air in the stunning and seemingly endless gardens decorated with statues of goddesses and fountains with marble basins. The garden designed by André Le Nôtre (1613–1700) inspires a long stroll. Check their site for the events program and schedule your visit to catch a classical recital, an opera or even a masquerade! To understand the ground-breaking fashions of the times that have continued to influence contemporary fashion, pore over the beautiful and highly illustrated coffee-table book Fashion and Versaille (Flammarion) by French fashion expert Laurence Benaïm.

LA MARÉCHALERIE

5 Avenue de Sceaux, Versailles
+33 (0)1 39 07 40 27
http://lamarechalerie.versailles.archi.fr/

If you have time left over in Versailles, visit La Maréchalerie, the contemporary art centre of the Versaille Architecture college (l'Ecole Nationale Supérieure d'Architecture de Versailles) the former stables of the chateau. The space works with both known artists and students, and talks are organised around each exhibition, usually revolving around the issues of space and architecture.

GIVERNY

Train from Gare Saint Lazare in Paris to Vernon (around forty minutes on the line to Rouen and Le Havre), then shuttle bus, walk or cycle 4km.

Check the weather forecast and when it looks like the sun will be out, head to this small village, 75kms from Paris, in Normandy, to dive into nature and refresh your senses with the flowers and freshness that inspired the Impressionist painters who visited and lived there, mainly Claude Monet, who moved in 1883 and spent the rest of his days here (until 1926).

FONDATION CLAUDE MONET – MONET'S HOUSE & GARDENS

84 rue Claude Monet 27620, Giverny
+33 (0) 2 32 51 28 21
http://fondation-monet.com/en/

Strolling around the world famous large pond framed by weeping willows, crossed with green Japanese footbridges and coloured with hundreds of types of trees and flowers, you'll slip into serenity and taste Monet's inspiration for his famous Water Lilies series. The second garden by the house is a floral celebration with irises, tulips, daffodils, forget-me-nots and dozens of other flowers that sweeten

Monet's dining room.
Ruby Boukabou

A part of Monet's flower gardens and house. Eric Sander

he air and the eye. Inside the house you'll get a sense of the pretty country house as it was, with a grandfather clock, bookcases, chaise lounge, writing desk, Monet's Japanese print collection. There is also a print of other artists such as Cézanne, Signac, Renoir and Delacroix. Monet's works (also prints) hang in the salon. You can almost smell the roast duck dinners of days past coming from he rustic kitchen.

MUSÉE DES IMPRESSIONISM
9 rue Claude Monet, Giverny
33(0) 232 51 94 65
www.mdig.fr

few minutes walk from Monet's Garden is he Musée des Impressionism with a small permanent impressionist collection and regular exhibitions on the likes of Monet, Manguin and various Impressionists and Post-Impressionists. Take an audio guide and plunge into a pocket of history, pick up a poster in their gift shop and absorb it all in the garden café.

HÔTEL BAUDY
81 Rue Claude Monet, 27620 Giverny
+33 (0)2 32 21 10 03
www.restaurantbaudy.com

Taste the famous omelette at Hôtel Baudy, open since 1887 and once a popular spot for Monet and friends. The hotel has kept it's quaint look and there's a lovely rose garden terrace for warmer weather.

EGLISE SAINTE-RADEGONDE
53–55 Rue Claude Monet, 27620 Giverny

You can take a fifteen-minute walk here with a great view over the countryside. Simply climb up rue Blanche Hoschede past the Musée de Mécanique Naturelle (pop in if you're mechanically inclined), walk up the hill instead of turning with the road and follow the track to the left until you arrive at a narrow path leading down above the church.

The small church has stained glass windows that magically project golden light onto the altar just before sunset, and if you take the path leading up to the cemetery you can pay your respects at the grave of Monet and family.

LE JARDIN DES PLUMES
1 rue du Milieu Giverny +33 (0)2 32 54 26 35
www.jardindesplumes.fr

If you want to shout yourself an exceptional evening, book into this Michelin starred restaurant and boutique hotel (eight rooms only).

LA GROTTE À BIÈRE
18 B Rue Vieille Charrière de Gasny, 95780 La Roche-Guyon
https://www.facebook.com/ LaGrotteABieres/

If you're in a car and want to finish your day with a local beer, cheese and chacuterie platter, wind your way over to this beer cellar, literally in a cave. While there you may even find a design piece to take home, (lamps, chairs and metal artworks).

GALLERIES

AS YOU STROLL down rue Claude Monet and neighbouring streets (you won't get lost, it's a tiny village), you'll come across a handful of galleries. Pop in, have a look and a chat to the gallerists, often the artists themselves. Some follow in a sort of impressionistic style with inspirations from the village's flowers and nature, others have their own thing going on with sculpture, pop art and contemporary flavours. Visit Alain in his gallery Espace 87 (87 rue Claude Monet) for example, who sells for various artists including his own fun bronze pieces of soap bars, deformed as if by time.

▼ *Artist Alain in his gallery Espace 87.*
Ruby Boukabou

MUSEUM OF JEAN ARP

21 rue des Châtaigniers, Clamart
+33 (0)1 45 34 22 63
www.fondationarp.org

Discover abstract sculptures, paintings, engravings and Dadaist reliefs of the artist and photos with wife Sophie Taeuber, James Joyce and Max Ernst.

VILLA SAVOYE

82 rue de Villiers, 78300 Poissy
+ 33 (0)1 39 65 01 06
www.villa-savoye.fr/en

Avant-garde architect Le Corbusier (Swiss-born Charles-Édouard Jeanneret) is known for his Modernist style. This

weekend retreat was restored by the French state and listed as a historic monument in 1964.

DOMAINE DE CHANTILLY – MUSÉE CONDÉ

rue du Connétable, 60500 Chantilly
+33 (0)3 44 27 31 80
www.domainedechantilly.com/en

Wander through the palace of Chantilly enjoying the works of Géricault, Ingres and Delacroix among others; the Musée Condé boasts a very impressive collection of fifteenth- and sixteenth-century paintings. The library, in the Petit Château, has in its collection a few hundred medieval manuscripts. Visit

Domaine de Chantilly.

the Museum of the Horse and the Great Stables and then head out to the large French gardens designed by Le Nôtre.

If things feel oddly familiar, you may be recognising the residence of baddy Max Zorin (Christopher Walken) in the James Bond film 'A View to a Kill'. The Domaine has also been used for Pink Floyd concerts and, in 1659, Molière's Les Précieuses ridicules, had its debut performance here.

CHÂTEAUX DE VINCENNES
Avenue de Paris, 94300 Vincennes
+33 (0)1 43 28 15 48
Visit the fourteenth-century château on the eastern edge of Paris, originally built as a hunting lodge in about 1150 for Louis VII, then became a royal residence and even prison (the Marquis de Sade was imprisoned here). If the weather is nice, pack a picnic to enjoy in the nearby forest.

Châteaux de Vincennes

Domaine De Chamarande. Henri Perrot

DOMAINE DE CHAMARANDE

38 rue du Commandant Arnoux
91730 Chamarande
+33 (0)1 60 82 52 01
http://chamarande.essonne.fr/

A beautiful seventeenth-century château and its gardens in the department of Essonne offers fresh air and lots of family-friendly entertainment with interactive artistic games for kids. Exhibitions take place inside, such as from the vibrant French painter, once street artists, Yassine Mekhnache (from Lyon). Sculptures and various artworks are also on temporary exhibition in the park/gardens.

15

TIPS ON BUYING ART

SO, YOU'VE BEEN wowed by the museums, inspired by the galleries and refreshed by the street art. You think it would be rather nice to buy an artwork to remind you of your fabulous Paris trip and decorate your home or office. Where to start? The galleries, the Portes Ouvertes, the Flea Markets, 59 Rivoli, the Marché de Creation (**http://www.marchecreation.com/en**) are all possible ways to go. But best take the experts' advice.

A tip on what not to do after the purchase? Don't jump in a taxi, take a phone call and leave your artwork on the back seat, as a French art dealer did with a 1.5-million-Euro Concetto Spaziale (Spatial concept) by Argentinian-born Italian artist Lucio Fontana in the Marais in 2017 (luckily the honest taxi driver handed it in!).

Jeremy Durack, originally from Western Australia, is the Finance and Operations Director and General Secretary of Sotheby's France. He worked as part of the management team to establish the legal and operational infrastructure of the French auction business prior to starting auctions in France late 2001. He says that buying art needs to be about...

> *a love affair. You're after beauty and quality. It doesn't matter how much it costs. After a week, will you still want to look at it every day? ... Paintings have a spirit. Before buying, educate yourself through visiting the museums that have a rigorous selection process. Find out what the influences are of the artists you love and research other artists in a similar style that may be more affordable.*

Helen Szaday von Gizycki of Paris Fine Art Consulting is also a

board member of the European Chamber of Art Experts and has over twenty years of experience of fine art advisory and expertise for clients in Europe, the USA, Asia and Australia. She previously worked as a private banker in New York and Tokyo and at Sotheby's in Asia and Paris (**http://www.pfac.eu/**):

> *Buy what you like, that's the key thing. You don't want to be buying something to put in a warehouse for ten years – what's the point?*

Sandra Hegedüs is a Paris-based Brazilian-born art collector who founded the nonprofit organisation SAM Arts Projects in 2009 with her French husband, Amaury Mulliez, to promote and finance French artists internationally, as well as foreign artists within France from emerging countries:

> *The most important thing is to buy with your heart and your eyes, and not with your ears- it's not because somebody told you that... no. Dare to buy what touches you, it's the most important thing.*
>
> *Find young artists at the salon de Mont Rouge [**www.salondemontrouge.com**]. A lot of artists whose works are now in galleries and very expensive came from there. Be the eye, trust your eye. Visit the galleries in the Marais, Saint-Germain-des-Prés and Belleville. And if at the FIAC, don't stay downstairs, go upstairs to the younger gallery section and you will discover exciting new artists.*

▲ *Sandra Hegedüs.*
Red Marigaux

Australian gallerist Joseph Allen Shea runs Galerie Allen (59 Rue de Dunkerque, 75009) and is among the most approachable and friendly gallerists in town today. (**www.galerieallen.com**) He says:

> *You need to speak to the experts in the auction houses and the dealers and get a feel for the market before you start buying. Build up a bit of knowledge about what you're collecting, what's on the market and what the prices are. Like for anything, shop around. There's a lot of very knowledgeable people who are happy to talk. Go to the art fairs and the galleries. People don't always realise that, while it can*

▲ *Joseph Allen Shea.*
Ruby Boukabou

be a bit intimidating, these people are happy to talk about the works and they're all passionate about what they sell. Doing your homework and speaking to the experts beforehand is part of the pleasure as well.

The beautiful thing about the commercial galleries is that it's free education. There are very important pieces on display and you can just enter and have a gallery owner tell you about the work. There may be an image of the snooty unapproachable gallery owner that can make it quite scary for a first time visitor, but that's what we're here for. Be brave and you'll be surprised. Go in, don't be scared, ask questions and ask the prices (which are, unfortunately, negotiable).

Tristam Diquatrostagno is a painter/sculptor and graphic designer based in Montreuil with an erotic/pop bent. He was one of the founders of the 80s Punk street-art collective 'Les Musulmans Fumants' (the smoking Muslims) at the time mixing with the likes of Jean-Michel Basquiat.

▲ *Tristam Diquatrostagno.*
Ruby Boukabou

If you can, go and see the artists in their workshops. The Portes Ouvertes is the best occasion. There are so many artists that you're bound to find something that you like and a budget that suits both you and the artist. It's more fun this way. Or head to the galleries in the Marais. For street art, if you see a work that you like there's always the signature of the artist somewhere. Look them up online and contact them. Once you've met one artist, in general they know many others who also may take your fancy, and are generally open about sharing contacts. You'll start to meet the artists and grow your own network. There are so many styles, you're surely going to find something you'll love.

Luc Saucier, Art Lawyer (Paris / Brussels):

At Drouot's Auction House [**www.drouot.com**] you can often find incredibly beautiful nineteenth-century paintings for as little as 100 euros. It's amazing. You can buy the most exquisite antiques and contemporary art for nothing at all.

Julie Eugène, Art Concierge, Le Royal Monceau Raffles Hotel Paris:

> *Art helps us transcend daily life and reach the sublime;*
> *it allows us to travel, question, revolutionise and*
> *communicate across the languages. But it's also very*
> *personal, so when a client wants to buy something, I*
> *can't choose for them. It's about their tastes. If they're*
> *not sure where to start, I get them to tell me which*
> *artists they like and what media they prefer – painting,*
> *sculpture, photography... then if they like tactile, colourful*
> *etc... then I'll direct them to the galleries that correspond.*
> *There's also a great gallery at the hotel, Art District.*

Charles-Wesley Hourdé, gallerist and expert in African, Oceanic and American Indian arts, advisor for Christie's (**www.charleswesleyhourde.com**):

> *[When looking at buying African and Tribal art] wander*
> *around Saint-Germain-des-Prés, look through the*
> *windows and don't hesitate to enter galleries, even if it*
> *seems slightly scary if they're empty or if you have to*
> *ring the bell. Follow your instinct on what you like. These*
> *gallerists are so passionate about their collections that*
> *once you show a little interest, they're more than happy*
> *to engage with you whether you're buying this time or*
> *not. But be careful of people coming up to you on the*
> *street – they'll try to sell you false pieces.*

Charles-Wesley Hourdé.
Ruby Boukabou

Galerie Antoine Levi, 44 Rue Ramponeau, 75020 (**http://antoinelevi.fr/antoine-levi/**):

> *Lots of collectors start by word of mouth, others by*
> *wandering into a gallery and liking something then*
> *having a conversation. But there's no magic formula.*
> *It seems scary, but you just need to enter and see*
> *the aesthetics. Each gallery has its own research*
> *that creates a movement. Then there's the FIAC and*
> *Paris International (see 'Art Diary'). It's like buying an*
> *album- maybe you've heard of the artist, maybe they're*
> *fashionable, or maybe you fall across them and are*
> *delighted. Most galleries have a decent variety of prices*
> *to give you the opportunity of starting small.*

16

ART DIARY

PARIS HAS INCREDIBLE art accessible all year round so that you can either sweat it out with other tourists in sunny August (when many Parisians have left town for their beach holiday, but be careful as some places are closed during this month), bound around in spring or beautiful September/October, or enjoy the quieter and much crisper months from November to April. However, there are many art events that may tickle your fancy and provide occasions to visit and rub shoulders with other international art lovers as well as curators, dealers and artists. If you're alone it's easy to strike up conversations while looking at art works, or at the bar. Make sure to check the exact dates on the sites as they vary slightly each year. Enjoy!

GRAPHIC DESIGN FESTIVAL
www.ddays.net/en/

Held at the Musée des Arts décoratifs and many places throughout Paris for five weeks between January and February, this festival, produced by D'Days and Artevia, celebrates all forms of graphics from typography to signage to visual identities. The debates, events, exhibitions and screenings are free.

CIRCULATION(S) FESTIVAL-PHOTOGRAPHIC HAPPENING
www.festival-circulations.com/en

Organised by Fetart sometime between January and March each year, this festival, at the cultural hub at 104, is programmed around talented young and innovative European based photographers with the ambition to provide audiences with dynamic contemporary takes on photography, while assisting the young photographers to launch into the professional world.

▼ Circulation(s) Festival.

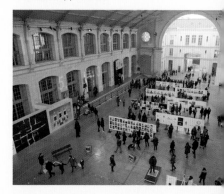

▲ *Salon du Dessin.* Tanguy de Montesson

ART 3F INTERNATIONAL CONTEMPORARY ART FAIR
www.art3f.fr/en

This fair, for established and emerging artists and galleries, travels around France and is held in Paris, usually in late January. It's a lively ambiance with a good accessibility to the artists and their sculptures, paintings and with a live street art element. Jazz is often played live and it's a family friendly occasion with a colourful kids' zone. Wine and sushi bars give pit stop options from the artistic discoveries.

ART CAPITAL
Grand Palais
www.grandpalais.fr

Over five days near the beginning of the year, the gorgeous Grand Palais presents a bustling art fair with the ambition to strengthen bonds between artists, galleries and the general public. Dive into the subtleties of water painting, charcoal, silk paper sculptures and pastels with over 2,500 artists to discover including painters, engravers, photographers, sculptors and architects.

SALON DU DESSIN
Palais Brongniart
www.salondudessin.com/en

Curators, artists, scholars and the general public come together at the Palais Brongniart every year in the third week of March for this delightful Drawing Salon

that invites thirty-nine galleries from the major art capitals such as Paris, Rome, New York, London and Geneva with specialities ranging from the Old Masters to the moderns to contemporary works with over 1,000 drawings on display. 'Drawing corresponds to today's sensibilities, at a time when the image is all-important', says organiser Bertrand Gautier. Among the events during the week long salon is a children's drawing competition with the winning works hung alongside the pros.

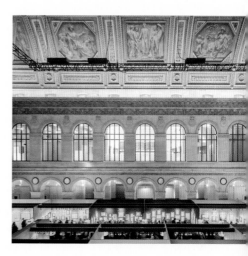

PAD
The Tuileries gardens
www.pad-fairs.com/paris/en/

In March/April, shake up your ideas on decorative arts and design with this fair, in the stunning Tuileries gardens, that attracts design aficionados and collectors worldwide and aims to provoke dialogues between modern art, historical and contemporary design and jewellery. Categories include sculpture, modern art, jewellery, glass & ceramics, 'Primitive' art, contemporary design, nineteenth- and twentieth-century decorative arts. The prestigious PAD Prize is awarded each year to one stand, one contemporary design piece and one twentieth-century design piece.

DRAWING NOW
Carreau du Temple
www.drawingnowparis.com

Also in March, this drawing exhibition brings together seventy-five art galleries plunging into the world of contemporary drawing. Around 400 artists are represented and over 2,000 works.

DDESIGN- PARIS CONTEMPORARY DRAWING FAIR
Atelier Richelieu, 60, rue de Richelieu 75002
http://ddessinparis.fr/

Held in March, this fair is for established and emerging artists and has its own award.

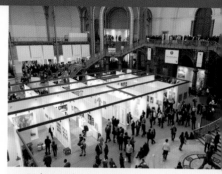

▲ *Paris Art Fair.* E. Nguyen Ngoc

ART PARIS ART FAIR
www.artparis.com/en

At the Grand Palais for over two decades this fabulous spring event is dedicated to modern and contemporary art from the post-war years to the present day with inclusions from emerging artists globally.

Tsuyoshi Maekawa
Challenging Gutai

Nguyen Ngoc

GREATER PARIS PHOTOGRAPHY MONTH
http://moisdelaphotodugrandparis.com/

Launched in 1980 and produced by the
Maison Européenne de la Photographie,
the festival, in April presents a rich
program with around 100 exhibitions all
over town. Praise famous photographers
while discovering emerging talent. Venues
include the Centre Pompidou, the Musée
d'Orsay and venues in greater Paris.

SALON DE MONTROUGE
www.salondemontrouge.com

Just south of Paris (but on a metro line),
Montrouge programs this fabulous
salon in April/May that promotes young
contemporary artists, and has been doing
so since 1955. Discover the next generation
of French sculptors, painters, sketchers and
video artists (while they're still affordable!).

LES PORTES OUVERT DE BELLEVILLE
ateliers-artistes-belleville.fr

Discover the art and artists of Belleville
during this great open-door festival where
you can wander right into the studios, chat
to the creators and pick up an affordable
work. (See also 'Art Close and Personal')

LA NUIT EUROPÉENNE DES MUSÉES –
THE EUROPEAN NIGHT OF MUSEUMS
www.nuitdesmusees.culture.fr

Workshops, concerts, exhibitions and
yes, free museum entries, are proposed

▲ *Musée de l'Homme.* JC Domenech

on the third Saturday of May. Over 3,000 museums participate in thirty European countries from Portugal to Russia. Download the app and get festive with a couple of million enthusiasts around France.

JOURNÉES EUROPÉENNES DU PATRIMOINE – EUROPEAN HERITAGE DAY
www.journeesdupatrimoine.culture.fr

Since 1984 the public has been able to get behind the scenes of heritage listed sites including theatres, castles, churches, town halls, museums and now landscapes with various events and guided tours proposed by the Ministry of Culture. Takes place in September.

PARCOURS DES MONDES
www.parcours-des-mondes.com

Wander around the quaint streets of Saint-Germain-des-Prés between up to sixty galleries participating in this 'tribal' art (meaning art of Indigenous peoples) festival every September. Examine

traditional woodworks and contemporar inspirations from Africa, Oceania, Asia and the Americas, stopping off for sips and snacks in the cute bars and eateries on the way.

BIENNALE DES ANTIQUAIRES
The Grand Palais
www.biennale-paris.com/en

This elegant fair, founded in 1956 by the Syndicat National des Antiquaires, is one of the world's oldest art and antique fairs, held annually in September. Be amazed by extravagant carpets, ceramic mirrors, chandeliers, watches, clocks, paintings sculptures and more. Luxury brands – Cartier, Bulgari and friends hav more recently attracted their own blingy crowds. If it's all a bit overwhelming, you can book a guided tour.

FASHION WEEK
https://fhcm.paris/fr/paris-fashion-week-f

Get among the glamorous world of haute couture during fashion week with Chanel, Gaultier, Dior etc in September/ October. There's no doubting the catwal creations are works of art.

PARIS DESIGN WEEK
www.maison-objet.com/fr/paris-design-wee

Across the capital, students, professionals and enthusiasts of design come together in September for events, exhibitions, talks and soirées celebratin

▲ *An OCTAVIO AMADO work in Paris Design Week.*

all forms of design. Galleries, schools, studios and workshops open their doors to show off their skills and innovations.

NUIT BLANCHE
www.nuitblanche.paris

After the fête de la musique where the city streets become alive with live music to celebrate the arrival of summer (21 June), the 'Nuit Blanche' or 'White Night'

event is one of the most festive evenings in Paris, held on the first Saturday in October. Free programs are distributed around the city, and people hop all over town visiting the museums all night long finding all sorts of contemporary art in intriguing locations: churches, sidewalks, warehouses, and by the Seine and the canals. You may cross fanfares on the streets, DJs in the museum bars and light shows complimenting the celebration.

FIAC FOIRE INTERNATIONALE D'ART CONTEMPORAIN – INTERNATIONAL CONTEMPORARY ART FAIR
Grand Palais
www.fiac.com

It's the place to be for the contemporary art world. Artists, gallerists, collectors, dealers, curators and art lovers flock to Paris every October to see, talk

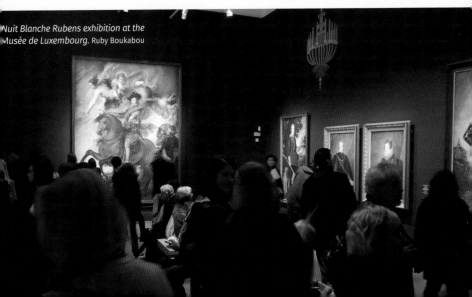

Nuit Blanche Rubens exhibition at the Musée de Luxembourg. Ruby Boukabou

and dream contemporary art in all its forms: painting, sculpture, photography, installation, video and digital arts. There's also an intriguing off-program at the Jardin des Tuileries, the Musée national Eugène-Delacroix and at the place Vendôme.

PARIS INTERNATIONAL
http://parisinternationale.com/

Paris International was launched in 2015 by a group of young French gallerists with the idea to support and promote young artists and gallerists that may not have to budgets to attend FIAC but that do have a lot of talent on offer.

▼ *Flamboyant American creations at PARIS INTERNATIONAL.* Ruby Boukabou

These gallerists are Crèvecoeur, High Art, Antoine Levi, Sultana and Gregor Staiger. The event is free and nomadic, venues have included the chic hôtels particuliers on Avenue d'Iéna and the ex-Liberation newspaper offices, founded by Jean Paul Sartre. Held in October, during the FIAC.

YIA – YOUNG INTERNATIONAL ART FAIR
The Carreau du Temple Cultural Centre
http://yia-artfair.com/

Founded in 2010, the fair hosts over 20,000 visitors annually and exposes over 300 artists, also in October during the FIAC. There's always a lot of mingling happening in the bar area. If you're lucky you'll meet some artists and may even end the evening with them on a barge on the Seine...

ART ÉLYSÉES
Champs- Élysées
www.artelysees.fr/en

In pavilions set up along the Avenue des Champs-Élysées, this art and design fair in October is a rendezvous for art aficionados and collectors, with French and foreign galleries presenting a variety of works from the modern and contemporary worlds and twentieth century design.

ASIA NOW PARIS
9 avenue Hoche, Paris 8ème
www.asianowparis.com

The Paris Asian Art Fair is a boutique affair of contemporary Asian art in October.

It showcases artists from Korea, China, Malaysia, Taiwan, Singapore and other Asian countries as well as European based Asian art galleries.

PARIS PHOTO FAIR
www.parisphoto.com

While the weather may be getting fresh, November is a good month in Paris for photographers and photography lovers with the annual Paris Photo Fair, the largest international photography art fair in the world. Events are curated for professionals and amateurs with over 180 galleries and publishers presenting work from vintage photos to avant-garde images to video. Meet critics, historians, curators and photographers, and Instagram your own snaps from this pretty area of Paris, by the Champs and the Seine.

SITES TO CHECK
Here are some sites you may find helpful for finding art events. If you plan your trip well in advance, you can also sign up to the mailing lists of the museums and cultural centres.

SLASH
https://slash-paris.com

Events, artists, venues, installations, videos.

FONDATION ENTREPRISE RICARD
www.fondation-entreprise-ricard.com

Find out about all sorts of exhibitions

and galleries. Their 'MAP', both online and printed, is an excellent gallery guide listing many of the openings as well as a little map of their selection of galleries.

PARIS ART
www.paris-art.com

Art, Photo, Design, Dance, Books, news, articles and a calendar of events.

TRAM
http://tram-idf.fr/

News and events on contemporary art centres and museums.

CREATIVTV.NET
WebTV for contemporary art, photography and comic books. Videos with artists, critics and curators.

FACEBOOK EVENTS
Once you like a few galleries and say you're interested or attending an opening, you can then search 'events near you' and the technology will often let you know of other openings around the corner from where you are. Practical!

INSTAGRAM
Start following artists and galleries that you read about and they'll post about upcoming openings and exhibitions. You can also find me on Instagram @rubytv. Bon voyage and I look forward to seeing your discoveries! #whiteowlartloversparis

Index

Bibliography

Anderson, Robert, *Salvador Dali* (*Artists in their World*) Franklin Watts London 2002

Buisson, Sylvie & Parisot, Christian, *Paris Montmartre, A Mecca of Modern Art 1860-1920* Pierre Terrail, Paris 1996

Clarke, Stephen, *Paris Revealed: The Secret Life of a City*, Viking 2011

Copplestone, Trewin, *Claude Monet* Regency House Publishing Wiltshire 1998 (reprint 2002)

Cumming, Robert, *Art: A Visual HIstory* Penguin Random House UK 2005, 2015

Georgel, Pierre & Labiau, Jean-Pierre, Masterpieces from the Musée de l'Orangerie, Art Exhibitions Australia Limited and Queensland Art Gallery 2001

Harris, Nathaniel, *Paul Cézanne* (*Artists in Their World*) Franklin Watts London 2003

Ingram, Catherine, *This is Dali* Laurence King Publishing 2014

Keazor, Henry, *Poussin* Taschen Cologne 2007

Kindersley, Dorling, *Eyewitness Travel: Paris* DK Limited Great Britain 2011

Lanchner, Carolyn, *Pablo Picasso* The Museum of Modern Art New York 2008

Meek, Jan (editor), *The Moderns* The Art Gallery of New South Wales 1984

Pitts, Christopher & Williams, Nicole, *Discover Paris* Lonely Planet 2017

Renoir, Jean (intro and chapters ed. Margherita d'Ayala Valva and Alexander Auf der Heyde), *Renoir* Rizzoli International Publications, Inc. New York 2005. Originally published in Italian by Rizzoli Libri Illustrati 2003

Sanna, Angela, *Impressionism* Scala Group Florence 2011

Walther, Ingo F., *Picasso* Taschen Cologne, Germany 1996

Welton, Jude, *Henri Matisse* (*Artists in Their World*) Franklin Watts London 2002

Wolf, Norbert, *Romanticism* Taschen, Cologne 2007

Zöllner, *Leonardo Frank* Taschen Cologne 2005

Websites include:

http://www.histoires-de-paris.fr/
http://www.digicult.it/
https://theculturetrip.com
www.timeout.com
www.lebonbon.fr
https://www.artforum.com
https://www.galleriesnow.net